The Hand
and Eye
of the Sculptor

 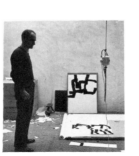 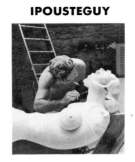 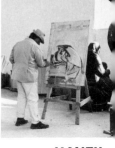

BUTLER **CESAR** **CHILLIDA** **DODEIGNE** **D'HAESE** **IPOUSTEGUY** **MANZU**

The Hand
and Eye
of the Sculptor

**Text and Photographs
by Paul Waldo Schwartz**

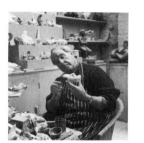

MARINI **MOORE** **TINGUELY**

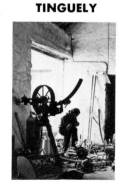

FREDERICK A. PRAEGER, *Publishers*
New York · Washington · London

FREDERICK A. PRAEGER, *Publishers*
111 Fourth Avenue, New York, N.Y. 10003, U.S.A.
5, Cromwell Place, London S.W.7, England

Published in the United States of America in 1969
by Frederick A. Praeger, Inc., Publishers

© 1969 by Frederick A. Praeger, Inc.

Library of Congress Catalog Card Number: 79–83348

Printed in the United States of America

Designed by Harold Franklin

For my parents

ACKNOWLEDGMENTS

The passages from Albert Camus's *The Rebel* (translated by Anthony Bower) are reprinted by permission of Alfred A. Knopf, Inc. The lines from T. S. Eliot's *Four Quartets* are reprinted by permission of the publishers, Harcourt, Brace & World, Inc. The quotations from Michel de Ghelderode are reprinted with permission from "The Ostend Interviews," which originally appeared in *Tulane Drama Review* (1959). The lines from Federico García Lorca's "Martyrdom of Saint Eulalia" are reprinted from *Lament for the Death of a Bullfighter* with the permission of William Heinemann Ltd., publishers.

Preface

PROBABLY ANY GENUINE BOOK, like any genuine sculpture, proceeds from an impulse prior to articulation, prior to what may seem to be the original 'idea.' The thing exists formless, invisible, until some confluence of events or suggestions confirms its existence and begins to give it shape. And so it was with this book.

What came first was perhaps a fascination with sculpture itself, a sense of elusive magic and permanence blended into one. And with that came its obverse, a sense of the strange incongruity of the sculptural object as a force, an element of power in an indifferent or hostile world—a world whose power currents and power symbols have become so subtle, so overwhelming, and, from the human point of view, so disproportionate.

There was also an idea that had been knocking about for some time, an idea for a fictional piece about the inner conflict of a medieval cathedral carver who realizes that he is not what he is supposed to be—an artisan in the service of religion—but a creative spirit in the service of . . . what? The twelfth century had no word for it. The implications might have seemed apostatic, or satanic.

The circumstances are not so hard to imag-

ine: Chartres or Autun, awesome in its uncompleted state; the ring of chisel and stone, sharp against an unbroken medieval silence composed of fortuitous natural rhythms—the chirp of insects, an ageless obscenity grumbled by some vexed stonecutter. And then, the consciousness of stone becoming a saint or a demon or an ass with a harp; the strange, inexplicable chemistry of moments sculpted by action and reflection; and, at last, in one mind among many, a blossoming realization, most likely ill defined, which might take the shape of uneasiness, or fear.

In Hertfordshire, Reg Butler made a chance comment that drew a good many parallel and provocative thoughts into focus: "Isn't it plasticity that defeats caricature?"

For ours is an age of caricature, of consensus, of principles, of theses—an age of the reporter, the photographer, the sociologist, the annotator—an age of trends and tendencies in varying, self-conscious equilibrium—and also an age of great thirst for . . . what? The twentieth century has no word for it. Or, if it has the word, is hard pressed to utter it.

Certainly, the longed for quantity touches upon the central question of power, which has never ceased to be an issue but which assumes new proportions in an age of so very much power.

During the eighteenth century, which doted on rationality—or at least claimed to—Lord Acton formulated his famous principle that "Power tends to corrupt; absolute power corrupts absolutely." During the nineteenth century, with its romantic preoccupations, Nietzsche said that the "will to power" was everything, the key to the only human dignity and salvation and preeminence. Our own century is heir to Acton and Nietzsche alike, without the specific limitations, or faiths, of either. Perhaps Albert Camus arrived at the most acceptable answer to the problem of how to resolve this dichotomy, even if the answer he proposed be limited in application:

"Nietzsche," said Camus, "could deny any form of transcendence, whether moral or divine, in saying that transcendence drove one to slander this world and this life. But perhaps there is a living transcendence, of which beauty carries the promise, which can make this mortal and limited world preferable to and more appealing than any other. Art thus leads us back to the origins of rebellion, to the

extent that it tries to give its form to an elusive value which the future perpetually promises, but which the artist presents and wishes to snatch from the grasp of history."

Camus also explicitly voiced the opinion that, "The greatest and most ambitious of all the arts, sculpture, is bent on capturing, in three dimensions, the fugitive face of man, and on restoring the unity of great style to the general disorder of gestures."

He concluded his essay on "Rebellion and Art" with these words: "In upholding beauty, we prepare the way for the day of regeneration when civilization will give first place—far ahead of the formal principles and degraded values of history—to this living virtue on which is founded the common dignity of man and the world he lives in, and which we now have to define in the face of a world which insults it."

This book is addressed precisely to that spirit of definition.

Of course, the clarification one seeks resides ultimately, and uniquely, in the sculptor's work. But in his studio, in his words, in the circumstantial order and disorder of his life, one finds another perspective, at once greater and lesser than the final articulated statement, the work itself.

There may come a day—the day may even be relatively imminent—when the sculptor's studio as we know it will disappear entirely. Art may, conceivably, be transposed to a plane of action where there is no permanence, a condition in which art reverts to theater and ritual, and in fact ceases to be art as we know it. If that does happen, then the men represented in this book will have been projected according to the perspective of time on to a plane identical with that of the nameless sculptor of Chartres. They and he will be seen as ancient disciples of permanence. They will be thought of as having shared the same faith and the same heresy.

On the other hand, the future may find for art new, evolving vocabularies of endurance, and the will to permanence may continue—along channels either similar to our own or very disparate from our own. That is speculation. In any case, here are time and timelessness intertwined, each evoking the other in something like a spiral pattern. Perpetual motion and absolute stillness may well be indistinguishable.

Contents

The Hand
and Eye
of the Sculptor

Reg Butler

OF THE TEN SCULPTORS represented in this book, Reg Butler is perhaps the man who most specifically rejects devices and formulations of style. Of course, in the broad sense of the. word—in that style can be defined as the projection of personality and the coherent shape of personality—he is an exponent of style, as are all these men. In that sense, style is almost synonymous with art itself. But in the sense that style implies the imposition of an internal system upon an external world, and in the sense that it begins to suggest a duality of form and content, Butler is almost an anti-stylist. And that in itself lends him a particular position in the ranks of contemporary sculpture.

Surely, style represents an issue in modern art; inevitably so, in light of the fact that modern art has become increasingly interior. Among the old masters, Tintoretto, for example, was a supreme stylist but he was also a supreme naturalist. Hieronymus Bosch

was a supreme psychological stylist, but he was also a realist, even if a realist *malgré lui*. These men had to be; they were confronted with flesh: of the nude, of the earth —all too solid or ethereal as the case might be. If they wanted to break down, to digest the objective fact, they had to go at it from scratch, like original sin. Wereas today the inner form has become dominant. The shape of shape cohabits with the shape of external form, at least in the more sophisticated of modern minds. One can debate the virtue of the consequences, but one has to admit that the consequences have created a certain amount of confusion.

Picasso may well be, to borrow one of his own visual metaphors, both full face and profile in this regard. On one side of Picasso you have Cézanne and the architecture of light and the fullness and roundness of the apple itself. On the other side are the offspring of Cubism, and the distant kin and the

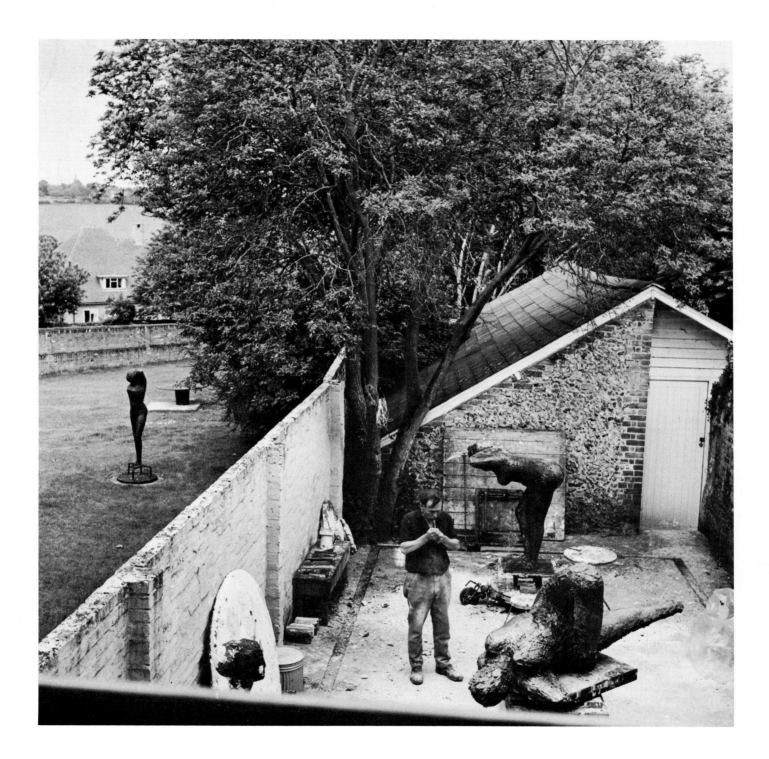

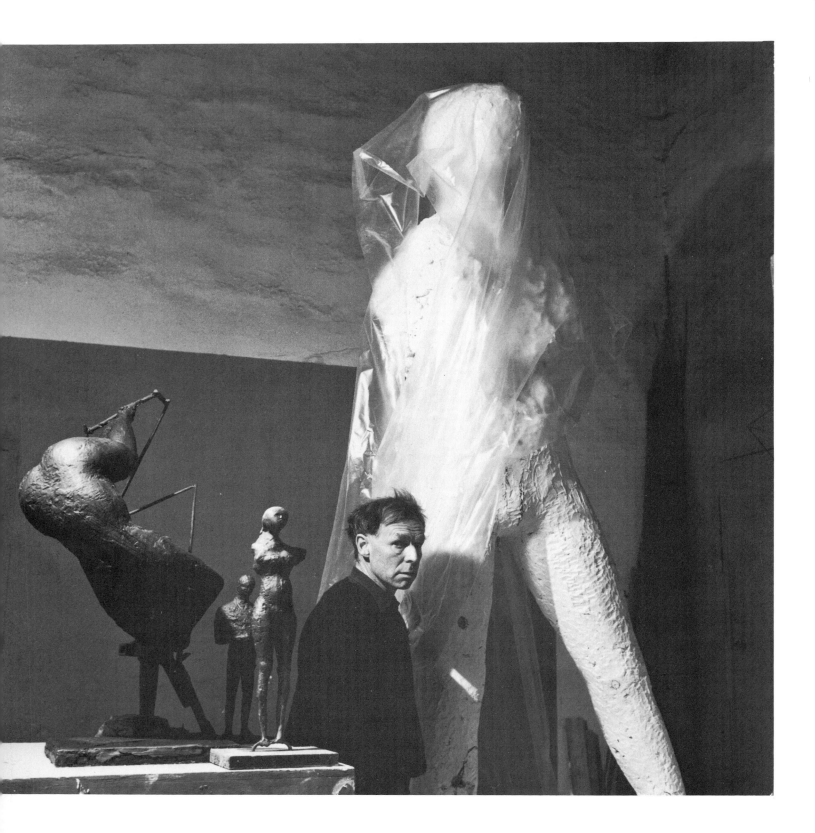

4 / REG BUTLER

bastards as well. Butler remarked that the double-face formulation was Picasso's most dynamic invention, but one which Picasso himself was able to use for only a limited time, and one which no one else was ever able to adapt or modify or extend. Yet, obviously, Picasso as a stylist is susceptible to heirs and disciples in a way that Picasso as a painter and magician of reality is not.

Today, then, one is faced with a labyrinth of internal metaphors and idioms blended with the external in greatly varying, irregular, often deceiving patterns. Where lies the flesh and where lies the shadow? The *maquillage*—the stage paint which so intrigued

Baudelaire a century ago—has become as familiar, perhaps as *natural*, as flesh. To some extent it even becomes difficult, perhaps naïve, to speak of the real and the artificial, even if one can still try to pass judgment on the authentic and the counterfeit. Was Abstract Expressionism perhaps an attempt to circumnavigate the problem? Was Pop Art perhaps a compulsive leap into the realm of the artificial? Was Op Art perhaps a symbolic expression of this state of vibrating, shifting illusion? Perhaps. The point is that there is no longer any absolute certainty unless that certainty be ambiguity itself.

Which suggests another perspective: Reg

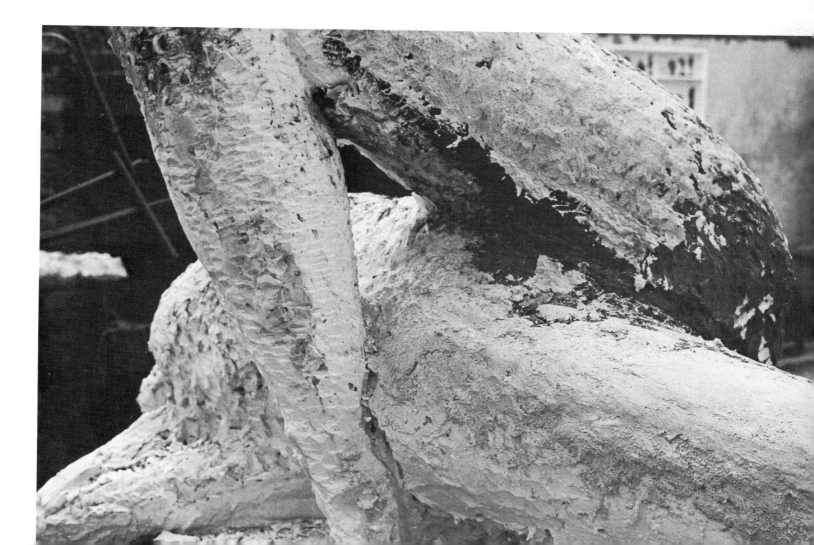

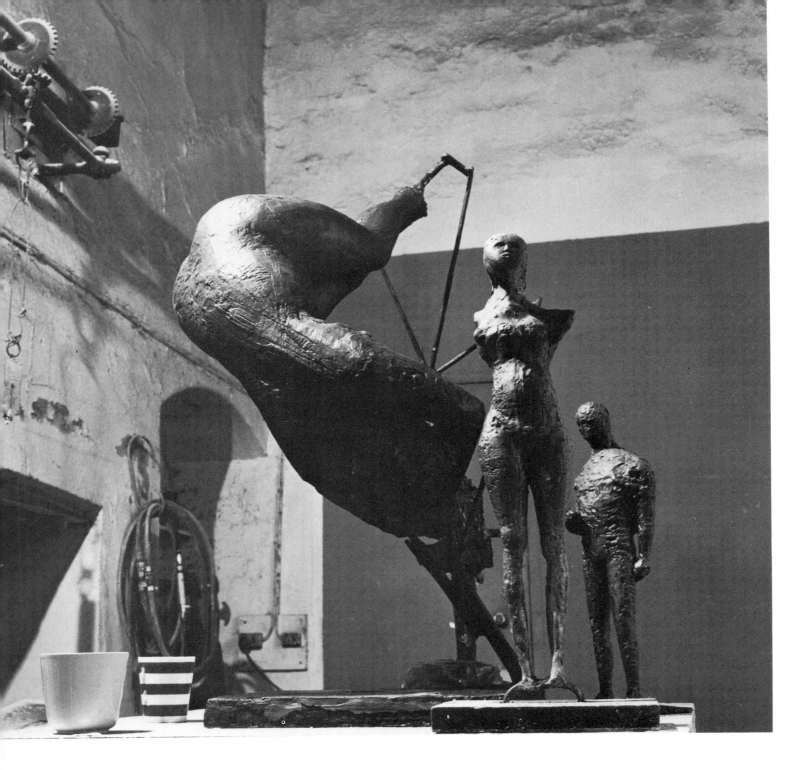

Butler is not a stylist in the sense that he is not a romanticist. The first person singular, the cult of the individual, the sanctity of the personal response—all these are triumphs of the Romantic movement which has been part of art since the mid-nineteenth century. Butler does not exploit this scheme of things even if, as the articulator of a personal vision, he does inevitably emerge from it. He speaks of the sculptor as "a maker of objects" and of the objects he makes as "fetishistic images." In his language as in his work one is struck by the absence of the egocentric point of view. One sees an introspective spirit turned outward—a position of extreme vulnerability—moving forward to make contact —physically, sensually, psychologically.

Contrary to the trend of much current expression, Reg Butler's art is not an art of conclusions as much as an art of experience and sensation. One thinks of Georges Braque's aphorism, *"Sensation is revelation."* Or Jean Cocteau's parody of Descartes, *"I am, therefore I think."*

The tempo at which Butler works seems particularly indicative: a slow, ruminative rhythm in which he and the work at hand appear to be in incessant dialogue. Which is true to some extent in the work of all authentic artists, but which becomes especially visible in Reg Butler's case. The meeting of flesh and flesh, of psyche and reflected psyche, very much parallels the meeting of two human personalities involved in the quadrille of a close relationship. Perhaps a love affair

is the best analogy. $A \ldots B \ldots C \ldots$ may appear to be the relevant sequence of emotions and events, whereas the true sequence is almost certain to be $A_1 \ldots B_1 \ldots C_1 \ldots$: an articulated level of consciousness, a hidden level of subconsciousness, and a dynamic intermediate level where the two intermingle and where action is truly motivated.

There are artists whose power of articulation consists entirely in their work. Others are also articulate *about* their work. Butler is as verbal as he is visual. He may discuss Camus and Sartre, Joyce and Beckett, and yet when I wondered just what sort of mental process goes on inside the brain of Rusty, his Welsh Corgi (the beast pauses hesitantly

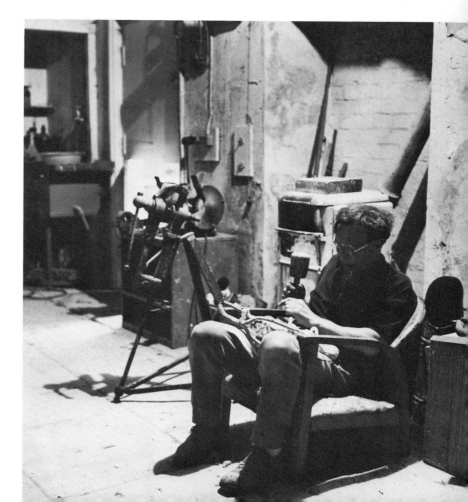

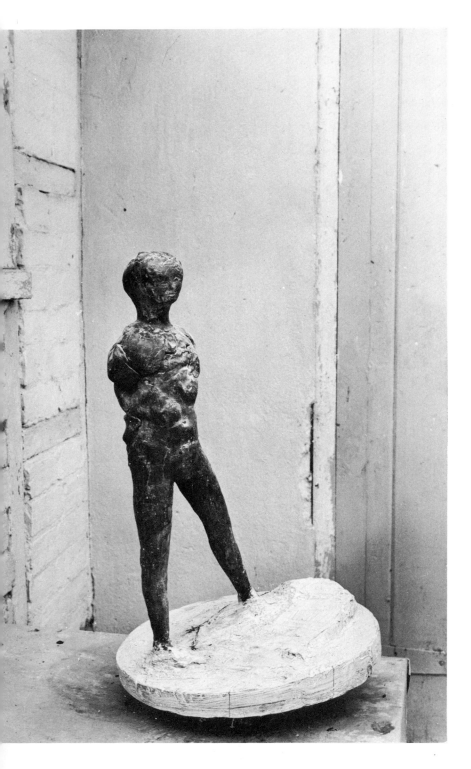

at the studio threshold as though conscious that something sets this room apart from the others), Butler replied, "I should think approximately what goes on in mine."

Precisely. One feels very much the weight of the negative moment, analogous to the negative shape. The period or instant of dormancy that permits an 'alchemic' compound of stimuli, rather than simply a mixture or juxtaposition of stimuli, is as vital as those stimuli themselves. Butler stops work, sits down, and lights up a pipe. The thud of hammer and chisel is stilled for a moment. The children, Creon and Cortina, laugh somewhere behind the studio wall. Rusty noses about silently and yawns. And then work begins again. The silence—not inert but live, not an absence but a presence—passes into the rhythm of shoulder muscles driving arm muscles driving the chisel. And the tap, tap, tap, the attack, feint, attack, establish a formal logic of their own: $A_1 \ldots B_1 \ldots C_1 \ldots$, to be translated, conceivably, as: tension of muscle . . . a circuitous, somehow centrifugal surging up of the dark, general 'idea' . . . an admiration and evolving contact with a flank that emerges in plaster. One thinks of various T. S. Eliot images of light and subconsciousness and obliquely evolving destinies:

> *Time past and time future*
> *Allow but a little consciousness.*
> *To be conscious is not to be in time*
> *But only in time can the moment in*
> *the rose-garden,*

Outside the studio, which can be lit by a single strong lamp, is a wooden enclosure for outdoor work. Another such pen exists some thirty yards down a slope of lawn, this for the really big projects. Which means that with each stroke Butler is obliged to run up the hill and take a look from afar. Someone suggested putting in a closed-circuit television to allow some perspective close at hand, but it seems probable that Butler would have to run the course anyway.

The combination living room–dining room is part of an added wing with a whole wall of nice, broad windows. The other walls are

The moment in the arbour where
the rain beat,
The moment in the draughty church
at smokefall
Be remembered; involved with past
and future.
Only through time time is conquered.

Butler's home, known as Ash, is in Berkhampstead, at the western corner of Hertfordshire (the other end of the county from Henry Moore's place). One portion of the house goes back to the eleventh century, but most of it dates from the time of Charles II, and was built in part with stones from the ruins of a nearby castle that had been erected during the reign of Richard the Lion-Hearted. Butler has been given to understand that Nell Gwynn used to "toast her toes" by the hearth in his studio.

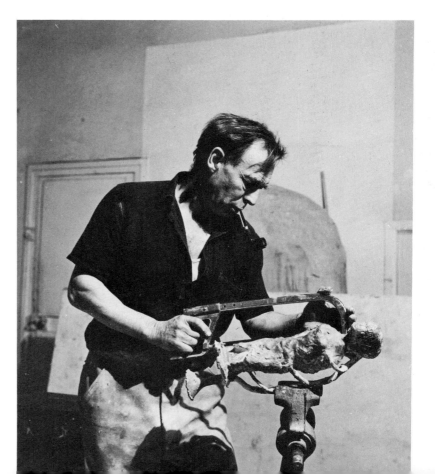

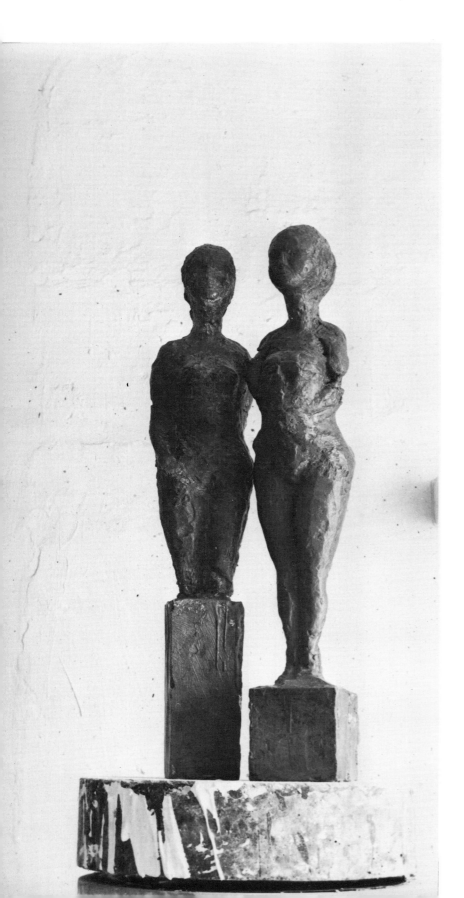

lined with drawings—nudes, taut and explicit—and with some small maquettes for the great tower projects: the monument to the unknown political prisoner, the *Macaw's Head,* the *Boîte des Fetiches.* It was there that Butler lit up a pipe and spoke about himself and sculpture and a good many other things as well.

Obviously, no transcribed text can quite suggest the actual quality and tenor of Butler's voice, which is ready-made for the stage. The voice is resonant; he speaks slowly, projecting each word with its proper emphasis, pausing now and again to reflect and measure his thought. Then he gives flow to precise, unbroken passages of totally articulate English.

He spoke about the most recent works, which are now about the house and the studio, in completed form or in progress. These are the figures—mostly nudes—which date from about 1953 to the present; and the towers, which first assumed tangible form about 1960. Most of his sculpture prior to the early fifties was done in metal, highly linear, and, in fact, greatly stylized. As Butler spoke about the later projects and the logic behind them, one felt increasingly justified in thinking of these more recent results as 'the real Butler.'

"If you are a very traditionally preoccupied artist, as I am in some way, there is the loved object—the female—seen from where I am. That is to say, she has wonderful breasts or a marvellous bottom, or the curve

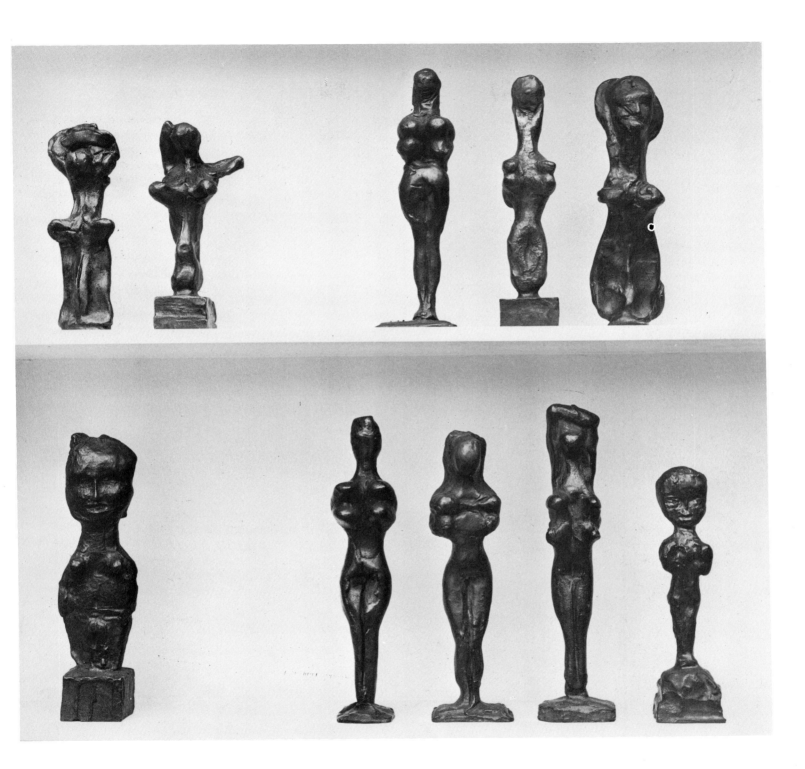

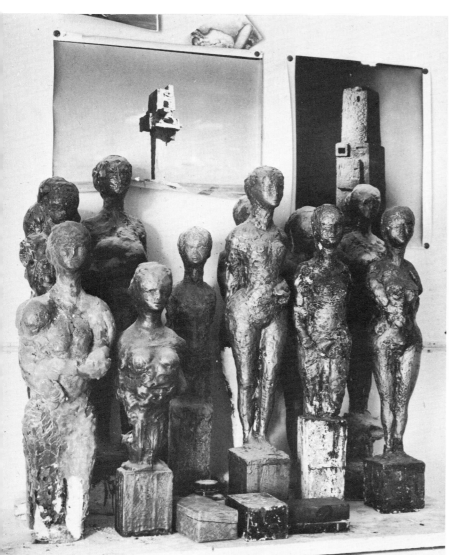

of her back, or the miracle that a thigh can be both plump and tense at the same time. But then, this is the man's image of the fetish object, you see. This is Marilyn Monroe or Brigitte Bardot *as* we use her as a fetish. This is not the Marilyn Monroe who was all balled up inside and finally took too many sleeping pills. That is the other side of the penny.

"Now, the revelation of the other side of the penny, to my mind, is in two ways. One is posture. You can tell the state of mind of a person—if you spend your life looking at people as I do—you can tell a great deal about the state of mind of a person by how he carries himself: whether he is depressed, buoyant, optimistic, and so on. And the other way is by a whole lot of minute changes in facial expression, and gaze, and the set of the head, and so on. Which, I think, really tend to defeat the sculptor. The better statements, perhaps, are the ones that are least specific. That is to say, a Giacometti impression of Annette is not sufficiently imitative to be disagreed with. It's quite obviously an artificial statement, and it carries as it were a shadow of that person.

"Now, the extent to which you can combine your fetishistic attitude toward the woman and your knowledge of her as a person depends to some extent on how old you are, because as you get older you develop greater sympathy with people and you know more about *their* feelings. They're not quite so much a mere attribute of your own environment. And I would say that the problem for me is very much— heads and tails, heads and bottoms. The bottom is the object *I* like,

and the head is the thing that looks at me. And at the present moment my world tends to fall into two emphatic categories. One: relatively small figures in which the head— and, more than the head, the face—is obviously very important. But I can only get some kind of appropriateness in it by a very unimitative, indirect kind of— well, it isn't even modelling. I'm not interested in modelling. I want to make the thing happen as though it's happened by some entirely meaningless activity. I don't want to say, 'Ah, that's a good piece of modelling.' I want to say, 'God, that reminds me of what it's like to be human.'

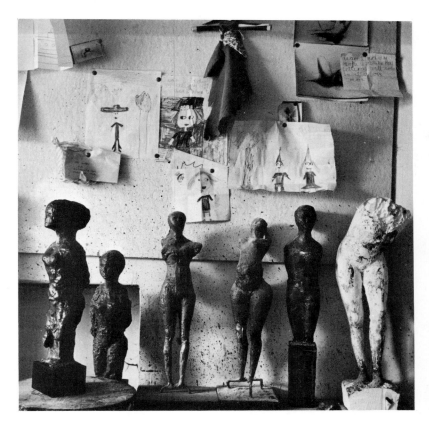

"On the other hand is the beauty and the sensuality and the excitement, and my fetishistic attitude to the human being. And each figure poses the problem differently. One figure may perhaps solve it by having the head in shadow, by looking down, or by looking up, or by plastically becoming terribly unimportant. There is something that I notice in my work: this combination of erotic plasticity with the tension building up to a vest or a shirt or a piece of loose modelling, which prevents the thing becoming, as it were, a statement about the clinical nature of the object, you see.

"There's a great deal of rough and smooth in many of my figures. The figure bending that I am working on at the moment, and some of the little ones, obviously involve an emphasis to say that what is important about this is not the portraiture element but the plastic response and the excitement that I get. Whereas, other than these little ones, it's obviously a face, a gaze, a personage,

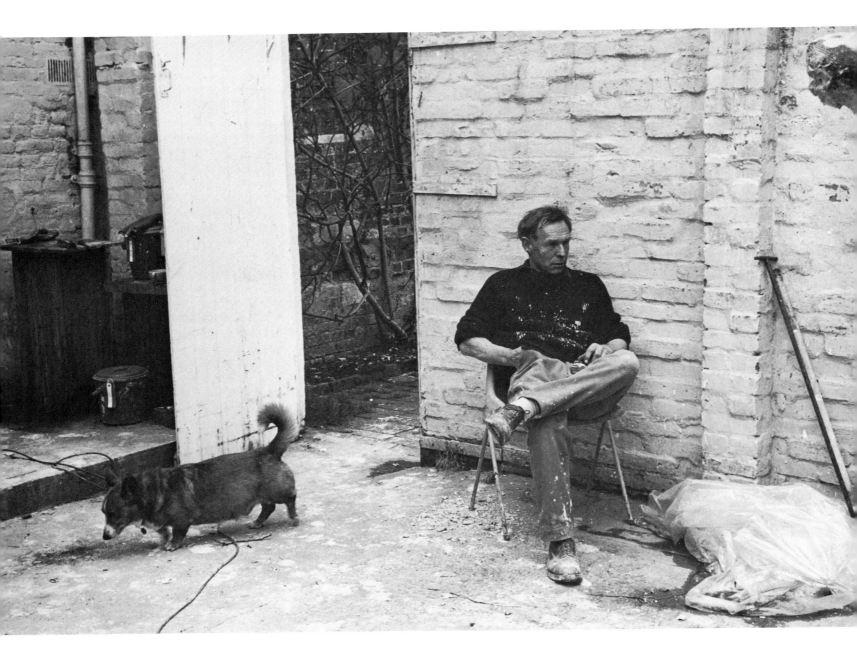

and the rest merely gets it up into the air, into the right place. But that's what I think today. In a year's time, or a year back, perhaps not the same."

——You were speaking of yourself earlier as a nineteenth-century personality——

"No, a nineteenth-century artist, in the sense that I am very much a humanist. I might even have said a Greek artist in the sense that although I don't subscribe to an anthropocentric world, for me the richness and the texture of my life are in my human relations. A beautiful landscape is no good to me if I am unhappy there, and I am not really sensitive to environment, in a sense. You know what I mean. What I remember and what makes an impact on me are things in relationship to states of mind rather than places that I've been. I mean, I go to Japan and someone says, 'What do you think of Japan?' I think the girls are marvellous, masses of them. You know, they carry themselves wonderfully. They are very exciting. There seem to be thousands of them between the ages of eighteen and twenty-four. What they do with them afterwards I don't know, but there they are. Every nightclub has the most ravishing girls in it. You go to a stuffy old museum and the director lays on twenty girls to sort of hold your pipe or give you tea or what have you. What I mean is, I think of my life in relationship to the people I've known and the people I know, and not so much as to where I've been. Where I am doesn't seem to be the thing that makes very much difference. I mean, this is a nice landscape, yet I work in a yard with four walls. But in that yard are human statements rather than something related to the larger landscape.

"What I'm saying is that girls aren't people, and some of my sculptures are about people and some are about girls. And there lies a change of emphasis. (This is probably one of those glaring half-truths that sound like a sort of profound statement. It's not intended as such.) You live your life with women. They have—in their teens, their twenties, their thirties—the quality of being fetishistic objects and, at the same time, human beings. But we perhaps notice it less than we do later on when they are only human beings. And perhaps the tragic thing about a Marilyn Monroe—which one does think about a great deal—is that here was somebody for whom life was anything but tolerable. She obviously had great emotional difficulties, but even at that same time—perhaps because of that—she became a symbol for a lot of people from outside. Well, a sculptor is an object-maker,

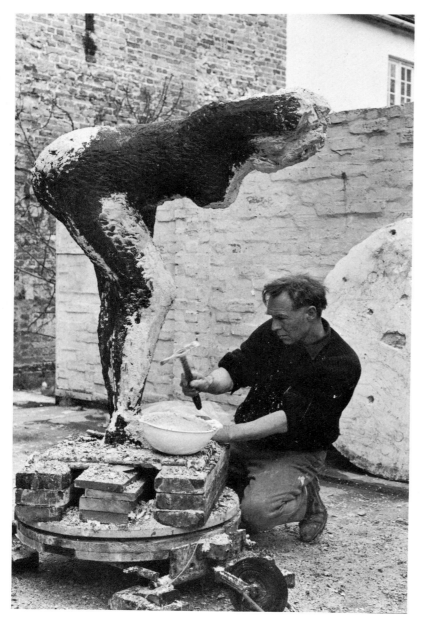

and one is making things that have the same relationship to society as a Marilyn Monroe. And things one's done a long time ago—objects like the girl pulling off her shirt,* for instance, or *The Manipulator*—are fetishistic objects, images, you see. The towers are otherwise. The towers are probably houses for these images."

The nudes, usually done in the outdoor yards, tend to belong to summer and spring. The tower train of thought results more in work done during the autumn and winter. The towers are indoor work. Perhaps motivated in part by the spirit of the season, they derive from an earlier preoccupation with boxes, enclosed areas, labyrinths. The idea of the labyrinth itself fascinates Reg Butler, and his comment on this seemed particularly pointed.

"Do you think we are interested in the whole labyrinth idea at the moment in the sense of a trap, in the sense of no way out, and that it's a carry-over from the vacuum left after the decline of orthodox religions? That if we no longer subscribe to the idea of an anthropocentric universe, in which we are all saved ultimately, and if we do have to find our own way, then the world very truly does become labyrinthine in a way that it never was before? You know, Sartre says something about— we cannot choose but we must choose. Well, you can bring that down to the level of the actual direction in which you walk, can't you? And what you see as you go by. And that makes the existential nature of the journey the important thing

Girl Removing Shift.

rather than the end of the journey. So that it's the deviousness of the labyrinth which is our environment now, rather than our sights on the ultimate place that we will get to, since we get nowhere.

"You see, in a sense you can take any experience and interpret it according to your character. Now you could argue, couldn't you, that because there is no objective, then the proportion of objects in one's daily life becomes more important, not less. In other words, if I am to live my life with the idea of salvation at the end, then the texture of my life is relatively unimportant because it is the afterlife that is my goal, you see—so I can live in sackcloth and ashes and I can be a Saint Anthony in the desert. But now, if there is no ultimate objective, then it seems to me that the greenness of the grass, the taste of a peach, the curve of a woman's thigh, and the shape of the architecture don't become less important, they become all-important, because that is what it is and that is all there is, you see. So that one's relationships with human beings, one's attitude to the movements of one's day between waking and going to bed again, are and have to become sufficient in themselves—much more like an animal.

"In other words, the texture of our experience, the rewarding texture of our experience, becomes sensational rather than a preparation for something to come later. This is why I think that sculpture is, for me anyway, an extremely absorbing preoccupation: because its meaning must lie in the sensations one derives from it, not in the accuracy or the profundity of any comment it makes.

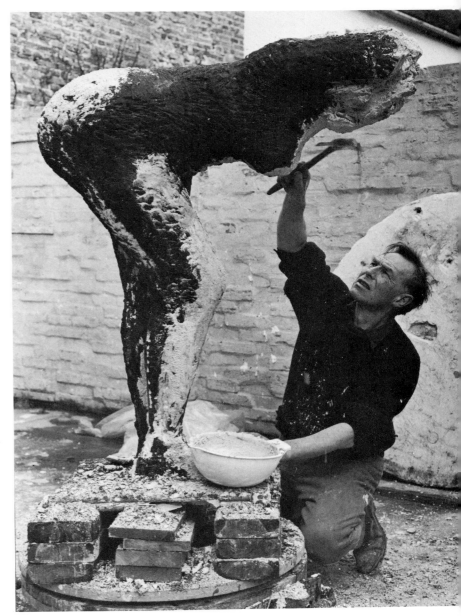

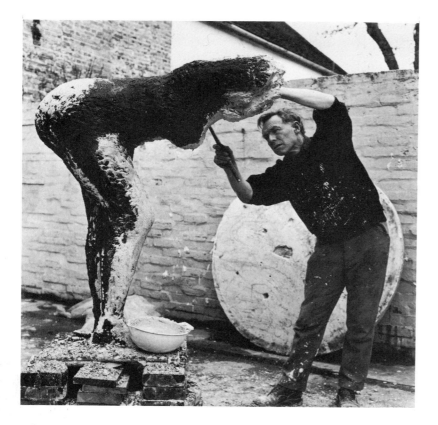

"One is now free to say, 'That piece of velvet—that's marvellous, that's made my day.' Or, 'This globe artichoke is just perfect.' Or, 'This conversation we've had is perfect'—and not try to demand that it lead toward something else, you see. And that is why I think the kind of sculptural problems that I engage in at the moment are so obvious that they call for no comment. In other words, whereas Rodin would do *The Gates of Hell*, I do a girl is a girl is a girl is a girl is a girl is a girl— period!

"It seems to me that, in a way, the sympathy I have for a younger generation that makes object sculpture is paralleled by the fact that there is no message as such in the figures I do. They are objects of sensation, and not philosophical statements, in the sense that— well, if you don't like that lake, well, OK. But it isn't anything more than a lake. I mean, it would be presumptuous to say more than that."

——Well, isn't this, then, very close to Sartre's existentialist position after the war, which was widely interpreted as a pessimistic thing—yet he says, no, it's optimistic: If there is no goal, then one is free to construct at will.

"Precisely. And free to respond to one's senses. And in that sense there is a great deal to be said for Op Art, which is message-less and which is an optical experience: it's not implying more than we feel our philosophy will stand at the moment. And it seems to me that most people who are not tied to a kind of a priori bandwagon are freer today to appreciate. I don't mean just pure lotus-eating. Because, in a sense, here is where Camus is such a strong character, as I see it, in the history of this century. If I read him right, the excellence of Camus's philosophy would be that one doesn't say, 'Is this person worth or worthless?' This person *is*, and my relationship with this person is as far as I am able to comprehend. Therefore—and perhaps I am preaching my own doctrine—I would say that there *are* good things and bad things: There are good relationships with people and there are relationships with people that have a bad shape. There are good objects made and there are ugly objects made. And having said that, there is no more to it, you see."

——Of course, there is also the problem of

communication—the fact that any statement one makes will be accepted by any number of people in any number of ways.

"That is true. But if one thinks again of sculpture, it seems to me that the nature of communication involves — or at least one can talk about—two levels. There is the level which is attached to our species, which is biological. I believe this very strongly. I believe there are certain kinds of curve which **are** good, certain kinds of curve which are bad. When I say 'good' and 'bad' I mean *good for human beings* and *bad for human beings*. In other words, without flogging the issue, it can be due to the receptive mechanism of our cerebral structure. It can also be due, as a Freudian might say, to the response patterns one developed as a child. But fundamentally, it's invested in our biology— that one will say: 'Now here are twenty pieces of nonfigurative art. I swear that this is a good one. I cannot tell you why it's a good one, but I know that it is a good one.' Now, I would suggest, very gently, that for me it is a good one because it contains within it certain references which are acceptable, and these are based not only in my culture but in my biology. So that if dogs made sculpture they would make sculpture with different plastic values from ours. So that when you say such and such an artist is a bad artist, it means that somehow some force in him is driving against the expression of his natural acceptance of values, within his species.

"And the other thing is cultural, which is built into time—which is something one lives just about long enough to ride through. If

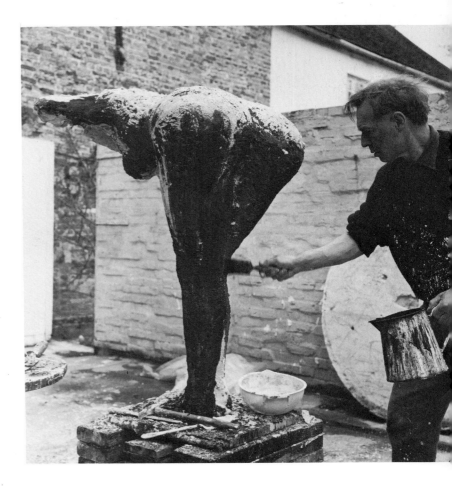

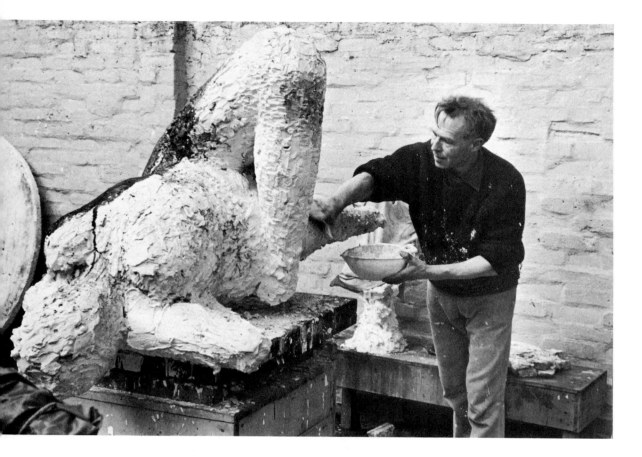

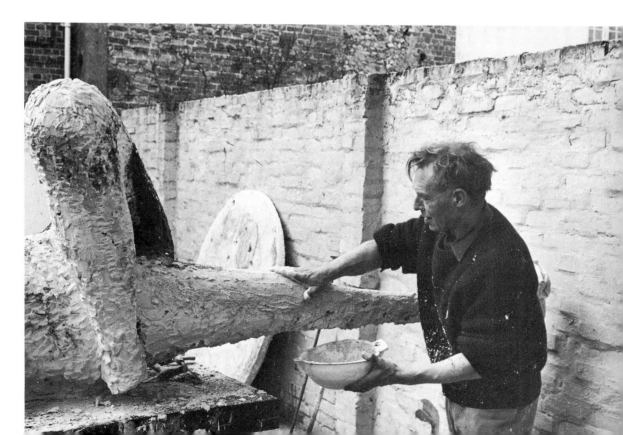

you take the more recent art movements, the thing that's important is the good artists working within those movements rather than the movements themselves. Giacometti is a wonderful case—isn't he?—of a man who could have been claimed by almost every art movement of the last thirty years. But then, he is diagonally across those fashions.

"This is particularly noticeable at the moment because of the rapid change in situations. So that if you are to try to get better you have to stay with what you are doing, because you need many years to try to develop your own problem. And that means that you are, *force majeure*, unable to change your problem, you see. Your problem will modify, but it won't change.

"I mean, I would seem, and have been for a great deal of my life, enormously concerned with volume and tension and the dominance of one in relationship to the other. That is to say, when I made thin, linear sculpture, it made me unhappy in the ultimate sense because it was thin and linear and nothing else but. I've never made wholly quiescent forms because they would be too much of the extreme pole. The thing that excites me is the conditions under which a volume can have tension—so that you can feel the sensuous plasticity—yet is not a mere relaxed, sleeping worm."

All of Butler's recent work—both the nudes and the towers—shows this concern for a balance between volume and tension. Aside from this, is there any other connection between the nudes and the towers—beyond, of course, the obvious connection in person-

ality? Or are they separate, perhaps parallel, themes? At one level, a certain verticality of structure unites the two, for in Butler's work one feels very much a persistent vertical quality, a lifting up, as in the strain of muscle. But more pervasive connections became apparent in the course of conversation.

"I'd love to build the two towers that have worked themselves out to a sort of definitive state. They would both contain rooms and passages and staircases and so on, in which all the figures I've made would find their place. . . . One is the thing called *A Study for a Great Tower*, which is a ninety-foot one, meant to stand in an open landscape, and which I think owes something, perhaps, to Camus's short story about the '*Maison des Fetiches*.' And the other is the one that I call the *Boîte des Fetiches*, which is a kind of chimney, you know, with rooms inside it, and so on."

Butler spoke of his past and of its relevance to the towers: "My father was a master, my mother the matron, of a great workhouse here in England forty years ago, which was a place where large numbers of people lived. By the time I was seven or eight I'd seen a child born and old people dying, epileptics and cretins, lunatics, and so on. And it was all knitted together within one kind of framework, so that there were butcher shops and laundries and places where workmen worked and so on. And particularly with the *Boîte des Fetiches,* I've always thought of it as a kind of total object that would have

figures in space in it: girls pulling off their vests, rows of brides on the walls. Many of the more macabre four-breasted figures out of the *Musée Imaginaire* would be kind of hieratical figures on the walls. But, one needs scale, you see.

"And the two [towers] that are very alive for me and concern me are two opposing types: this one, the outside one, which is like a fist in the air and which I see on a vast sort of open landscape, desert preferably; and the other, which is like the furnace of Shadrach, Meshach, and Abed-nego, and which is full of internal—if you like, rather surrealist—elements. The *Boîte des Fetiches* would have corridors that ended in a dead stop, you see, and flights of steps that ended in a deep well.

"I hold views based on my own experience about the dominant effect one's childhood has on one's later life. I was an only child. I am still an only child—and that sort of artist. As an only child I made my sculptures in my playroom all by myself. I still live in the studio all by myself, and make my sculptures. This place where I live, here, is full of the same kind of weirdness. The room we use as a children's room is over a 350-foot well, which is about the deepest well here in Hertfordshire. From the lawn out to the castle there is a great underground roadway all bricked in. One chooses. If one is that sort of person one recreates in one's adult life certain values that gave one satisfaction as a child. Now, these towers are part of that,

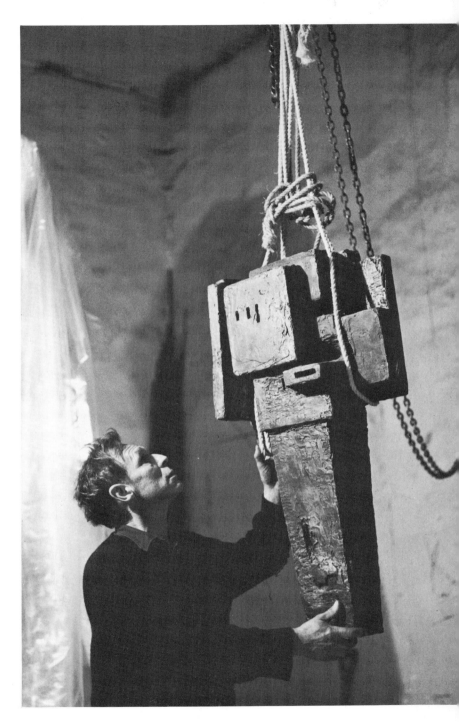

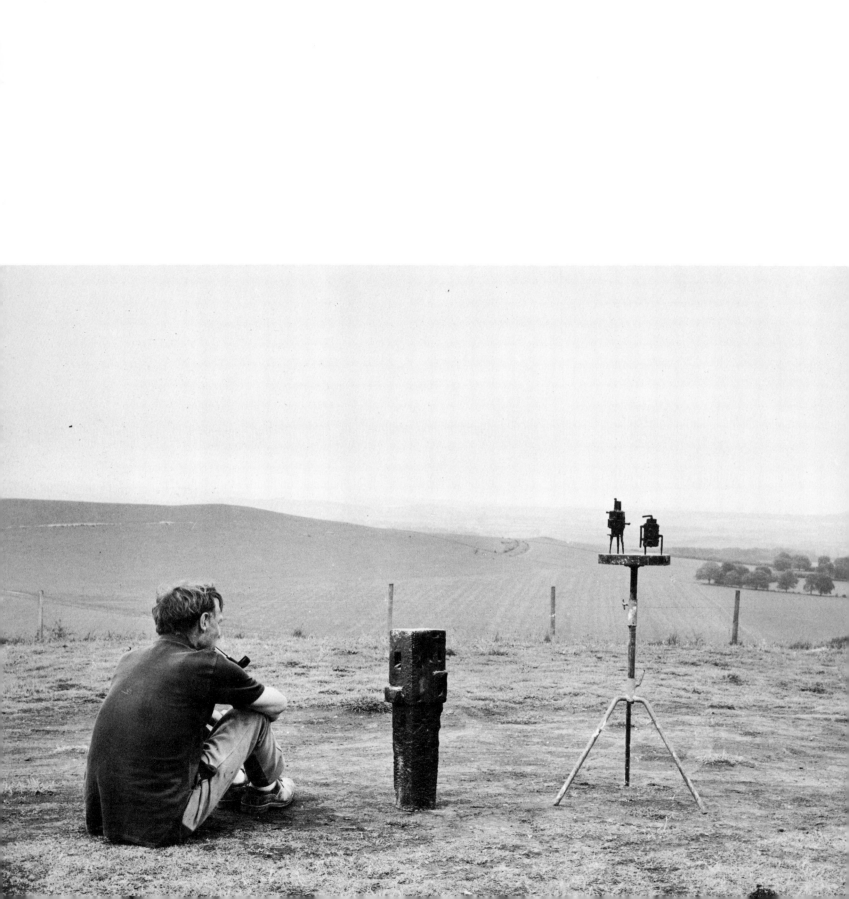

you see. These are this great house, this great center, and the sculptures belong to it. So that I could visualize myself spending five or six years of my life getting one built, and then being the janitor, the doorkeeper. . . . In other words, one would make a total, single object out of one's whole life."

The physical problem posed by the towers is blunt and perhaps insuperable. Ideally, they ought to be roughly ninety feet high, sufficiently massive for entrance and exit, a true environment of passages and apertures. The obstacle at this point is about £50,000 in each case—to quote Butler, "a considerable sum for the arts." He tried building a compromise solution fourteen feet high, but it didn't work. The little maquette rings true in scale, and has a convincing presence. But the intermediate size was wrong—analogous to the difficulties painters have with any figure three-quarters life-size: it must be substantially reduced in comparison to the original, or at least life-size.

So we drove up to Ivinghoe Beacon in the Chilterns, the originally proposed site of the project, about twenty minutes out of Berkhampstead. From the heights, Hertfordshire, Bedfordshire, and Buckinghamshire meet and stretch away far and undulous, the colors changing from green to yellow to rust, until the hills go violet and melt into the sky. There Butler set up his towers, half in silhouette. I

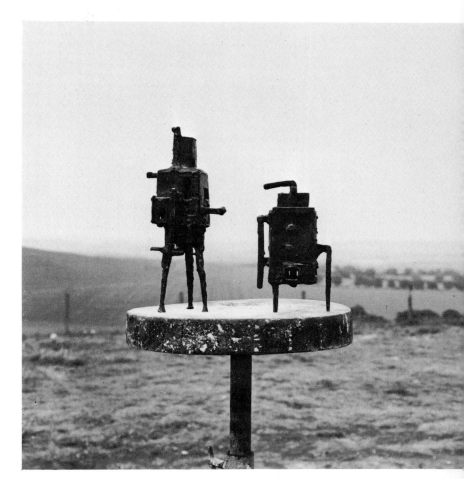

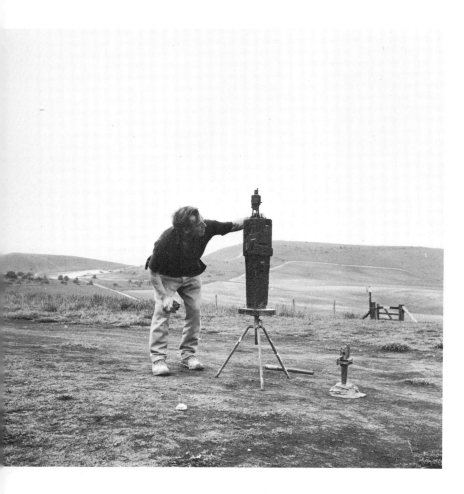

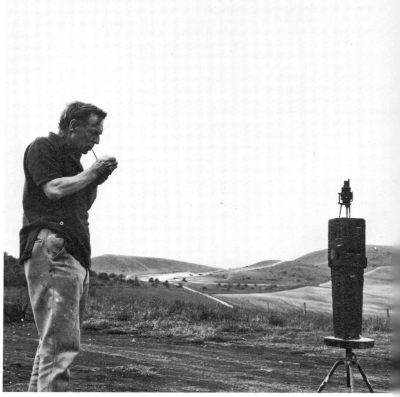

squatted and squinted, and saw them tall and aloof against the distant, gentle horizontal of the landscape, or perhaps menacing, or perhaps, more appropriately, as contemporary sphinxes, the posers of a challenge.

And, in fact, the sphinx drew a victim. A middle-aged gent taking an afternoon's Hertfordshire air came around and circled the towers and peered at them for some time. At last he said he hated to trouble us but he was puzzled since he "hadn't the vaguest" what those things might be. Butler asked if he couldn't guess, and the gent shook his head slowly, and said no, he hadn't a clue.

"Well, how often is it," asked Reg Butler, "that you see something so mysterious that you have no idea whatsoever what it's possibly about?"

The gent left, slowly, with repeated glances over his shoulder—as one might slip out of a deserted room with the unsettling sensation that one is not alone.

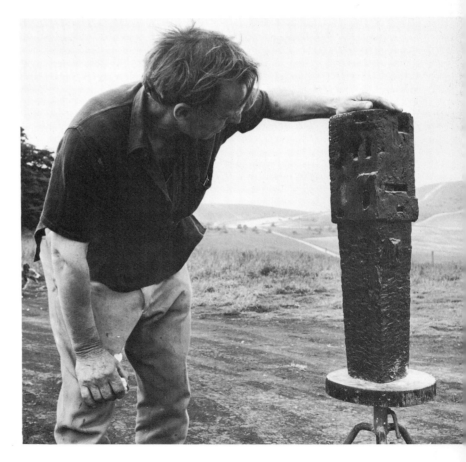

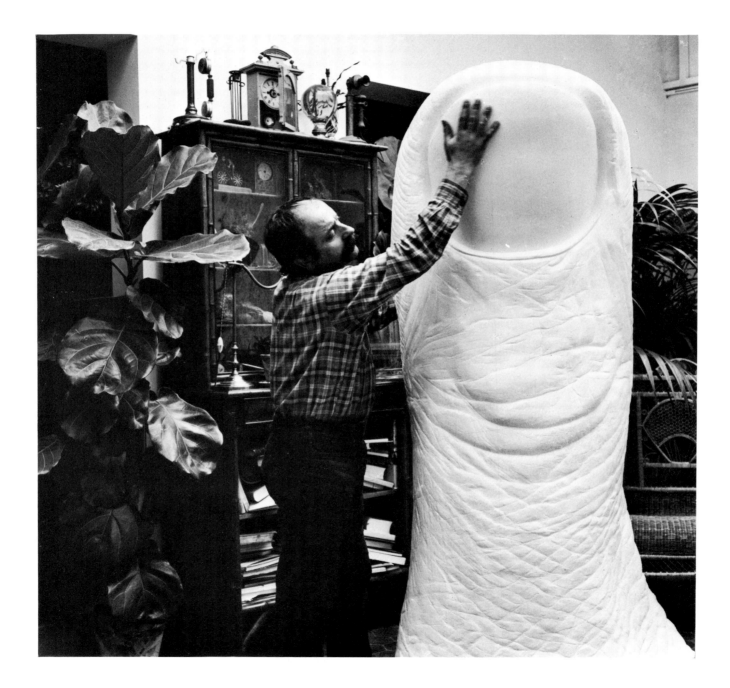

28 / CESAR

César

THE FULL NAME IS CÉSAR BALDACCI. The man is a Mediterranean spirit, Marseillais to be specific. His sculpture is born with the fingers, the wrist, the nervous system—or at least it was. As in all things, opposites attract, so in time the bronze was abandoned for plastics, the lingering caress became a snap of the magician's fingers. The Mediterranean curve and patina became something otherworldly or simply non-indigenous. Which seems to add up to a long and circuitous voyage. Most would think so. César says no.

His Marseilles accent, strained through a Pagnol moustache and thick as *bouillabaisse,* is difficult but lovable. Incessantly, César threatens to leave Paris, which would be roughly equivalent to the city's losing the Eiffel Tower. A new restaurant opens in Montparnasse, César is the first client, and the country-fresh *pot-au-feu* hardly discourages his yen for a studio in the Midi.

"The problem— I am paralyzed. Paralyzed. You can see it's true. I am completely lost. I've just spent two months out of Paris. I return, completely disorganized, and find that the men in the factory where I do my work have moved all my materials——"

——But haven't you worked a long time in Paris?

"In these conditions?"

——Yes.

"It's been some fifteen years now."

The factory in Arceuil, just south of Paris, is actually one of several shelters were César has been nomadically working out the twists and turns of his attitude toward sculpture. The building is a metalworks big enough for the manufacture of airplanes, and César works in one corner of it. The place is convenient to the extent that both of César's foundries are also in Arceuil. One is Fonderie Suss, a great clattering plant where he stopped in to check on the progress of a big nude being cast in bronze. The other is

Fonderie Valsuani, more a diminutive work-shop set in a cottage behind hedges. There César worked a bit on two versions of his *Man of Draguignan*, the winged, walking figure, and one of his plaques, a rectangular, richly textured screen facade.

These, one might legitimately argue, represent the real César, these evidences of sensibility, this preponderant concern for a form whose weight and texture and intimate exterior are quite integral to its whole meaning. Yet César has moved far and controversially afield. In brief, for better or for worse, he objects to an identity that is in any way predetermined. He sees the departure from self—even if his better self—in terms of a liberation. Which must be reconciled with his apparently contradictory opinion that anything he does will reflect the true shape and dimensions of his personality.

His own house, in a Parisian complex of villas sheltered behind hedgerows, is perhaps a clue. He has no studio there. The place is done up in what is roughly *Art Nouveau* style, a provocative barrage of shapes and suggestions, comforts and curiosities, the ensemble almost overbearing. Here a chair made of entwined cattle horns, there a baroque gew-gaw or a camp leg protruding from the wall. And the delivery men made a mistake: they delivered César's *Thumb*, a six-foot plaster enlargement of the sculptor's own digit, to the house instead of the factory. So there it stood, a white, surreal promontory, audacious and pugnacious amid the whole farrago of objects and presences. *The Thumb* became the magnetic center of the entire room, bigger in size than

César himself from head to toe. And it seemed as though that fact might prove symbolic as well as actual. *The Thumb* represents only one facet of his work, but existing as it does in plaster and in bronze and even in plastic, and given its shock value, it risks becoming a leitmotif he may one day regret. Charles Boyer claims never to have said, *"Come with me to the Casbah."* Chopin would probably have been better off without "The Minute Waltz."

The Thumb bears César's fingerprint. Yet it reflects none of his creative sensibility, being not a true sculpture at all but a straight cast of his exterior. We spoke about that over the *pot-au-feu*, and, in consequence, about the multiple worlds that César inhabits.

"Ideas are of little importance to me. I think the idea passes, and then the only valid idea for me is a purely internal idea (not simply instinctive, in the sense that you feel a need to do things as soon as you have an idea).

"I think that creation is absolutely independent of 'the idea.' It's like a woman who makes a child. That's what I think. Perhaps it's too bad I don't think otherwise, because I am very intrigued, very interested, by the activities of the young people. I find these days there are attitudes among the young that fascinate me."

——Which particularly?

"Everything. Everything. All these people, all these young people who have a sensibility and a retina for *now*. I don't know if that's going to continue. I don't know if it's

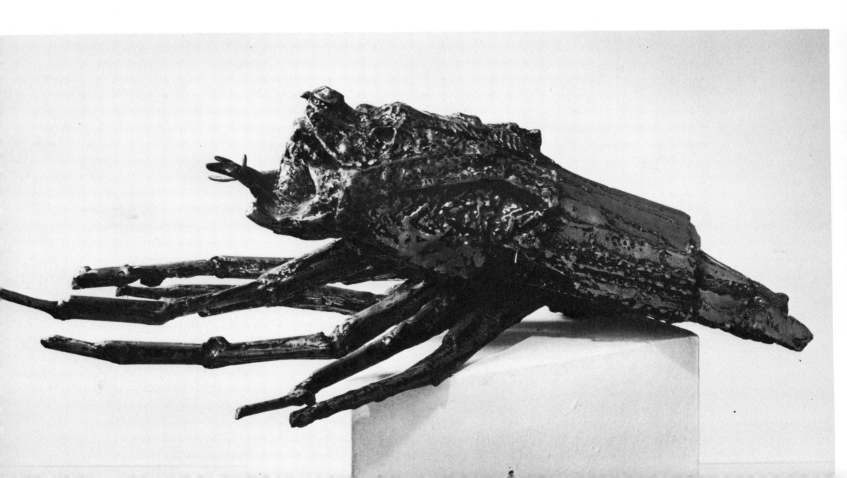

going to replace the sculptor as such. It hasn't changed the fact that Giacometti was a great figure. It doesn't keep Picasso from being a great sculptor. It doesn't stop a type like Manzù—whether or not you like Manzù, he's still a very great sculptor. I don't think it can change what is. . . . In fact, sculpture can only change in an external way, but in reality, it never changes.

"I think I've no reason to feel guilty for trying to be *au courant*. Each individual has his own role to accomplish, that's all. You understand? One must. A woman who makes a child doesn't have to face the problem that another woman already made one. She just makes it. Each makes her own. Now, it's

possible that doing is insufficient. But if you put that question to yourself, you don't do anything. So, you do—and afterward you see."

During my conversation with Reg Butler, he mentioned a series of hands he had done, not realizing until late in the game that they all had four fingers. And then he reflected that in fact one of his father's hands had only four fingers. Ipousteguy awoke and saw his thumb as a giant on the horizon. César saw his thumb as a giant in the foreground of the moment.

César maintains that if his later work, from *The Thumb* on, is to a great extent automatic and even mechanistic, it also parallels the earlier bronzes, figurative and not, which were the immediate, perhaps inevitable reflection of sense and sensibility. After *The Thumb,* César went still further with a number of works evoked in liquid plastic. These fluid tides of what ends up looking like hardened lava took about three minutes each to produce. The liquid is poured. It expands in a gush of volatile foam, and then it jells. The element of control is minimal, though the color can be predetermined and various combinations and juxtapositions are possible. César sometimes laminates the material with another plastic. He even grafted a white foot to one of the smaller liquid effusions. And then, turning one of the larger liquid specimens on edge, he let it take on the suggestion of a great arc of the solar perimeter.

At the same time he also works in polyestrene foam, which has much the weight and

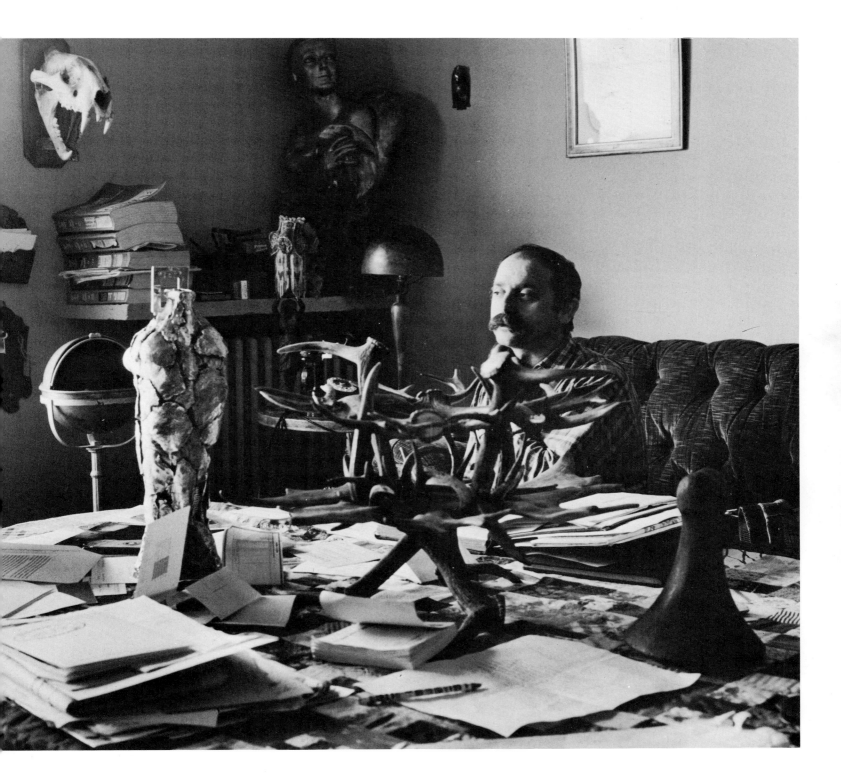

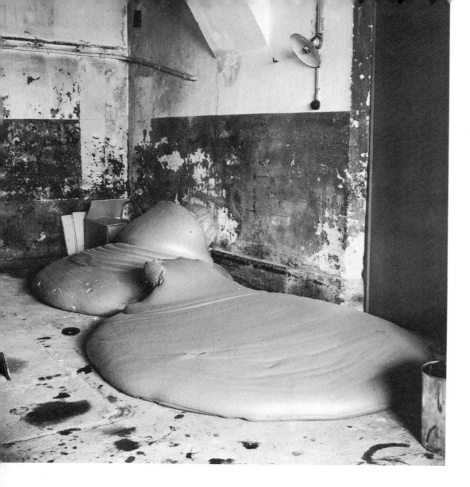

right to develop an idea belongs to the one who finds it first and who then, through a union of material with the idea, inscribes it in the reality of the present moment. (Actually, the present moment is not just the present moment. It is really part of time, and I am speaking of something that goes beyond the present and can inscribe itself in time.) But me, once I have an idea, I am no longer able to exploit it."

——Like *The Thumb?*

"Like *The Thumb*. I wanted to do a mold, an imprint of my head, of my nose, of a tooth. I wanted to do a mold of an American woman. I wanted to do a mold of Jane Fonda, and then do another very big—to make a whole exhibition of Jane Fondas, for example. But, once I had done *The Thumb*, the rest was no longer possible for me. As for *The Thumb*, I got the idea of doing it, then

quality of sponge rubber. A far more stable substance, it can be carved like the more conventional materials, and it is not surprising to see a torso emerge, latent but visible.

Is César prepared to accept the possibility that all this might lead back to the nude? "Oh, yes. It's entirely possible." He is less ready, though, to anticipate a return to bronze. He sees plastic as a thoroughly modern substance of unending possibilities, and it captivates him.

At this point in his career, César sees the passing instant of creative force as more significant than the goal. "One has to exploit an idea at the moment one conceives it. The

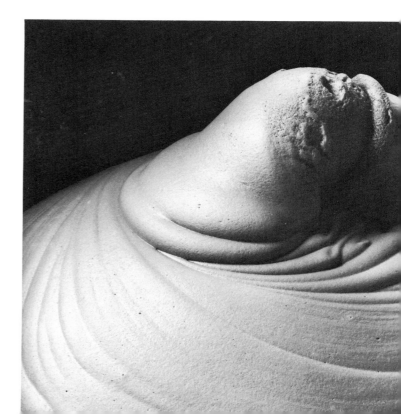

developed the idea by enlarging it. I lived moments of terrific exaltation, just as if I'd done a sculpture-sculpture—in the sense of ancient sculpture. And then, once that was done, I relaxed, I no longer felt the need to continue. The experience being over, I was not capable of more."

——But where did the thumb idea come from?

"I wanted to do a mechanical sculpture. I wanted to do it mechanically. For example, I can very well be a fine craftsman, make technically well-made sculptures, elaborate upon these sculptures, construct them well, do them well—but that's crap. So I wanted to see if, with simply an idea— well, if I could develop a sculpture mechanically—like the compressed cars I've done, but with a completely opposite technique. So I began with an idea and I developed this idea mechanically. I began with a human imprint, which is not sculpture, which is nothing at all. So I began with nothing at all. I took a mold of my finger, and I went to a specialist who enlarges sculptures, who takes classical sculptures of very small scale and enlarges them.

"I found— well, I find that I do not agree with sculptors who make sculptures twelve inches high in order to enlarge them to eight feet high, or ten feet, or thirty feet, or sixty feet. It *is* possible to enlarge certain sculptures—which have, in their size itself, a certain interest. But I don't find that such creation is complete. The idea of taking a human imprint and the idea of developing it mechanically to a height of six feet—a six-foot-

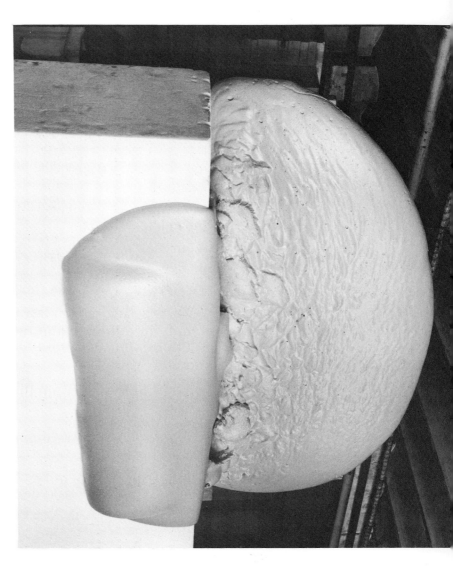

high thumb— I think that through the dimension I managed to surmount the object. That is to say, through going beyond the object, going beyond the anecdote. And I think even the thumb that is only three feet high is—I don't know if it's a good sculpture, but I find that the thumb is far more a sculpture than other elaborate and well-made sculptures."

——And yet you found it limited all the same, not to be continued.

"Not by me, personally. A young person today—that is, one of these young chaps in England or in America (even in Paris, despite what they say about nothing going on here)—a young person would take that and would continue with it. But as for me, I can't. I have to have the illusion that I am perpetually creating. That is, when I do a sculpture, I am in a second state. I don't know where I am going. Each time it is an adventure, every time, every day. Each time I do a sculpture, each time I move, I am exalted—I destroy—I rebegin—I redestroy. The road is always mysterious and there is never a predetermined goal.

"With a sculpture like my compressed cars (or *The Thumb*), I took the responsibility, and I had a grand passion at the moment I did it. I consider them sculptures in the same category as my other sculptures—precisely because I didn't exploit the process. Because there *is* a process. While in a sculpture-sculpture, in the old sense, there is no process. You understand what I'm say-

ing. I don't know if I explain all that well, but what I want to explain to you is that, in any case, one has the craft. A potter, when he makes a pot, doesn't think about how to make it. He works as he walks, as he breathes. Well, I think the sculptor who makes sculptures thinks. He goes beyond his craft. He uses his technique, his craft, in the service of a sentiment, in the service of an internal focus, in the service of all that makes him do what he does. That is, there is a passion, a love behind it. He makes use of all he's learned technically, but when he makes use of it, he doesn't know he's making use of it. He's forgotten that he knows how to do it. He works as he breathes and, at that moment, the combat takes place between the material, the technical side, and the creative side. The invention side, this invention that is not part of the technique, is in the organs. And when one does art—what one calls modern art— there is a confusion— with an inventiveness

mold a hand *because*—because of this or because of that For me, it doesn't do away with the quality of Ipousteguy's sculpture, but it can divert the sculpture. It's what makes his quality, but it may also be his weakness."

There is a moment at which words and sentiments, intentions and accomplishments, blur; at which a certain rhythm or rectitude survives the precepts that generated it. The quality that is independent of 'the idea' is surely present in Ipousteguy's work as well as in César's, rather more in Ipousteguy's *La Femme au Bain* than in César's *Thumb*, and more in César's great nude at Fonderie Suss than in most of contemporary sculpture. But the idea and the haptic or sensual impulse enter into a rapport, and finally become inextricable.

——And pursuing this line of thought, what about *The Man of Draguignan*, the winged man?

that is purely external. It's enough that a chap gives you an image of the present—that is, contemporary. It's certain that if I use polyester, or other very modern materials— it's enough that I take no matter what modern material in the raw state and that I decide it's a work. I have only to change the context, to put it into some appropriate context, for it to become a work."

——Well, Ipousteguy spoke about using molds of real hands for his bather because he wanted to be the slave of a certain anthropomorphism. Isn't that a similar idea?

"No. Because he decides a thing through the function of his intellect, the function of an idea. From the moment you decide to

"Ah, there too you have weaknesses. Because the material and the technique came to play such a role that they led me to concern myself with something external, something intellectual. And, basically, I made wings simply because I was making the most of a material which offered possibilities I wouldn't have been able to exploit had I used clay."

——Which material?

"Steel. The technique of steel permits me to develop an aesthetic that comes from the technique itself. Which is perhaps interesting as such, but not so important. It's not important. I could very well have done a portrait of my neighbor from Draguignan with no special technique. Because, although I use a contemporary technique, it is with a vision that is, despite everything, fairly ancient. Let's say I'm classic at heart. I am not a modern sculptor."

——But to be classic is to be modern in the broadest sense.

"Yes, I imagine that to be modern is to surpass the object, to go beyond the object, even if there are doubts about the method. Giacometti was very manneristic, and it was a very archaelogical mannerism too. It makes one think of things in history. But I think he was strictly of his own time due to the presence of his objects. Certainly it will be said that Giacometti did so and so at such and such a time. He was the first. Thanks to him, one has done this, the other has done that.

"All that is splendid, it makes things evolve. It's interesting, marvellous, to see the possibilities of everything in a certain area. Yes, it's interesting to see people who have taken on problems, but it's not that that's so very

important. There are characters who have done nothing, but who have done all the same, and that's as important. They've found nothing—on the exterior plane. You understand? I might very well want to do your portrait in a Greco-Roman style, and approach it with all sincerity, all the passion that I can have; if I do it with humility, but with great conviction—I could do a contemporary work of art.

"Now, it does not matter that I worked with compressed cars— even when I worked with them I was within a certain tradition, just as everyone always is. (Everyone bears all the influences of everyone else. No one has ever invented anything. All that is pre-

tension.) Good. I was in a factory, in a suburb of Paris. I was working in a factory.—Now it's the style, but before this no one did it. There was iron in the factory, the soldering arc, all that. I discovered scrap iron. I used the scrap iron because I hadn't any other way, any other material to make sculpture. I had no money. Perhaps if I had had money I wouldn't have utilized scrap iron. And it does not matter if I became known at the moment I compressed the automobiles— because it produced a scandal, and all that. They said I did it purposely to create a scandal. Actually, I felt the need to go the limit in the area of materials— because I was moving toward an attitude, I was moving toward modern art. Well, automatically, I was exalted by the achievement of discovering the possibilities of using machines. In one blow I discovered that, in the compressed block, I was able to draw the quintessence of the material. I went the limit in the area of materials, and I think that any one of the blocks is more beautiful than—is as beautiful as no matter what sculpture."

——But a species of extreme.

"Well, yes, but look. Inasmuch as I used it one single time in connection with an idea — If I had exploited it, if you saw me going into factories and redoing compressed cars, and selling them to everybody, and profiting from a situation, and all that, I think I would be dishonest. But if others are interested in what I've done, it is because others have as great an interest in this as in no matter what nude, or no matter what insect, or no matter what thing I've been able to do. Perhaps even more. Perhaps the only thing I've done

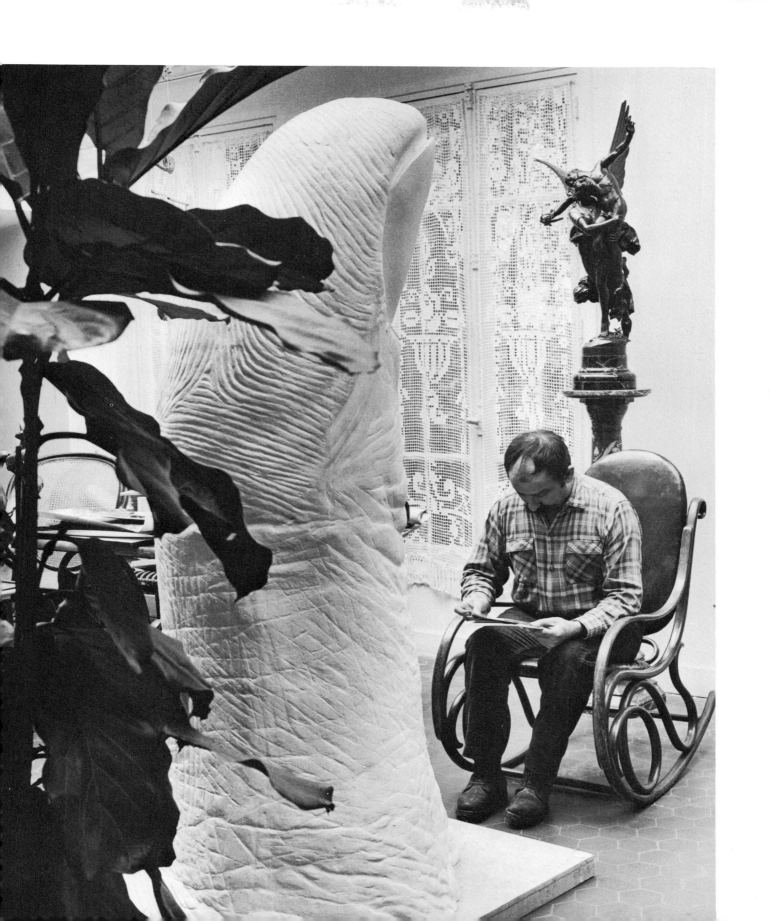

in my life, on the aesthetic plane, is the compressed cars."

——I would doubt it.

"I'm speaking of the exterior plane."

——But perhaps there is some connection between the insect and the compressed cars.

"Certainly there's a connection. Of course. It's certain that from the outset, when I first took up scrap iron, little by little I entered into it. It exalted me. Which is why I found a great joy up to the point at which I adopted the compressed car. When I discovered the compressed blocks in the yard where I bought the material I had a shock. And at the moment I had a shock, it became certain that I

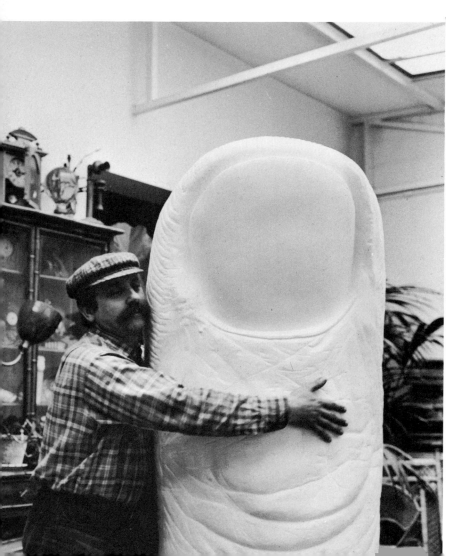

had to be the first to appropriate it, to assume the paternity of it, and to utilize it to the limits of its capacities. Which is valid."

——For that matter, in the material of the nudes, and the other sculptures as well, there is always a certain exterior quality, a certain handling of the surface, a concern for smooth and rough surfaces, a texture, almost a patterning——

"That, yes. You're right. Yes, that comes from the fact that I'm Latin. It's despite myself. I am excited, despite everything, by the quality— well, why make ugly? If I take the position, the intellectual attitude, of making ugly, then that becomes just as beautiful. Perhaps, too, I let myself be guided by taste. That's perhaps my weakness.

"When you allow yourself to follow taste, according to the retina— What would you have me do? Not that I have a taste for doubtful surfaces. You understand? They say to you, 'You have to avoid it.' Certainly, you have to avoid doing things according to taste. You have to have strength, but that doesn't keep you from having a certain taste for the surface. That will never diminish the sculpture."

——But what of the flat screens, the plaques such as the one at Valsuani, which are reduced to flat areas, surfaces?

"At the same time I am interested in the idea of occupying space with something extremely flat. Because, in the final analysis, you always have three dimensions. It's not because you do a thing in space with volumes of six feet, of ten feet, that you occupy space. You can occupy space with a leaf. Calder certainly occupies space with little

bits of cut metal that are as thin as cigarette paper.

"There's a total ambiguity, in my opinion, always an ambiguity. There are always doubts. I am seized with internal problems, with external problems. I am seized with doubts, I am seized with anguish. And I think I can unburden myself, and arrive at expressing myself with a great strength and a great simplicity, by trying to follow a strict rigor in regard to myself. But, despite myself, there are moments when I feel great delight, when I let myself go toward a certain—toward what people call a certain passivity.

"So I am for just as I am against, I am against just as I am for. Which is to say that I'm a fellow who feels as though he's in the Sahara. You understand? There are mirages: I advance, and then I advance, and then— I find I am not advancing at all. I see mirages

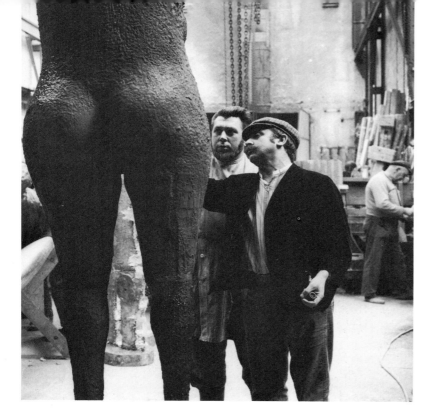

to the left, mirages to the right, and I stagger about with the hope of finding a road. Sometimes I approach, and then— there is nothing. And I think the image I am giving you is the real image of me."

——But the road continues——

"Well, it's precisely that fact—that the end of this road is in sight, that you approach it, and that it always moves off—which creates the possibility of continuing. Otherwise you don't continue. If you arrive, and you find the end, you have to start looking for another kind of end."

——Then the road rather than the goal is important.

"Certainly, it's the road you follow. As to the end, there are people who have a much more intellectual attitude—like Mondrian. I am sure that those people who work with such rigorous means, and all that, I'm sure they know where they are going because they have theories, they can talk about it. They make maquettes for their work. You understand?"

——And yet, even Mondrian followed a path that was unpredictable at the time. Perhaps far more so than his followers.

"Yes, but all the same, there are people who have an intellectual attitude. That is, they can be precise about it, talk about it, discuss it, have theories about it. Certainly I chat, I talk, but it's very ambiguous, it's unstitched. None of it has a very great coherence—including all that I'm saying to you."

——Well, Roël d'Haese said he feels that he lacks intelligence because he feels that he lacks an analytical capacity. I said I thought the intelligence of his sculpture was the greater precisely in ambiguity.

"I think ambiguity is the very meaning of life, it's the flow of intelligence in the animal state, in the pure state.

"I say—well, about Vasarely or about Agam, whom I know and whom I esteem a great deal because I feel them to be at such a distance from me—that automatically these intellectuals' language, their aesthetic, their work, arouses a very great curiosity in me, because it's something that would be impossible for me to do. It automatically creates a mystery—as with, if you like, accountant

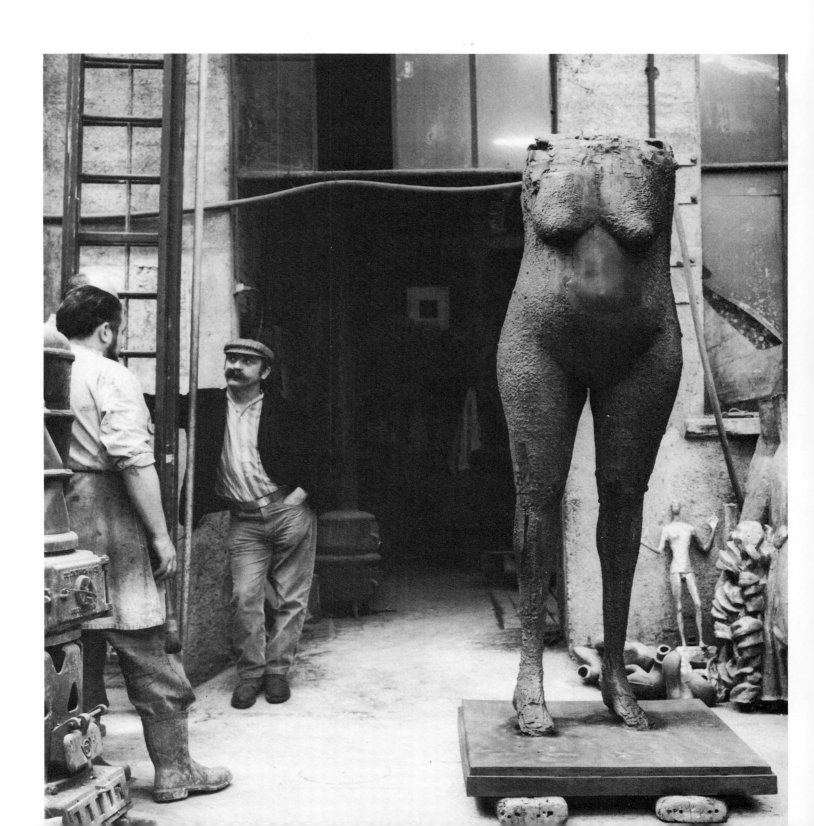

types. I know that there are people who are accountants. For me, that's a very big mystery, accountants. When I think that there are people who can add thousands of figures and keep their heads straight amid all those figures, that impresses me. You understand? It's like someone who plays bridge. For me bridge is something absolutely— well, I don't know what it means. I see people who tell fortunes with cards, and it intrigues me.

"Well, these artists intrigue me in the same sense (in a deeper way, too, of course). I mean in their way of working, if you like, in their vision. It's certain that some people can do works of art with a square, a compass, and a rule. Let's say that these people make works of art, that they make their mark in history,

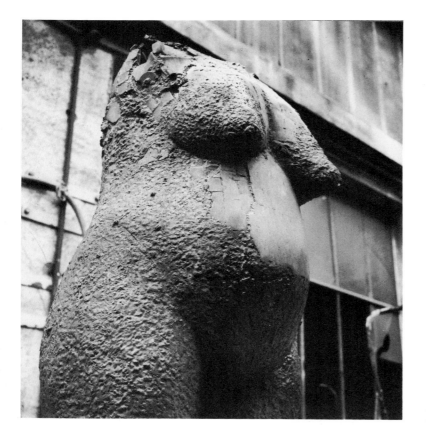

that they convey a human message through art. I certainly have to acknowledge that these people have brought a revolution to the contemporary epoch. None of this leaves me indifferent. But it is beyond me. I don't enter into it. I have a respect for it in the way of culture—but not a physical respect. No, I am closer to other people—to masons, if you like. I'm closer to the mason than to the architect. Of course, when I talk about the mason, I mean the mason-architect. I don't know if you know a book called, I think, *Architecture Without Architects*. Curious that all the great architects have been inspired by this architecture by non-architects—the Arabs, the troglodytes. When you think that all the great architects have been influenced by them! In that sense, I am an architect. I would like to do architecture."

César, in other words, delineates a vision of simplicity, or rather of spiritual wholeness, and at the same time a contemporary dilemma. The ideal is complete spiritual health, balance, a mind that functions in a complete concord of brain and nerves, of the whole biological entity.—The mason as architect.— Sculpture as sculpture, in the old sense. —A verity that overrides time.—A harmony of taste and function. And then, on the other hand, the dilemma.—The concern with a presence.—A consciousness in search of a context.—A disassociation of the parts of the self, and of the self and its world. All of which ultimately has to be worked out, as César testifies, in the act of working. I asked if he draws a great deal.

"That depends. That depends, because as soon as I draw, I no longer have any— I don't know— It's curious, because I ought to draw

able to sculpt. I knew, if I drew a nude for six months, or three months, or even fifteen days, that afterward I could sculpt that nude, keeping in my memory the essentials of all that I did in drawing the nude. That is, I could keep the spirit of the thing. But they still weren't drawings made *for* sculpture. They were just a way to impregnate the memory with the spirit of something.

"So, you draw, you draw, you draw—and that's what I did. Afterward you say the hell with the drawings. At that point you can build the nude very quickly, forgetting all the details, the quirks that catch the eye. The eye always falls on the imperfections, the trivial features. But by that point you can keep the essential things, the spirit of the thing."

with a view toward sculpture, but I don't. When I draw, as soon as I am on a flat surface, I follow another pattern of behavior, I have another attitude. I am no longer in touch with the sculpture. Because my imagination stops. I can't make the effort to imagine my draughtsmanship in space. Because physically it's false. I can very easily work with objects—clay, iron, plastic, any material that I can utilize in space. But as soon as I take a sheet of paper and draw a line or a spot on it, my behavior is entirely different. I am no longer a sculptor who happens to be drawing. I would like to be a draughtsman— but a draughtsman is not a sculptor. To draw *for* sculpture, that doesn't exist. You can have an idea, you can do a sculpture in drawings, but they have nothing to do with the sculpture. They are notes. You understand?

"Earlier, when I was at the Beaux-Arts, when I was younger, I drew in order to be

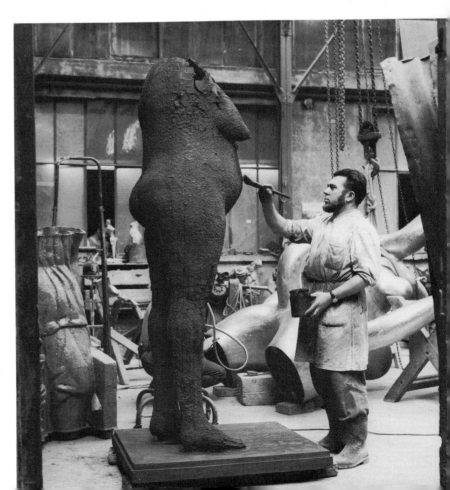

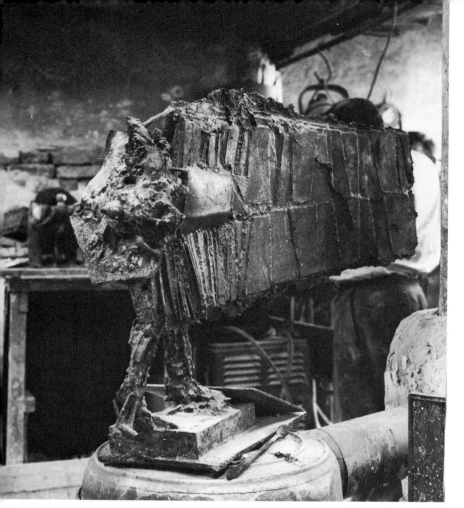

The Man of Draguignan

Voltaire said that men invented words to disguise their thoughts. César distrusts words entirely, just as he distrusts thoughts independent enough of the total sensibility to demand separate expression: "In your own words, you can more or less show that I am in an exalted, comatose, undecided, imprecise state. But that whole ensemble of things forms a reality all the same—that is, what I in fact am. If that's what I am, good, that's what I am. I can express myself through sculpture in a much more visible way, because there I show what I feel and not what I happen to think. While the others can talk about what they think. They can write, they can employ words, they can go on about sculpture.

"But it isn't sculpture they go on about—because sculpture is what I tell you it is. One can't talk about it. It's love, it's passion, it's tenderness. It's sculpture."

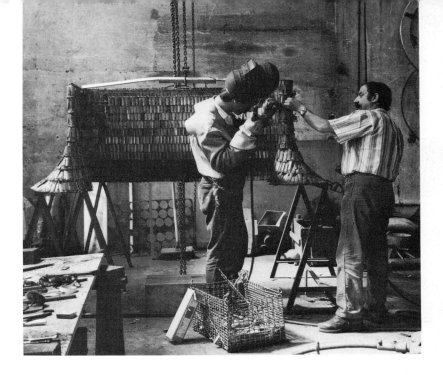

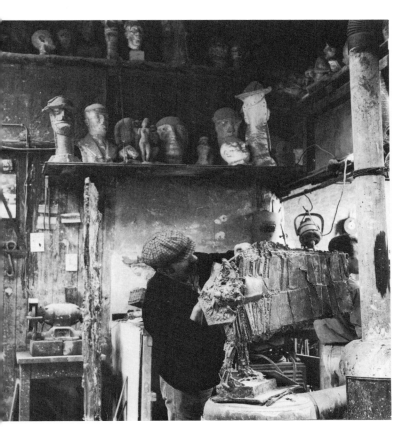

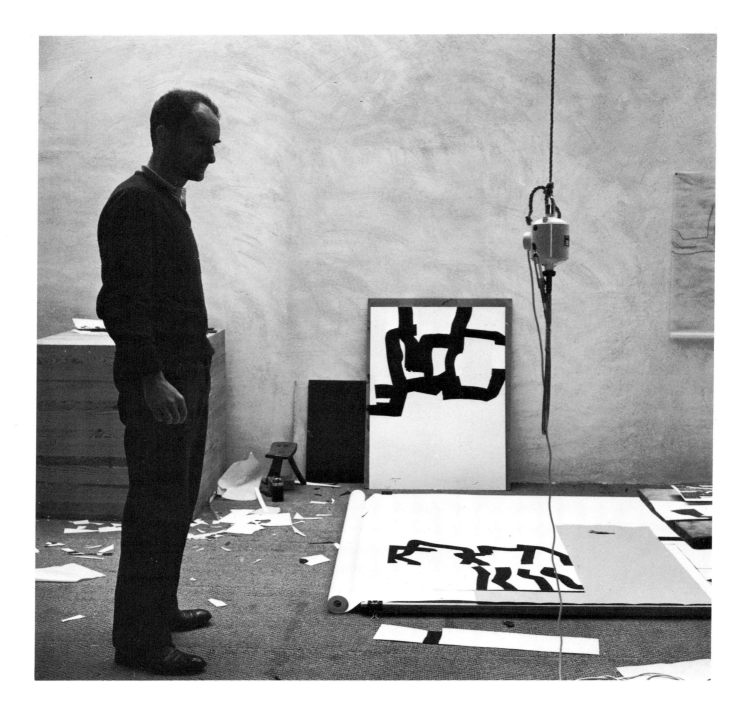

50 / EDOUARDO CHILLIDA

Edouardo Chillida

THE TREES THAT LINE the oceanfront at San Sebastián are stern, terrestrial pillars that seem to have found a *modus vivendi* with the sea. During the hot months, they sprout a primitive, spidery foliage, rather like seaweed but far more fine and fibrous and tough, and the heavy branches are masked in a cloud of pale green flame, almost white, almost the color of El Greco's Toledo. But in the cold season, even this sturdy, resigned leafage falls away and the branches are laid bare—angular, tortuous, putting out their rhythms into the sea wind. During the cold months they hold their life deep inside themselves, sharp against sea and sky and river. It is precisely at this time that the trees of San Sebastián bear a strange resemblance to the work of Edouardo Chillida.

Without doubt, Chillida is Spain's leading sculptor today. Significantly, he is a Basque, from a world that remains hermetic, a world that speaks a remote, consonant-laden language of untraceable origin, a world that straddles two countries. San Sebastián, where Chillida lives with his wife and eight children, is an urbane landmark of that frontier.

It is Basque, and Spanish, and just a step from the French border.

Its spot on the Bay of Biscay is striking. On summer nights the crescent coast is illuminated. Streams of copper and gold spill into a black sea, to dissipate like dying fireworks. Lamplight sharpens each surge of the tide, visible in every bubble and point of foam. From a booth above the beach, the Centro de Atraccion y Turismo shows color slides against an open-air screen, and crowds of tourists stand mesmerized before false, petty images of the view that towers, unseen, above them.

Chillida lives and works at the Villa Paz, on the road that leads to France. The villa is an elegant building, kept elegantly simple, mostly white, and furnished with a modernity appropriate to the sculpture. On one wall of the living room, amid white flowers and balancing a white alabaster piece of Chillida's, hangs a late painting by Georges Braque, from the Norman bird series, inscribed *"avec mes amitiés."*

Back of the house, across the driveway, is a special studio building. The ground floor

in this case, though, the moves are limitless in direction and possibility, while the rules— and there *are* rules—have to be divined and justified. The heavy black lines curve, parallel, concatenate, draw apart and together and apart. The rhythm becomes agitated or calm, the facade becomes dense or dispersed. And, as in the chess game, the precise determination of each move implicates not only an immediate position but a chain of consequences. Unlike the chess game, in the collage technique no move need be irrevocable. Nor will success be calculated according to a relativity of winner and loser.

These collages and drawings are not studies in the usual sense. Often they anticipate a given sculpture, but usually in spirit rather than in physical fact. They represent the working out of a train of thought, a sensate logic. They establish an equilibrium. And they are themselves complete.

Chillida speaks with perspective and precision about his own work, and he succeeds in confirming the idea that any commentary beyond the plastic resolution itself is superfluous. Perhaps the best commentaries anyone can offer are, instead, poetic parallels— for example, two visions expressed in Spanish, those of Jorge Luis Borges, the Argentine, and Federico García Lorca, the Spaniard. One thinks of Borges' 'labyrinths,' conceptual yet tangible, pursued with a cool, aristocratic zest (which is to say a devotion

consists of a garage-like sculpture studio, indistinguishable from a machine shop, busy with saws and hammers and vises and burrowing instruments—ferrous, shadowy, dusty. Up the outdoor, white sugar-cube stairway into the drawing studio, and the scene changes entirely. This is a crisp, light world dominated by the good life of paper, a place where ideas are digested, problems resolved. On the broad, flat worktable, a wine bottle filled with black ink stands amid stacks of heavy, sketched-on paper.

The floor is littered with collages in progress. Chillida manipulates these like a chess player rehearsing his next move, fingers pressed to the vulnerable piece in motion;

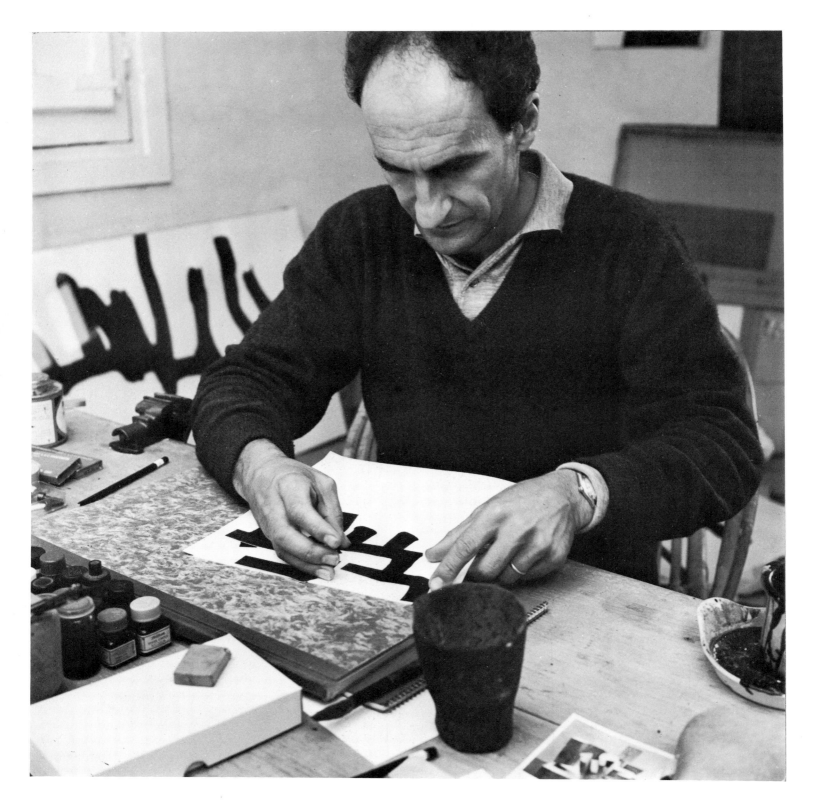

54 / EDOUARDO CHILLIDA

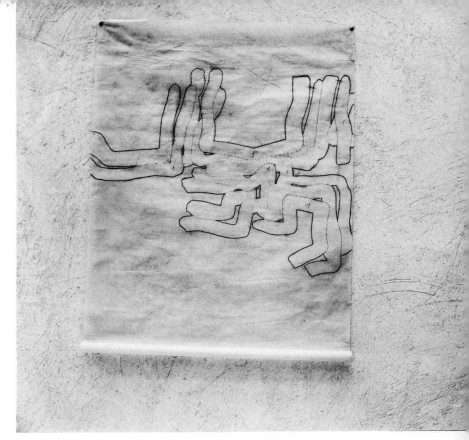

that ignores possession), a gratuitous curiosity, always with an eye to the grand cosmic scheme, but always embracing the weight and flavor and luster of the moment.

And then, of course, Lorca—this from *The Martyrdom of Saint Eulalia*:

> *Here lies the undulating snow.*
> *Eulalia hangs from the tree.*
> *The frozen air is blackened*
> *by her charcoal nudity.*

.

> *The broken snow is falling.*
> *Eulalia white upon the tree.*
> *In her side, squadrons*
> *of nickel are joining their beaks*

Not the snow itself, nor the saint, nor the martyrdom, but the weight of the words pivoting upon consonants, the black and white, the sensuous yet stark logic, and life evoked and resolved through a formal, rhythmic celebration. All this is Chillida.

With time, Chillida's work has become less linear, more voluminous, less fluid, more specifically architectural. He had just finished at the studio in San Sebastián a major work in iron, cut in massive, angular shapes, the latest result of a dialogue of exterior and interior form which has long been Chillida's obsession. But a project even larger in scale was then nearing completion at a quarry outside Vigo, clear across Spain on the coast of Galicia, near the Portuguese border. In fact, this is the biggest of Chillida's projects to date, involving in its finished state fifty tons of granite. Its title, in Basque, is *Abesti Gogora*, which translates as *Violent Song*. Chillida loves the sound of the name in Basque.

In 1965 Chillida, who happened to be in Paris, met James Johnson Sweeney, Director of the Houston Museum of Fine Arts. They

discussed a long-standing dream of Chillida, a sculpture big enough to be entered into, one in which the dialogue of interior and exterior form could be made monumentally explicit and physically tangible. Sweeney was interested. He envisaged a kind of gateway to Mies van der Rohe's museum building.

There were material problems involved at that point, and after several months Chillida assumed the idea had come to nothing—until he received a telegram saying, if he could get it done by September, to go ahead. He had counted on approximately a year. The commission left only seven months for work and delivery. And Chillida did it.

Therefore, the whole width of the Iberian Peninsula separated the beginning of our conversation from the end. At the drawing studio in San Sebastián, Chillida talked about his ideas and about their natural resistance to explanation. And in Vigo, twelve railroad hours away, he went into some of the consequences of those ideas.

The interior-exterior theme seemed crucial, basic both to the recent works and, in fact, to almost the whole of Chillida's career.

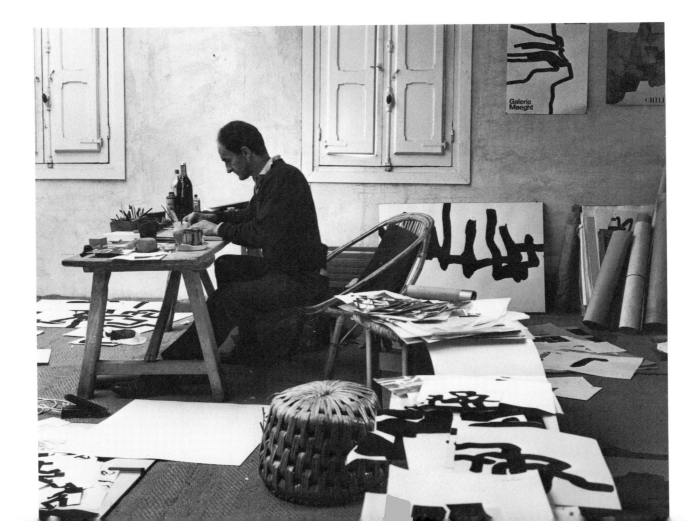

"I find that at heart this is an exceptionally mysterious problem—interior spaces, of course, have always been treated by architecture, but in a very different fashion. Because the architect, let's say, has created interior spaces by enveloping them within two-dimensional surfaces which are the walls—not with volumes in three dimensions, which is my problem. Well, that changes everything because there exists an *equivalence,* a kind of dialogue between the positive, exterior volumes and the negative, interior volumes of space. There truly is a dialogue. Even in works that cannot be entered because of their size, one can— see a certain image, through the exterior volumes, concerning what goes on inside. In fact, that's just what I did with the large wood sculptures which I showed in Paris and elsewhere. There are areas of interior space, areas absolutely inaccessible to the eye. Only I who made them know what exists in the interior. They are totally concealed within, but I tried to communicate what happens inside—where one can make no contact via the senses—by the first contacts that one has with the exterior, the substance, the wood, which explains in its rhythms and its manner of construction what goes on in the interior, invisible. There is an interior dialogue, interior-exterior, which is reflected by the exterior."

——But previously you were much more linear. Now, it seems, the volumes have become increasingly important.

"Which is to say that in the evolution of my work as a whole I felt a need to direct

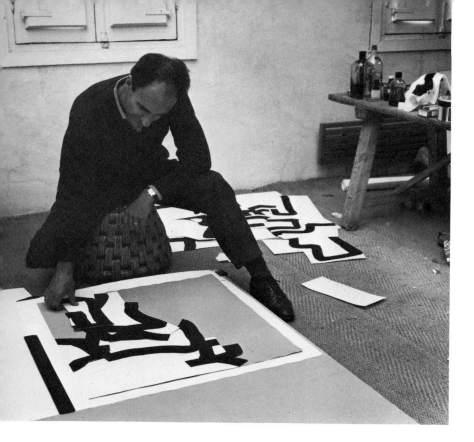

space in a certain sense by enclosing it, by limiting it. One cannot give form to a thing without limiting it. To give form to interior spaces I was obliged to limit them. But if one limits them totally they no longer exist for the senses. They remain hidden. That is, in a wooden ball there may well exist some magnificent interior spaces, but no one can see them. One would have to find certain forms—let's say positive, material values—which would indicate along the exterior any exceptional spaces or interior particulars. That was the first step I took in approaching these spaces. The part—call it the material part—in which I work as a sculptor becomes more and more important as a means of enveloping these spaces. That is why I came to wood, which was better adapted for carry-

myself somewhere. I think a great deal about those things, and I know very well just how I evolve. And so, some years ago, my work was different. That is, it has, on the whole, the same bearing, the same calligraphy if you like, but the relationships have changed enormously. Before, the material part of the work was the most important. I was far more occupied with the material. On the other hand, the material substance was itself less massive than it is today. The work was in fact a kind of gathering place for geometric spaces. My work consisted of places where infinite spaces join. Today, while this infinite space obviously exists everywhere in nature, around everything, I try to dominate this

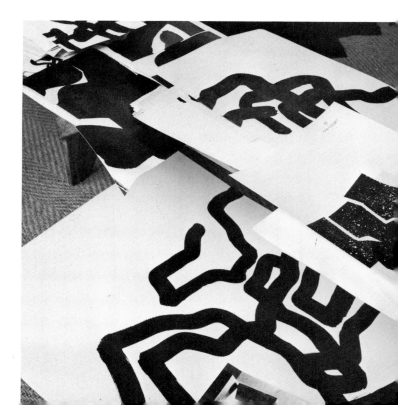

58 / EDOUARDO CHILLIDA

ing out this step than the iron I had used earlier. And now, when I work in iron, I work with a different concept."

——Does the large iron sculpture in the studio have a title?

"Well, there is a title for a series of recent works, which is *Surrounding the Void (Autour du Vide)*. It's the title I gave to the first iron piece in which I had a clear idea of this theme we've been discussing—which, at heart, had already been touched upon in the wood sculptures. But that one was really the first in which I voluntarily applied this concept, in which I truly separated myself from previous ideas, other, unrelated ideas. I made two— three *Surrounding the Void* works. And the big one downstairs is a continuation of that. I haven't yet given it a title, but it's in that vein, that series."

——And how far back does that go?

"Well, this one was finished a month ago.—The evolution is really very mysterious. I don't often talk about such things, but one wonders how such radical changes come about, and all the while without changing something which continues steadily. I can say that I've never tried to maintain a given appearance. Not at all. I change totally. For example, about 1955 or 1954 my great interest was perhaps a certain perforation of space, which had a relationship to time, to music. Which is general and which is always manifest in my work. Space, time—that counts for a great deal with me. Well, my interest at that time had to do with perforation. There

were some works which had points and which were described as 'cruel' by some people. It's not true—that sort of thing has never been in my line. You can see those works on the Basel Museum poster. They perforate, they pierce out into space.

"Whereas today, you see, in a work like the one down there, you have parts in which the form, the substance, ends by being flat, precisely the contrary. A spatial scheme comes about where everything comes to a clean stop. Which is explainable: it's because the

works of the earlier period, as I've said, tried to be places where innumerable spaces meet. But now, if I want to limit those spaces—short of building them up myself within the work —I cannot end up the same way. I have to finish cleanly in order to apply limits to those interior spaces without impeding entry. Such is the only existing possibility. At heart it's completely rational."

——Which is an evolution from the implicit to the explicit.

"Completely. Quite often I've said to friends that I saw my work becoming more and more hermetic, and there are people who immediately think of a kind of psychological hermeticism, even of a desire to conceal things, and so forth. No, it's physical —a question of physical laws which oblige me to construct interior spaces. There are no other means."

——The square and rectangular alabaster sculpture on the table—that poses the same situation, doesn't it?

"Yes. There you have one solid block—almost impossible to penetrate materially with tools, and almost impossible to conceive in an architectural dimension."

——In other words, you have an exterior metamorphosis, and yet an interior logic that remains constant.

"Precisely. And the one is a function of the

other, and vice versa. I would be incapable of telling you, ultimately, if it is the interior space or the positive exterior space which commands. The two command together. This dialogue begins when I begin the work and is truly a dialogue when the work is finished."

——It seems that the large iron *Surrounding the Void* downstairs has a great architectural atmosphere, almost an atmosphere of the Aztec temples.

"Yes, because of the massiveness of the forms—and, above all, because of the proportions."

——And these proportions or relationships are what the architects themselves tend to forget these days.

"Yes, very often. Obviously the architects have many problems, other problems than we have. In a certain way, we are much freer."

——And yet, they lose almost everything when they forget proportion.

"Yes. I find that proportions are what give magnitude. Everything comes of establishing true relationships. You see that in photographs. You do photographs of works of art—you look at such a document after a certain time and find that you've had an altogether false impression of the dimensions of the work in respect to its real size.

"I don't remember who said to me re-

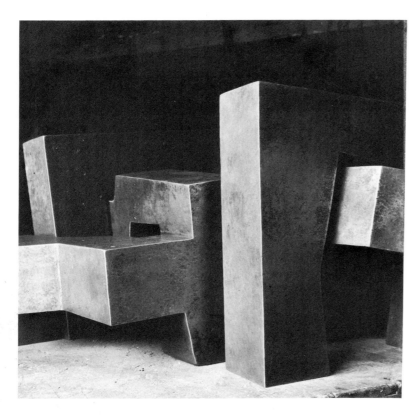

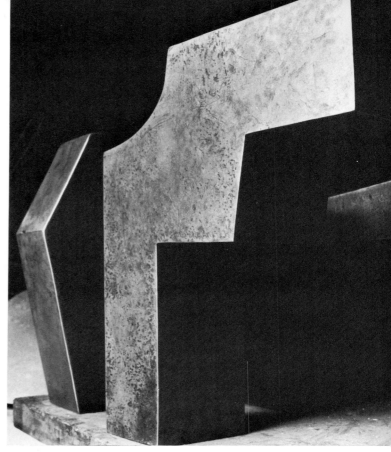

cently, 'I saw a work of yours in a collection in America. It was enormous.' I asked what collection. He said, 'Such and such a collection.' But that work is not big. I knew it wasn't big. He had seen these relationships, which gave a kind of grandeur to that work."

——Because it was a success——

"Yes, in a way— That one, for example, had a certain grandeur from that point of view, and it demands a possible further development. I would like to walk underneath it. I would like to walk inside a work like that, enlarged. But that touches upon a very serious problem. I have had great difficulties with the Houston piece because, for me, any work has an optimum size. You can't cheat on that —you can't make a maquette and then produce a version twelve times larger. No, that changes everything. That is—I don't know the word in French, when you have a triangle and another triangle exactly the same but larger; there is a word in geometry that expresses their absolute equivalence—that exists in geometry, but not in art."

——Psychologically, that changes everything.

"Completely, in that respect. Because

there are notable differences between geometry and art, even the purest art. For example, a point, in geometry, has no existence. It's a place, it's not a dimension. In art it *is* a dimension.

"From all points of view this traditional and normal procedure in art, especially in sculpture—making a maquette and then enlarging it—is one that falsifies everything. Most of the works done during the last few centuries have been falsified in this sense."

——The maquettes are often better.

"They are always better. The big works have the advantage of beautiful material. And great size—that is an advantage. But as to realization, I always prefer a Maillol in plaster to the big Maillols you see. It's much better. You can't compare them."

——And the same is often true for painting.

"Though painters in general envisage their works directly. At least I think so."

——Yet, even so, the little studies are usually more alive.

"Yes, but it's not only a question of life, because you can be alive in one dimension. But it's necessary to work directly. That is, it is the direct confrontation of man with matter—with canvas, with wood, stone, iron, what you will; wax, it's all the same—which gives the éclat and the contact. And then, there are still other explanations of this prob-

lem. Because when you make a maquette, you expend your energy, your thought, your sensibility, on that maquette. You are *living* your work during a given moment in relation to the time spent, even in relation to your life. If you finish that maquette and then think about making an enlargement of it, you are denying yourself from that moment until the completion of the big work. You are working on your past, which is really very serious. These are problems that I con-

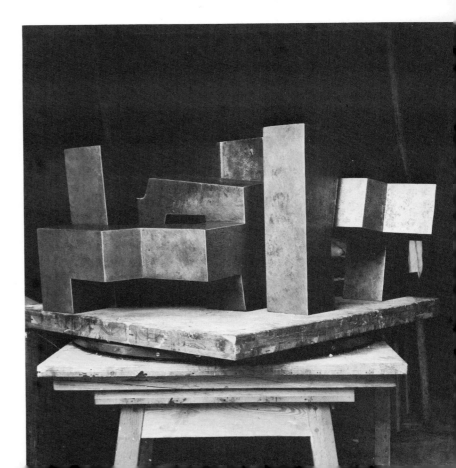

front very often when I attack big works. I pass very difficult moments because it is necessary to attack on a large scale and almost directly."

——And how have you resolved the problem of Vigo?

"I try to resolve these problems by trying to catch the spirit of the work in advance, especially in form. That is, I draw a great deal. Most of the drawings you see here are drawings in themselves, collages, what you will, but at the same time they are steps toward finding something, the spirit of something, through form. From a formal point of view they are completely independent of the

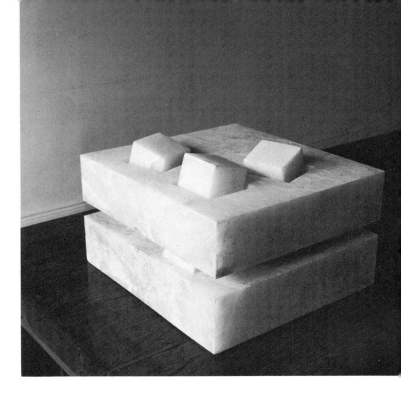

works which they originate, and yet they have a rapport with those works. That is, the spirit of those works will have connections with the spirit of these drawings. From the moment when I have this spirit, inside myself, I know it. I then have something to which I can attach myself. But, from the formal and material points of view, I am completely free in the handling of the work. It is the only solution which I've found valid."

——Does that mean that when you began the work at Vigo, in its major proportions, you were not following a maquette?

"At the start I drew a great deal—though I would have been able to do it even without drawing. I would have been able to write down all I felt about the spirit of the work I was about to undertake. I felt, in advance,

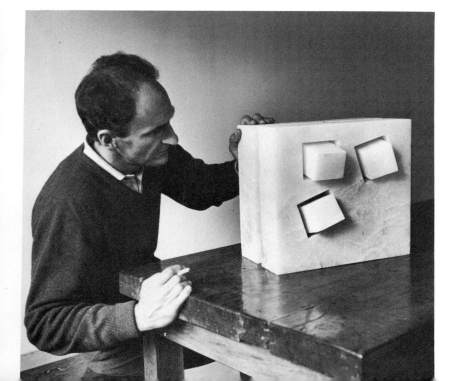

the sensations of someone who would one day penetrate the interior of a given shape. Obviously, I drew to evoke this spirit, and then I made sculptures—one in wood, one in plaster—which changed, one in respect to the other. But the process taken as a whole led me to something valuable and precise. These are sensations that cannot be explained easily. But I knew in what direction I had to act in applying myself to the spirit of the drawings in which I searched—and in which, in a sense, I found. And following the varying proportions and relationships and modulations discovered in the two sculptures, I was able to attack securely in order to arrive at the result I had anticipated.

"And then, of course, I had to know how I was going to cut the raw stone in the quarry to a dimension, a weight, of one hundred tons. It's not easy—you can't make a mistake."

The road across northern Spain, out of the Basque country into Galicia, is a rising, winding route. The hills sharpen, become craggy. The emblematic silhouette of a horned bull; the hot mineral ocher and brown and green and white of a resistant soil; the infinitely repeated image of old peasant women mummified from head to toe in black cotton—all this is Spain in profile. The landscape magnifies in grandeur as the tracks wind west. Great veined rock deposits succeed each

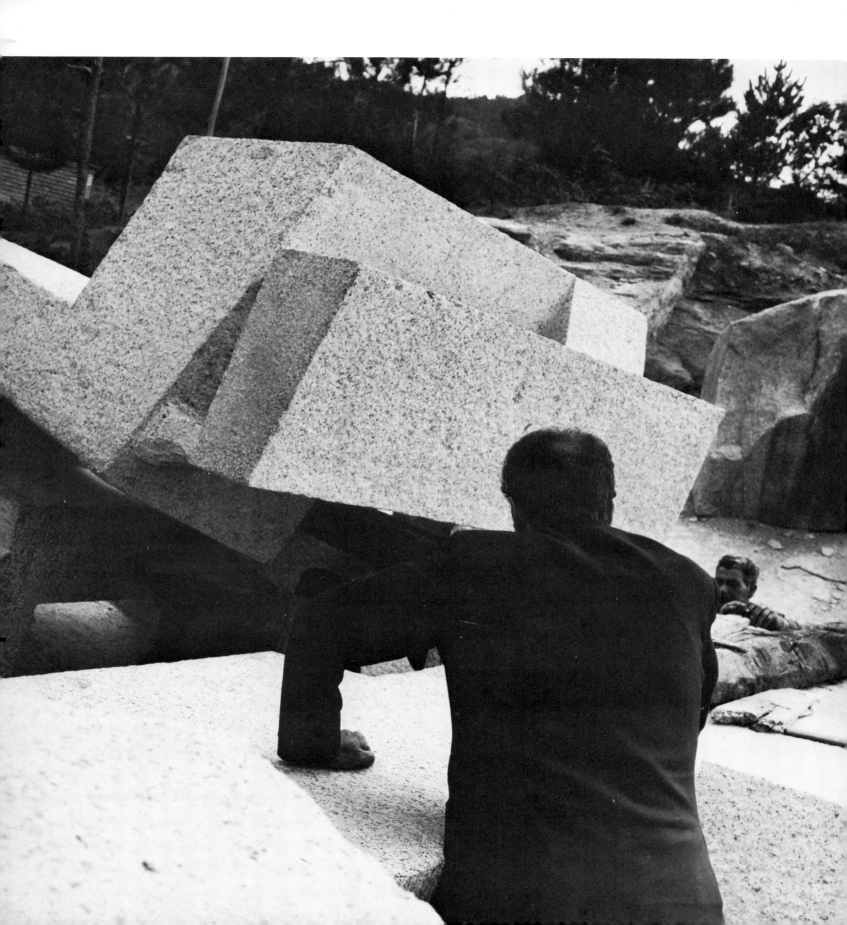

other flank to flank in the miles between the little white railroad depots, where a peasant and a goat and a weary stationmaster stand waiting, inevitable and, in their own mortal way, monumental.

Then Vigo, a port city along a handsome stretch of coast. The dockside cafés are un-floored, hot and damp. The beer is warm. Flies web the air and tread the bulging eyes of pink shrimp and the knotty terrain of an occasional slowly graying octopus. In a café-concert garden, a lively band parodies the same songs you hear in Paris, in Barcelona, or anywhere else.

And at last, up narrow coils of unpaved road, Budiño, the site of the quarry. This was an abandoned, largely unexploited source of precisely what Chillida wanted—a white 'Porrino' granite dislodged from below the stratum of fossilized matter, mixed with sparkling bits of mica, milk-white quartz deposits, and dark flames of feldspar. Its surface resembles sea-foam at low tide.

Access to the place proved a problem. The quarry happened to be near a school, and the authorities feared the consequences of using dynamite. Chillida and Nicanor Carballo, his right-hand man, convinced them that no explosives were necessary. After the schoolmaster and the mayor came the road officials: the problem was to get permission to haul the sculpture along unwilling roads to Vigo, more than fifteen miles away. This too was solved, although the sculpture had to be made in three parts to make transport possible, and three parts meant three trips. In fact, Chillida was obliged to leave the slender transitional portions unfinished and over-

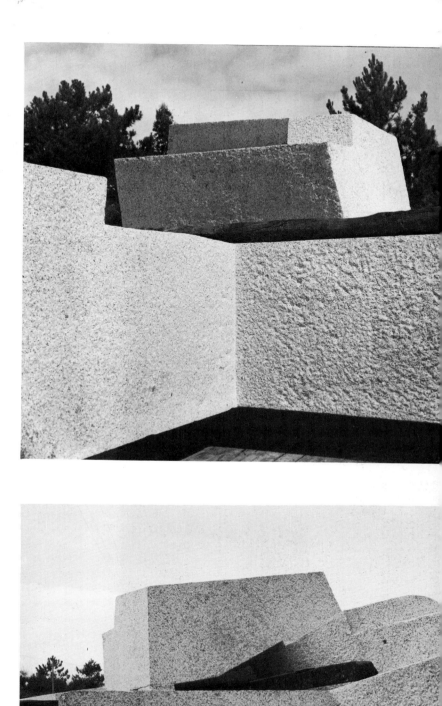

weight as insurance against the hazards of travel. Nor was the Budiño-Vigo road the last headache, even if it was the most dangerous. It turned out that no shipping line made regular passage from Vigo to Galveston, so an Italian freighter, the Sebastiano Veniere, was engaged to make a special call at Vigo.

But all went well. The open truck, better equipped for hauling olives than art, creaked over the stones and potholes. At the port, while Chillida held his breath, the great winches picked up each element of *Abesti Gogora*. Each white section revolved against the sky like a little maquette on a gallery pedestal, then was set down at dockside. "This," said Chillida at the end of three round trips in two days, "has been the most exhausting day of the whole affair."

All of which may seem circumstantial from one point of view, yet less so from another.

Chillida spoke with unqualified admiration of the men who assisted him—not only Carballo, but also the truckman and the chap who manipulated the crane at Vigo. He admired, and visibly enjoyed, their competence and interest, just as, in another way, he respected the quality of the land that yielded the stone, and the stone itself.

Insofar as Chillida's work is nonfigurative, and because his intellectual grasp of it is so clear and cogent, his sculpture might suggest a purely cerebral phenomenon, but it is far more than that. It is intellectually coherent, buit it is also sensually complete. It does take from nature, but it also gives to nature in the way of a sensible and neural submission. Its intrinsic celebration of forms is balanced by a tangible external contact. Which is reflected in Chillida's obsession with what he calls the biological aspect of reality.

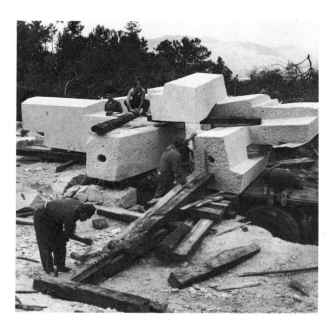

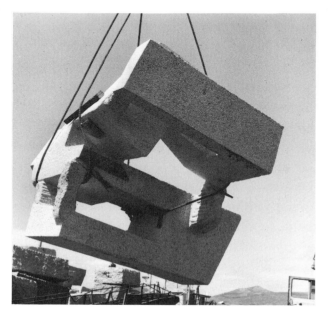

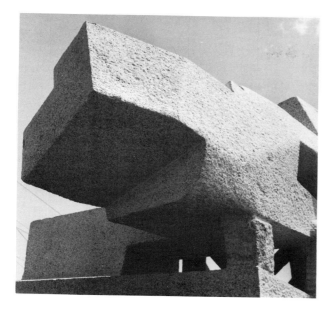

—One would say that there are very human analogies in your work. Suppose one were to say, for example, that you have—there—certain qualities of a dancer——

"That is possible, but it's not at all wanted. Perhaps it's because of a relationship with life that is at the heart of my procedure. You always have the laws of life, which are the most interesting to me. Biology is the science that interests me above all. It *is* life. My work has had no relation to appearances for about fourteen years, at least—in fact, since 1950. But a relationship to reality is another thing. Appearances are the hide of reality. Behind that hide lies a very deep reality where the laws of life are found, and those laws are my masters.

"What can possibly exist of greater interest in the way of procedure and instruction for an artist than the science which deals with the laws of life, the process of creating life, the successive levels of life, even to the budding of life prior to birth? That is, one leans upon this area of knowledge and upon all these essentially mysterious laws.

"I can, let's say, copy (a word everyone is afraid of), I can copy life—not the appearances, but life, the steps that life takes in evolving across time. Things change, evolve. I can copy this evolution from the temporal point of view. That is, in my work, I act just as a tree acts. But it's not that I want to make a tree; I want to make something else. It's a parallel of a certain kind—a very free parallel, you understand, but very useful all the same. And it is precisely in this spirit that I am a great *amateur* of the natural sciences. You see, I have learned much from these things, not in the sense of their form, their color, their proportions, but rather in the sense of questioning, wondering how this bark or this stone or this form came about. It's there, but earlier it was not there. It took many steps."

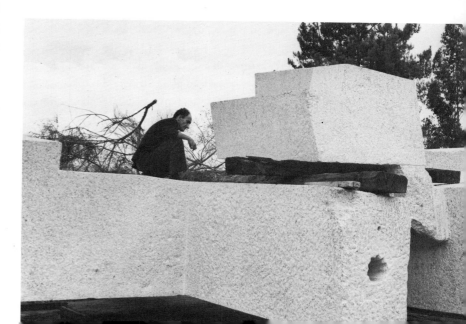

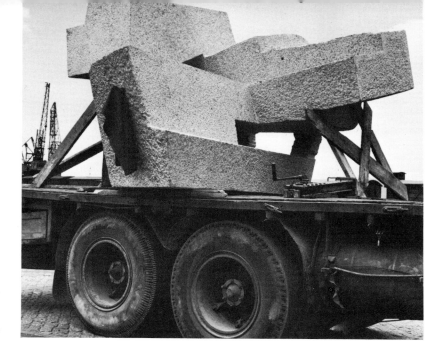

——And yet a lot of people are going to associate these recent works with Cubism, even though there is no real connection.

"I don't think there is any connection at all. There may be some formal coincidence with certain Cubist things, but from the conceptual point of view I see no relationship. In any case, I personally don't see it— Yes, the work has become more architectural, that is obvious. But architecture came about long before Cubism, and perhaps one must look at it from that angle."

——But as to the origin of the title—*Violent Song*. How did that come about?

"The connection between the title and the work? It's a title in a very broad sense. It isn't a particular or precise name. It is, perhaps, a way of finding in the words that make up the title, the work's character. 'Song' in the musical sense of the word. That is,

in music, song is something that evolves in time. It's a way of composing with temporal elements and in a line which exists in time. My *métier*—my way and my work—is the equivalent of that in space. That is, time is exchanged for space, for what I am doing in this case with stone, with granite. It is from that point of view that I call it 'song.' 'Violent' because of the structural conception of the work, because of the violence and strength the entire work has as a whole. That's why I gave it this title, which is, in any case, very beautiful in Basque, even in its sonority: *A-bes-ti Go-gorr-a. Violent Song* is a free translation. But the sonority of the words is magnificent in any case."

——Yet the formal concept always precedes the idea.

"Yes, yes. It is always the structure of the work. That is, I never envisage a work in terms of a title. Absolutely not. I do a work which has a certain spirit in its bearing, a spirit which finally—or perhaps right from the beginning—becomes concrete enough to assume a title. Then the title comes naturally.

"For example, earlier, in the *Anvils of the Dream* or the *Combs of the Wind*, the idea came quickly enough. Almost before beginning the latter work, I had the idea of making a monument to the wind. And how to do

it? I conceived of it as a comb, a comb of the wind. There the title came fairly quickly. In other cases it comes rather more slowly. I make a work with a certain determined idea, and suddenly I discover associations bearing upon the idea—something concrete, as was the case with *Anvils of the Dream.* It's a different sort of anvil, involving a point of contact between the work and the base which is rather less solid than either the work or the base. And that is what made me think of an anvil of dreams, because in order to forge dreams, the blows ought not to be very heavy—given that dreams have no material weight. They are light. They can fly. And it all came from that. It's a poetic idea, if you like, but in keeping with the structure of the work.

"The way of making it is everything."
La façon de la faire est tout.

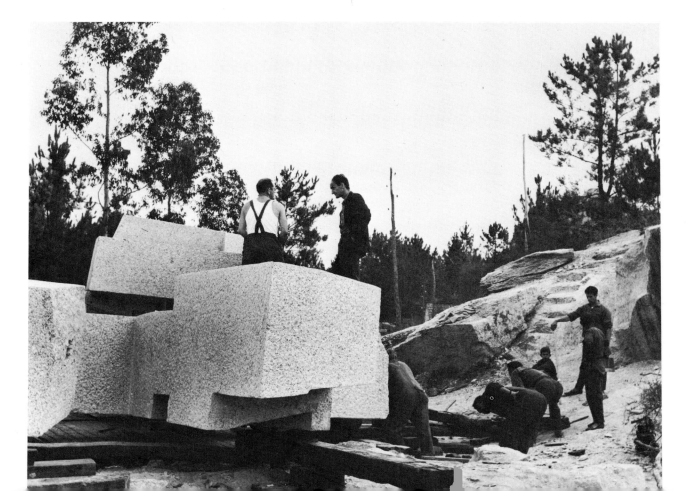

Eugène Dodeigne

Travel ten minutes east of Eugène Do-
deigne's place and you have to produce a
passport at the Belgian border. A few miles
to the north—the English Channel. This is
very much a pivotal region, where Europe
slopes into the lowlands. The old, futile ma-
chine-gun nests still deface the frontier. The
land itself has a wiry, no-nonsense rugged-
ness. The earth is veined with coal and rich
with stone.

Le Nord is probably the most denigrated
region of France. You hear it described as
tarred, industrial, and dull, but this is false.
The air is crisp, the light is fresh and modu-
lated, the landscape is angular. Lille is a
pleasant town, very northern. Narrow, or-
nate, heavily carved buildings press tightly
together in Flemish storybook fashion. At
night, the restaurants and cafés and taverns,
mahogany and amber, glow like beneficent
beacons. At holiday time, the city's medieval
escutcheon lines the stone flanks of the Place
du Général de Gaulle.

Eugène Dodeigne's house is in the country
at Bondues, a short drive out of Lille. He
built it all himself, with a friend's help, out
of the stone and wood of the region. It in-
cludes a studio with a kiln, where Dodeigne
draws and works out his lost-wax bronzes.
In back of the house he has constructed an
immense barn of a studio in dead, business-
is-business concrete. And there he works in
stone. The place is a shell, entirely without
suggestion or atmosphere, so big that it dares
the monumentality of his great figures. But
their humanity is manifest. They have a light
of their own. They inhabit their concrete nest
like the unexpected biology of some cold
planet.

And some of them stand or kneel or recline

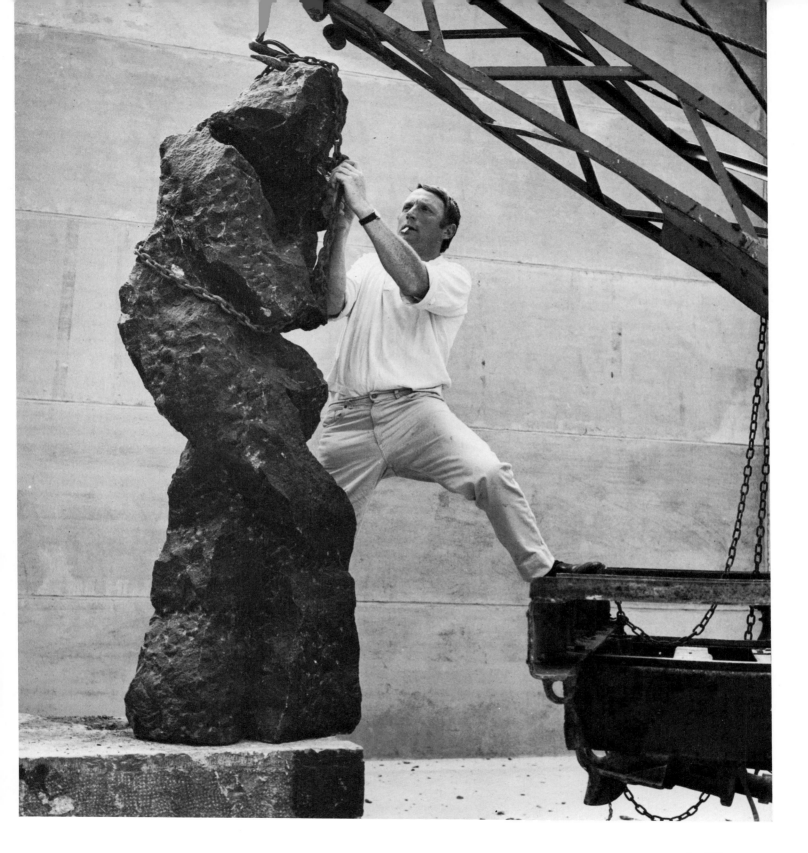

outdoors in a landscape that has much to do with their origin. I asked if Dodeigne would countenance the possibility of working elsewhere, perhaps in Paris.

"No, that wouldn't interest me at all."

——Then, do you find the character of this country of absolute importance?

"Yes. The character of the land— the sculpture is like that. . . . And then what the earth is, or the pear trees, or the light, or the wind: all that exists in the sculpture. And obviously the people too. You would have to settle here during a winter, and do sculpture, to see how it is."

——But the people— from what point of view, especially?

"The head of the people, the shape of the people, how they live on this land—that, surely. If you think of my stone sculpture, you feel it very much as part of this country. That's natural. As to what makes some one

work in Paris, I really don't see the interest. It's a pleasure to go to Paris from time to time, but as to working there, it holds no interest. Especially in sculpture, a *place* is necessary."

Great slabs and blocks of raw stone also lie about in the ferns and weeds. They, too, will one day be chiselled into form and light, but for the moment they resemble a neglected graveyard. And they have a curious, inchoate eloquence related, perhaps, to the fact that Dodeigne was apprenticed as a stonecutter. His father is a stonecutter—a carver of tombstones—and it was he who taught his son the *métier*. Which is at the heart of Dodeigne's work—this direct contact with stone, this intimacy with stone, with its properties, its poetry.

The material he loves best is known as Belgian granite, though it is not really granite at all but a calcareous stone mixed with bits of fossilized shell, patches and veins of milk-white quartz, and bright particles of mica. It is a tough stone, resistant to the chisel. In summer it becomes forge-hot, and a blackened, broiled caterpillar is likely to turn up in one of its recesses. But during the cool seasons, the stone seems to retain moisture, and it responds to the touch with the dankness of humid flesh.

Much contemporary sculpture is interior sculpture, at home within the white, angular confines of an art gallery. Dodeigne's work is not. Its liveness, in part the liveness of the earth, quite defies the limits of the museum. One is scarcely prepared to encounter anything quite so direct and undiminished, so touching, yet, in a sense, so menacing. Which

is not to say that Dodeigne intends his work as an aggressive force, but rather that the urban mind is used to encountering the life force only in diluted doses. Dodeigne's measure is precise but undiluted. He said, laughing, that someone had actually accused him of finding his sculptures in the earth—suggestive of human forms in the way clouds suggest beings and specters. The charge, thoroughly miscalculated, rings a defensive note: in effect, let it be nicely circumscribed or let it be coincidental. As in considering eerie phenomena, let it be an illusion or let it

be untrue. But banish the possibility of a world in which magic negotiates a separate truce with mind and matter.

Dodeigne's sculptural expression challenges the comfort of an easily arrived at equilibrium. The manifest weight and solidity of his *personnages* is opposed by a fleeting quality, a transience something like the quality of flame. But then, fire *is* something like sculpture—or perhaps so diametrically the reverse as to be a flawless opposite. Stone is still, yet in it one perceives motion. Flame is ever in motion, yet in it one sees a sculptural permanence. And both are creative elements. In Dodeigne's sculpture there is a permanence that alters according to angle and light. Call it a protean precision. His work is the enduring fact, the single moment of completion compounded of many moments of impact, chisel against stone.

But first comes drawing, which Dodeigne describes as the source of his expression and the means to his gradual, steady evolution.

"In general, I draw without interruption during two or three months of the year. But only for the pleasure of drawing from nature. And it's only later, within that series of drawings, that I find the theme that corresponds best to stone or to bronze: bronze for a greater suppleness, stone for a brutality which corresponds to the texture of the material. The sentiment is different."

There are piles of large drawings about the studio. These are often directed to motion, calculated to set down a broad equation of mass and movement, full of muscular activity. The most recent include a series involving two neighbors, done from life, a great hulk of a chap and a frail old lady. Dodeigne seemed to enjoy counterbalancing the disparate shapes and balances.

And then—it would perhaps be incorrect to say flatly that the 'idea' resolves itself—there comes about a moment of readiness, a poised position based on observation and appetite. So comes the moment of stone, a moment that is thus a continuation as well as a beginning.

First, the selection of a proper block. "You make it ring—like that—with a hammer. You hear immediately if the stone is cracked inside."

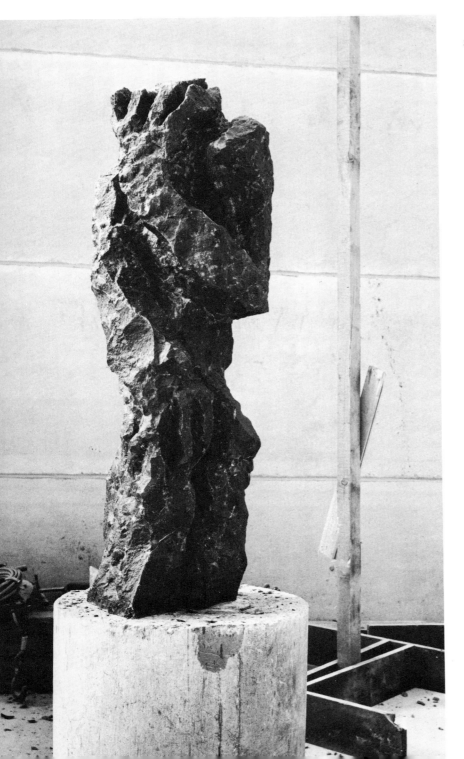

——But you also listen while you work the stone.

"Yes, the sound is important in working stone. You sense when a blow is going to smash the block. It's foretold in a series of contacts; the sound changes, and—pop!—you have an explosion. I've tried stopping my ears with wax corks because I worked amidst noise. But then I tackled the mass, tried for the vital point— and struck to the side. Well, I didn't hear anything. It didn't work at all. No doubt about it, you work stone with your ears."

Dodeigne does not simply act upon stone; he interacts with it. For him, the stone's resistance is an active force, not simply a passive obstacle. He describes stone as an enemy. "Sculpture is a combat, a battle with materials—with stone above all. You have to make a fist. You have to parry and fight." (Dodeigne has a working companion, his shepherd dog Foza, a temperamental beast who likes to snap at the flying chips. "He doesn't understand," Dodeigne said. "He thinks they're butterflies.")

——But, finally, you have the problem of knowing just when to stop.

"That's a question of emotion. That is, when you are really at work and all is going well, it's like boxing, or a tennis match.

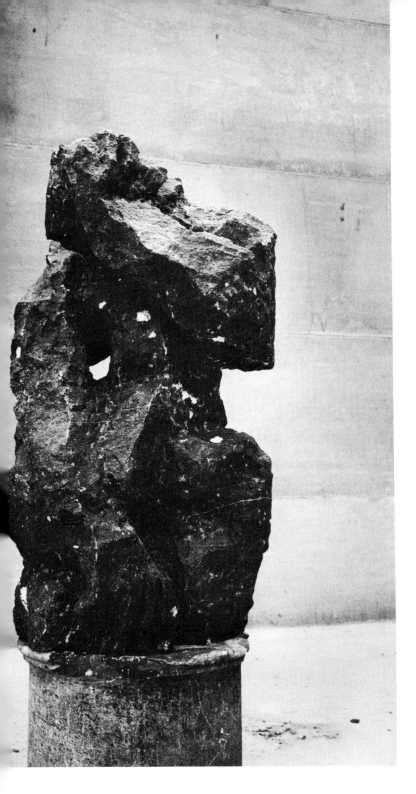

When all is going well and you are at one with it, it works out. But at the moment it begins to stop going well, it's because you are no longer with it. When the sculpture is finished you sense it. You say to yourself, 'Good, it's time to stop—because it will be a catastrophe if I go further.' Either it will break, or it will go soft, or it just isn't necessary to go further. Well, one feels that."

——In all your stone sculpture there is a certain balance which it must be difficult to reach exactly. If one works with geometric forms or smooth forms it must be easier to know immediately when the moment has come. And then you have this quality of light——

"Yes, that's true. But I think it's first of all that each work is arrived at *in* a place, in a light, with a subject—a theme, from the point of view of expression—and that's all that counts. For me it's not a question of finishing a sculpture, it's a question of expressing with precision, in a way which brings a kind of liberty, through a rapport with the material. And as to what one calls 'finishing'— it must always be expressive, remain very free on the external level. One feels whether it's finished or not. It's not because it's smooth, for example, that it's finished. That would mean nothing. It can be

smooth and completely dead.

"Work in stone is a blossoming out. It's done so fast. It's done extremely fast. It doesn't take long to do a sculpture in stone. Of course, yes, for those who don't know how to work stone it takes a long time, because that's scraping down, not stonecutting. Stone sculpture is done very quickly; it's spontaneous. A sculptor who is a true stonecutter— that's rare. It's a whole apprenticeship. Sometimes I do a very big sculpture, three meters high, in two to three weeks. Sometimes those are the best. The quicker I succeed, the better the results."

——And yet you always work with drawings.

"Yes, just about."

——Which means that you know almost exactly what you are looking for.

"Indeed, yes. Obviously, though working from the drawings, there is still a liberty in the stone. It has the expression of the drawing, but often the relationship of proportions in the stone block is different, which implies something from the point of view of liberty in realizing the stone. And while coming from the profile of the drawing, it often has another profile which is better than the one I began with. That happens. You say, 'Here is the face, but it's the back which is better.' It becomes a combat, a game of turning around, climbing, coming down,

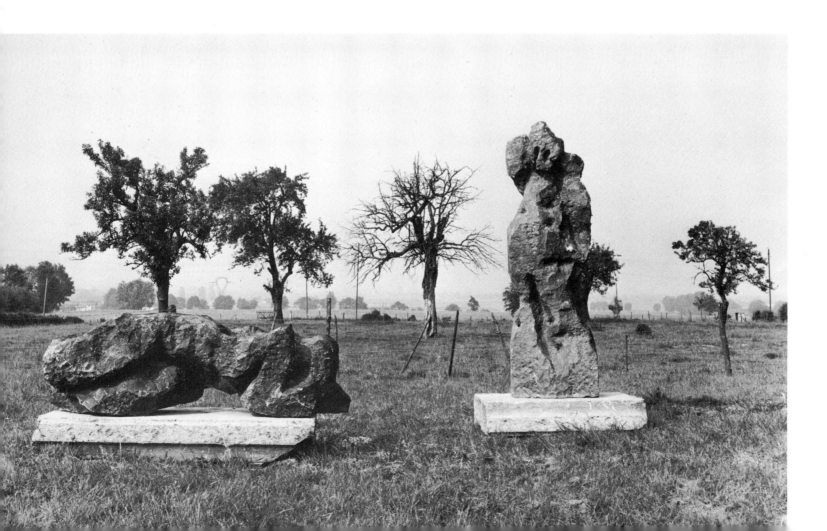

moving to the other side. All of it is done very quickly, and sometimes the back *is* better than what one calls the face."

——It can even become another idea entirely.

"Yes, absolutely. That often happens, because on the other side you find a liberty that wasn't there before, where there was a slightly closed theme at the beginning. Above all, sculpture in stone is a great pleasure. Yes, a very great pleasure. You throw yourself into it, and then—of course, you are possessed by a theme of expression."

——At heart, then, you prefer working in stone to working in bronze.

"Yes— well, when I work in stone I prefer working in stone, but when I work in bronze I prefer bronze. But yes, stone is obviously much more direct. Then, when I get tired of the stone, I prefer bronze. I even prefer wax. It's completely different. You've seen the bronze at Van Derkerkov in Belgium. Compared with, say, this stone, I wouldn't dare say which I prefer, because the bronze worked out very well. I would like to do bronzes of that quality often. It's perfect. There's a torsion there— and at the same time there is a sensuality in the bronze. In the stone there is a more expressive brutality, but in the bronze there is a sensuality. One feels the skin, the epidermis. It's very different. The bronze is a skin, a surface."

Which is true in Dodeigne's bronzes because he works in a lost-wax process: a husk of wax is burnt away from the mold and the result is, indeed, a skin, often pierced

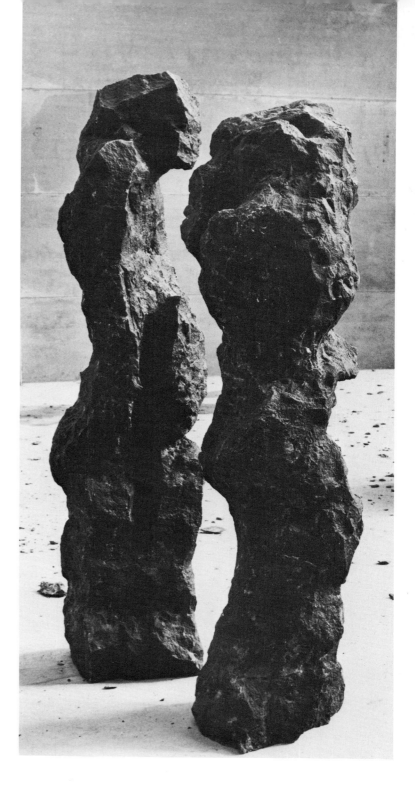

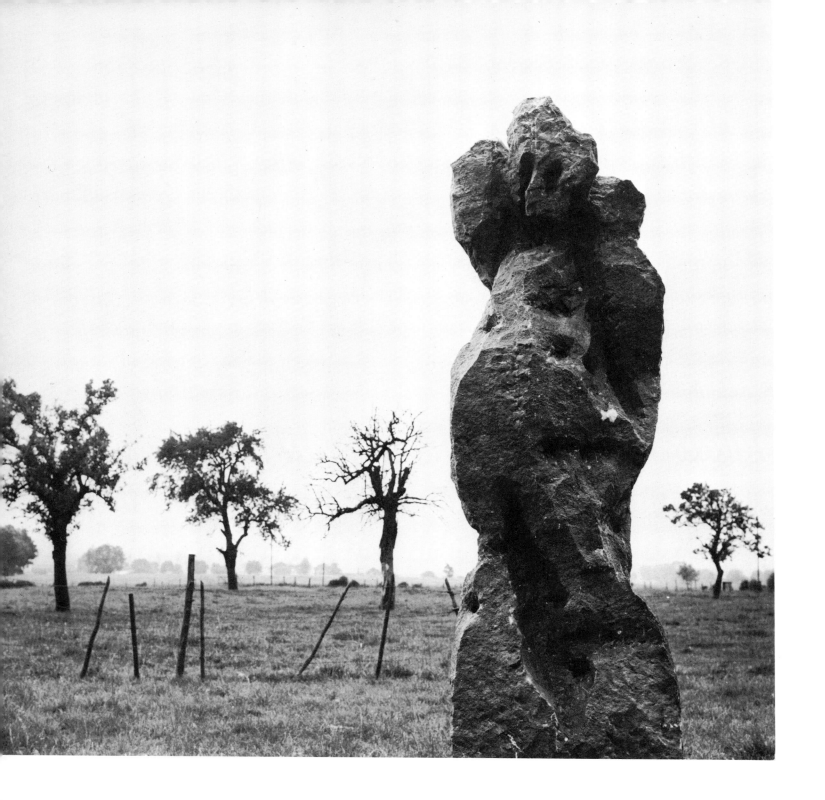

by the heat, luminous, with a certain fragility in its bearing.

——As for painting, are you working with that at all now?

"No, but it involves me regularly almost every year. It has for about fifteen years. It's a kind of recreation. One must change about a bit. So, sometimes, I want to paint. But each time I begin again I almost have to re-learn the medium. That tires me quickly enough, and then I feel like returning to sculpture."

——There is no direct relationship, then, between the painting and the sculpture.

"None, none at all. No, sometimes the painting does bring something to the sculpture——"

——But not like the drawings.

"No. The drawing is really the basic work. It's through drawing that everything renews itself, because in the drawing there is a rapidity of expression. Thought is immediately fixed. And emotion—it conveys that, too. And each year the series of drawings—done over a period of several months—is new. Because a year has passed. I can't explain why, but it's certainly so. There is a great difference between the drawings of four years ago, for example, and those of this year, not only in the way of making them, but in the emotion. And that is what renews my sculpture. If I didn't draw I would have a tendency always to do the same sculptures."

In other words, observation brought to bear upon the inner impulse, and exposure of the inner domain to outer forces, a periodic insistence upon fundamentals. With time, and always through direct contact, comes a metamorphosis. For that matter, even the stone changes with time and light. It comes from the earth very dark, almost black save for its white markings, and then turns gradually lighter, to almost a pale slate color.

During the summer of '66, Dodeigne worked steadily and prodigiously at Bondues. The studio had been emptied out thanks to large exhibitions in Belgium and Germany, but by late August the great concrete hall was again inhabited. The new stone *personnages* were often different in key. This time there was an element of gesture and action that had not appeared in the earlier series. One especially, a narrow, taut blade of a figure, had an almost Gothic flavor.

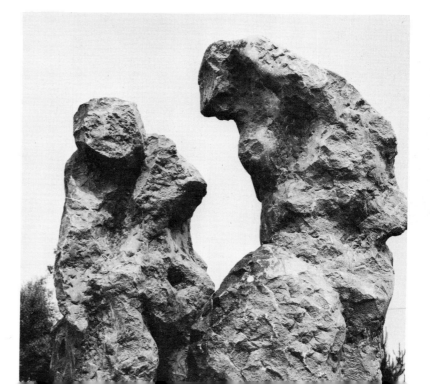

——And in what spirit was this series begun—as a continuation of the earlier ones, or as a definite departure? Because there are innovations, especially in this vertical one.

"Well, it must be said that from the point of view of spirit that piece is entirely separate from the others. At the outset, it was due to an accident—that is, the block broke. I let it be for a while, and then it suggested the idea for this sculpture. It suggested something and I pursued it. When the accident happened, I said to myself, 'It's finished, I can't do anything further with this stone.' And then, to the contrary, it brought me something else."

——Was the accident caused by the structure of the stone?

"Yes, there were fissures in the stone—which I knew, in fact, from the start. I was afraid of a disaster with this block."

——One almost thinks of the prow of a ship.

"Yes. Well, it has become something of a prayer. But at the same time, it is perhaps a departure toward certain things that I would like to do, because it brings back the spirit of my earlier things. I rediscovered the spirit of my earlier things . . . very close to a kind of reality, a very human and a very expressive reality, close to a human sentiment."

——You also have a quality of gesture now, specifically in the figure with the hands on the head, in the other with the hands behind the head, and even, for that matter, in *The Prayer*.

"Very simply, it's the continuation of a series of drawings done at the beginning of the year—as every year. And each time I recognize that things move on. Why, toward what, and from what, I don't know at all. And it doesn't matter to me. What I see is the result, that's all. It makes itself felt—just as one walks, just as the tree pushes up, either to the right or to the left—and that's all. It's absolutely not preconceived. It's as one breathes. And then that works a transformation. From one series to another, each year, it

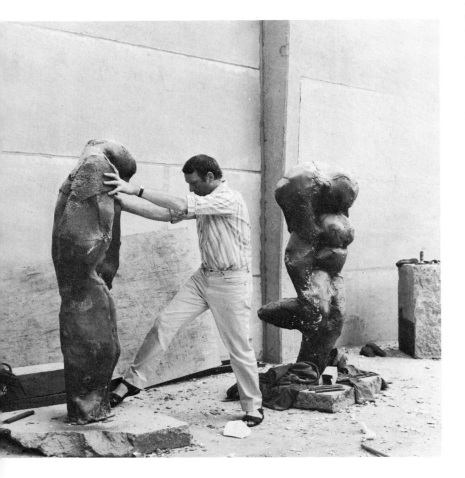

is certain that there is a difference. There is an evolution. It's not necessarily better, but it has moved along."

——But it's not a direct evolution.

"Oh, absolutely not. It's not preconceived. The next series will be— what? I have no idea."

——And then there are some here which are quite without gesture.

"Yes. Well, I can explain that to you. That's the first in the series. It very often happens that the first ones pick up just a bit of the themes of preceding series, and so come out of a more preconceived idea. It's less free. That one, for example—the one with the hand on its head—is the last one in the series. The further a series goes, the more open it becomes, the more unreflected, the more spontaneous. And at the moment I ar-

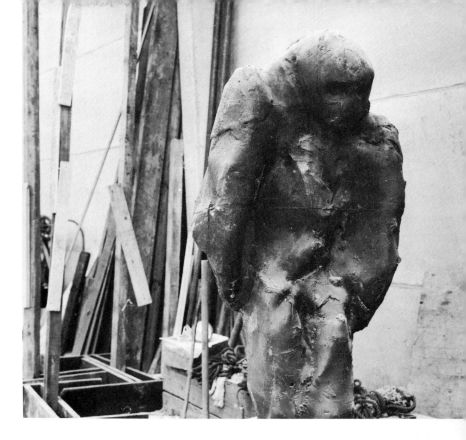

rive at that point I say to myself, 'I have to stop. I can't go further.' Little by little, the way opens through which I arrive at that point."

——Which means, in this case, that the series has become more and more specific— from the human point of view. The earliest one in the series is almost more abstract.

"Because it comes much more out of a preconceived idea. In the movement of the earliest one, the thighs and the pelvis became a spiral—that came out of an idea of movement, of geometry. It's much more geometric, whereas with the others you have much more sentiment— But at the start it's far more abstract, more intellectual."

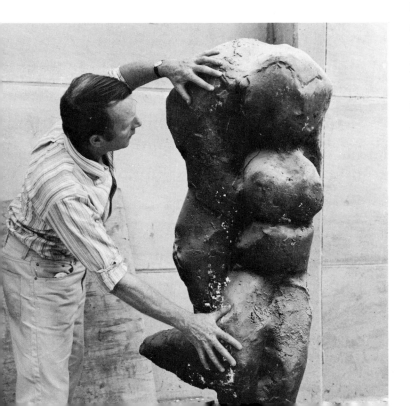

EUGENE DODEIGNE / 85

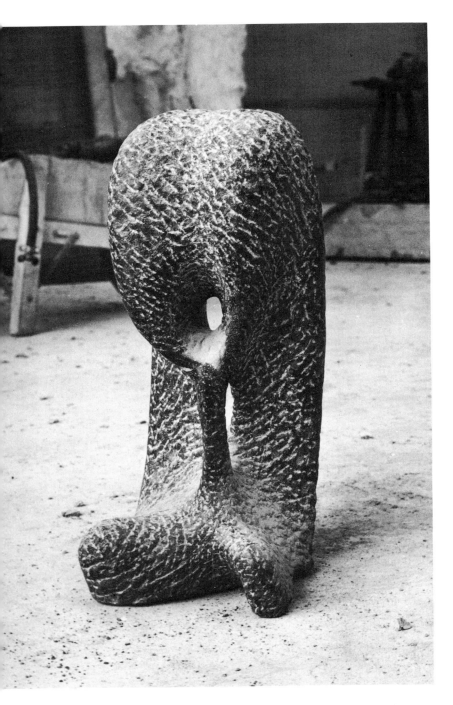

——It's interesting that the sequence moves in that direction. One would expect a progression from the more specifically human toward the more abstract or formal.

"Well, but when I begin to sculpt again, obviously I have to get back into it. It's much more intellectual than when I am really *in* the stone. When I have lived with the material, with the expression, then a breakthrough occurs. *The Prayer* was thought about a great deal. After what happened, I asked myself a great many questions. I said to myself, 'I have to do something so as not to lose the block—to find a very interior theme, something that comes from the depths.' All the others are fairly externalized —the *personnages* express a spontaneous idea. But *The Prayer* remained in suspension for three or four weeks after the accident. Always returning to it, I little by little rediscovered a theme and fastened on to it from that moment on."

——In all of them there is, of course, a great solidity, a great permanence. Yet there is also an evanescence, a transient quality. It is not a matter of a form which is a fixed form—modelled, in a plastic sense—but rather a form in motion, from the point of view of expression.

"Yes. Plasticity doesn't interest me. It's something one has inside oneself. One is a sculptor or one isn't, that's all. It's pretty fundamental. What counts above all is to express—and to see to it that it still remains

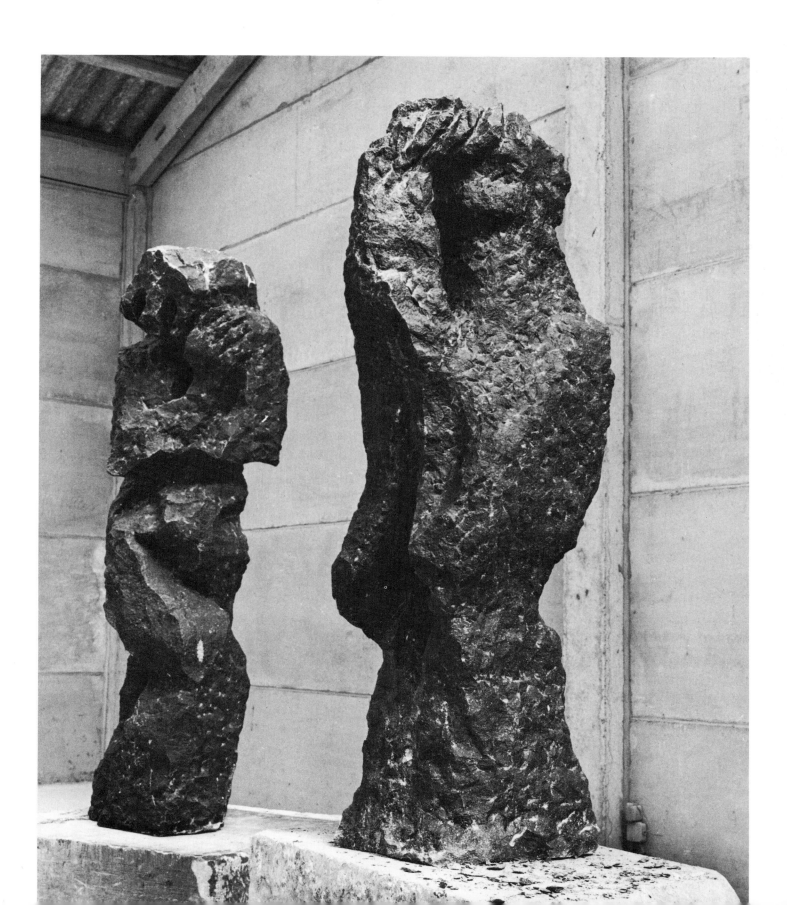

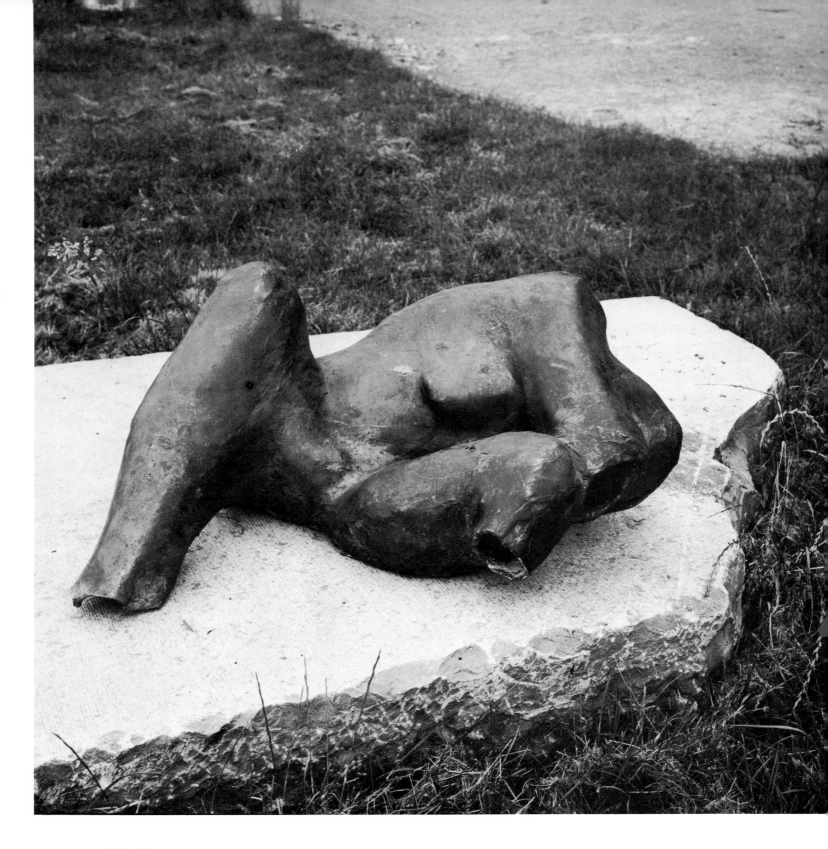

sculpture. But apart from that, it's not a thing that haunts me, that bothers me. Not at all. A sense of relationships, three dimensions, abstraction, light and space— One is a sculptor or one isn't."

——But—without being literary about it— how do you feel about the human side of these works? These two *personnages*—the one with the hand on the head and the other with the hand behind the head—they have a very human side, a definite presence.

"That stems from the direct study of nature. For example, the figure with two lifted elbows: in the beginning that was a woman lifting her nightdress—very simple, a completely natural gesture. After that it became plastic: the instant frozen in stone. Just as the other—the one with the hand on the head —is a friend I work with (the one I built the house with). He always gesticulates and works that way; he has magnificent gestures like that. And it's that moment, completely frozen, expressed in stone. It takes on an eternal aspect, but it's just one specific moment which, in the beginning, expressed nothing in particular for me. Once it has become sculpture, yes, then it can express something, because this gesture of his answers to what he is and expresses something of him. Which is where the titles come from, afterward. But before, I don't think about it, not at all. It's a pretext for making sculpture; and obviously, in this gesture, I rediscover myself. There is a correspondence between this man's gesture and me— It's *he* who makes

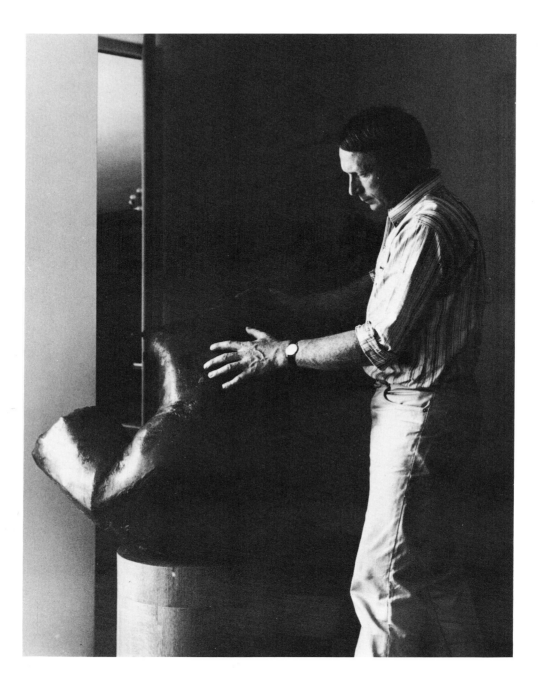

the gesture. *I* sculpt it in stone. The idea for this head, this hand—those are all things that correspond only to what I am."

——And the kneeling figure?

"There as well—it's the same thing as the other. The position is different, but it's the same *personnage:* having knelt, he stood up. Look. It's exactly the same sculpture. It's like a ballet, because it's the same *personnage*—here kneeling, with the hand on the ground, and there standing up, with the hand on the head. It would please me a great deal to be able to do a ballet based on these sculptures, since there, too, gesture is caught, and it should be possible to develop a real ballet based upon the gestures of the sculpture, the sculpture being the point of departure, and disappearing, giving place to the dancer. It stands on the stage, then is transformed. The dancer appears and takes a cue from the theme of the sculpture, and it all joins, because it's the very sculpture that has moved. That is also the same sculpture. They're always the same— but the figure moves, like that. What is, in fact, very important—it all takes place so rapidly—is bringing in, in the two pieces in the center, the themes of the couple and of provocation—the two verticals in the center. You see it—this sort of provocation of the woman? And the man, the man who approaches? There, in the middle. On the other hand, they are also very hieratic."

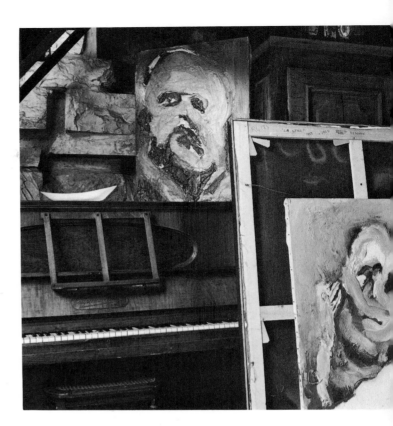

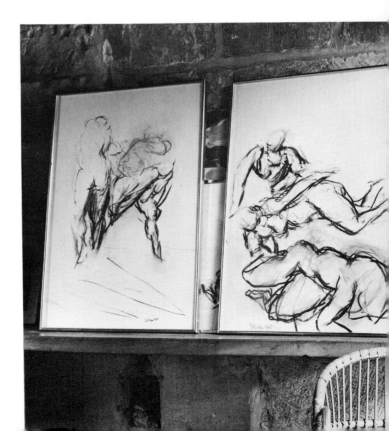

92 / EUGENE DODEIGNE

——And in such a ballet one might do a great many combinations, vary the relationships among the sculptures.

"Indeed. Indeed, yes."

——And this is the last one?

"Yes. In terms of plasticity, that one is very architectural. Immense architecture— to arrive from this column on the left, at the projection of the arm on the right."

——It's an interesting head—the three carved lines——

"But no, not at all. That's the hand. Look——"

——From that angle, yes, indeed. Now I see it. But from where I stood I saw a head. There——

"Ah, yes. It even makes sense as a head from there."

——Well, like Picasso's double face—in this case head and hand. For that matter, there is an expressive parallel as well. In fact, your heads often have a great variation according to the angle of vision—multiform.

"Yet in the case of Picasso, when he has a profile and a full face, it's a fairly intellectual idea. But here, not at all. It's very spontaneous. There is movement because the face moves, because the arm moves. It doesn't come out of an intellectual process. But there are Cubist sculptures by Picasso, which are very beautiful, which also come from the idea of the movement of the face,

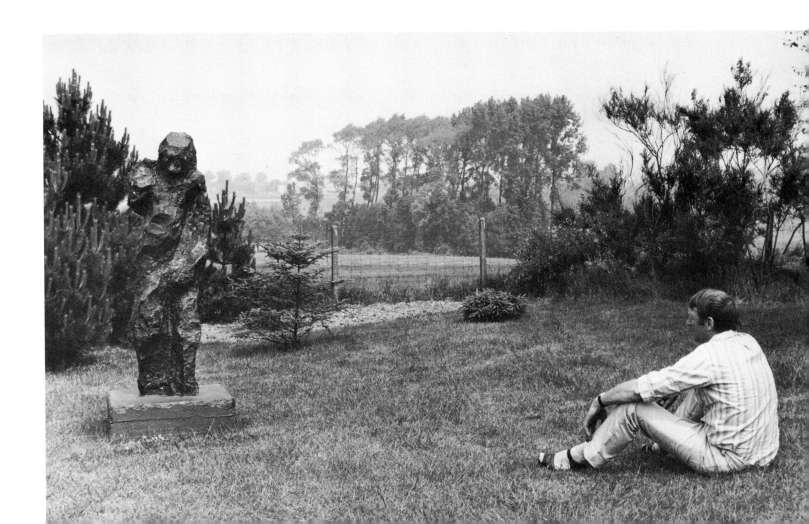

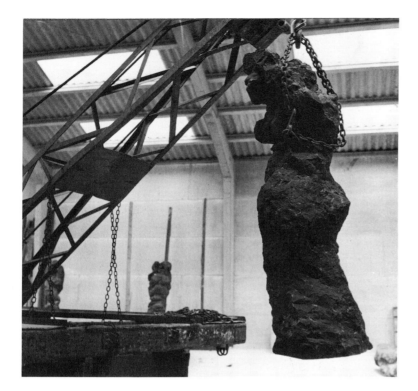

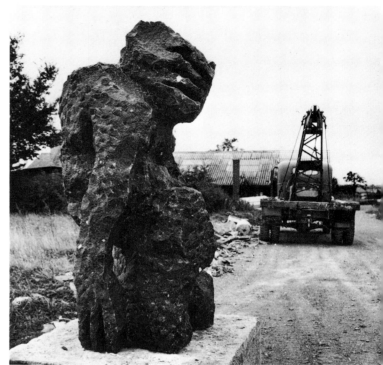

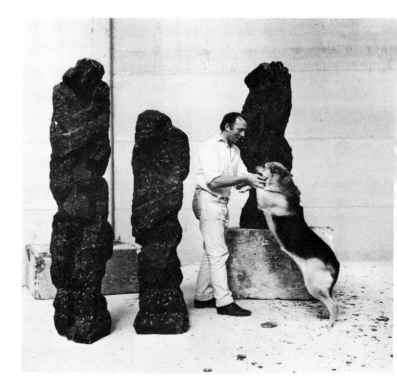

where the intellectual side is entirely forgotten. One especially that I've seen, a magnificent portrait, an inclined head—it's admirable."

——And in *The Prayer*, where the breakage of the stone produced a certain result— does that happen from time to time?

"That never happens. Not in any of the sculptures, because they always derive from a very precise theme, and from a precisely cut quadrangular block. And the sculpture has its own life from the outset. But, in that instance, it was true: the block itself split from one end to the other."

——But wouldn't it be possible for the stone to suggest something?

"Obviously that would be possible, but it doesn't happen at all in this series. If one sees a rock and says to oneself, 'I see a head,' then one can continue it, but that isn't at all the case."

In the weight and tension and specific humanity of Dodeigne's *personnages* one is likely to think of the Gothic vision, or rather of the Gothic spirit. And yet, as the stone-worker who concerns himself with articulating movement and light from an inert mass, Dodeigne sees the matter differently:

"What I find most beautiful, for the pleasure of the stone, the sculpture in stone, is the Greeks. The Parthenon is still a summit of sculpture in stone, with all its possibilities—its suppleness, its vibration of colors, of lights, and its depth."

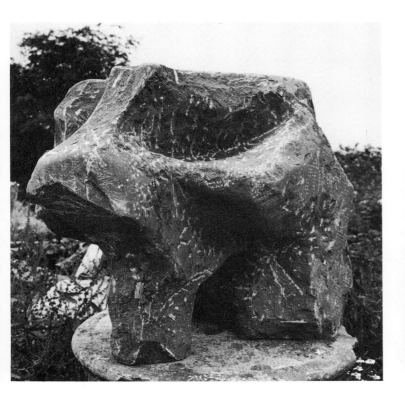

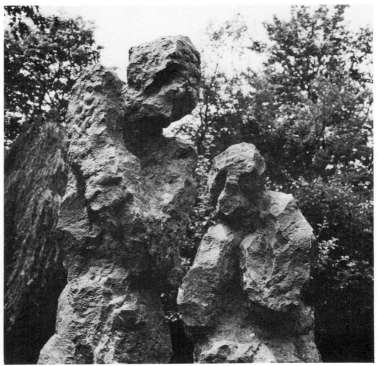

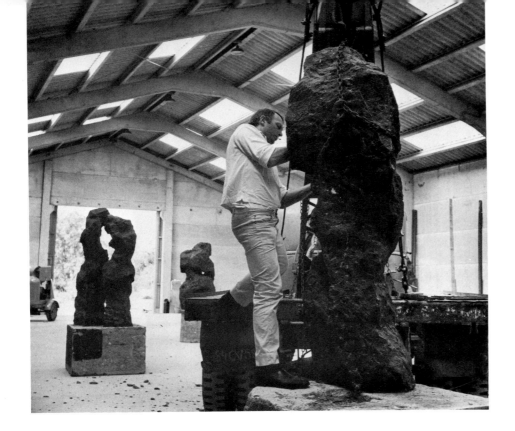

The Prayer is at the extreme right

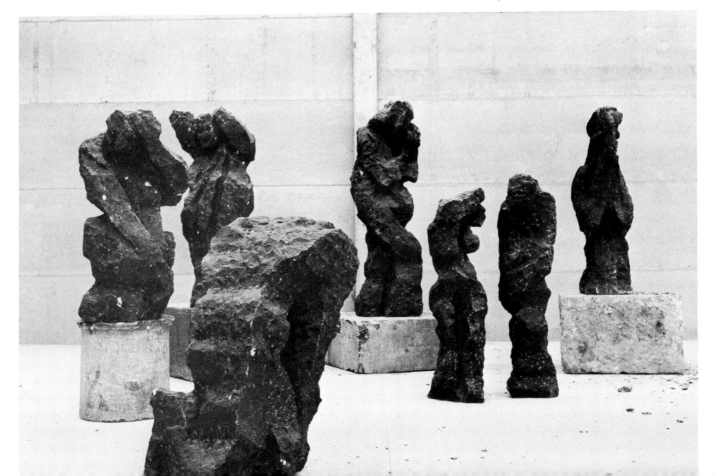

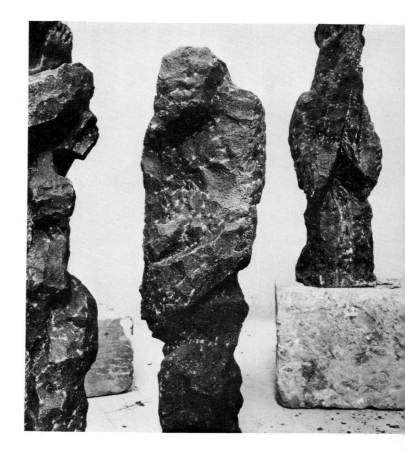

——And the Gothic?

"The Gothic, too, but in its expression, rather than in the quality of the sculpture. Yes, the Gothic— but I think of fewer examples than with the Greeks. Still, it makes no difference to me the moment it's a work of art—beyond any category."

Every sculptor deals with the enigma that is composed of permanence, at rest, unfugitive, and, on the other hand, of life, which is inevitably moving, transient, vulnerable. Perhaps Dodeigne has come especially close to the center of that equation. For him stone is a kindred element, a familiar and necessary substance, not simply a material or a medium. He is able to describe it alternately as his enemy and his love, and his expression comes of that combat and that intimacy. His way is precise, and yet, in tribute to the earth, greatly resigned.

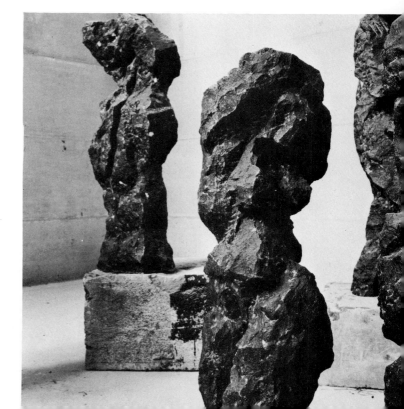

Roël d'Haese

SAID THE LATE MICHEL DE GHELDERODE, "*The world has need of fables.*" He also said—this author of *The Chronicles of Hell*—"*I discovered the world of shapes before discovering the world of ideas.*" And he observed: "*One has seen objects seeking to do one ill, to hurt one physically, and Hieronymus Bosch has depicted very well for us the inscrutable, redoubtable world of things. He shows you a knife, for example, an innocent and terrible knife, from which legs have suddenly sprung and which comes toward you hypocritically. Today it would be called radio-controlled.*"

All of which he said in Ostend on the Flemish coast, next to Roël d'Haese's own Nieuport-Bains. There is a great rapport between the thought, and more particularly the faith, of these two Belgians: There can be no fables without an enduring innocence, no meaningful shapes without awareness, no recourse to the "redoubtable world of things" without a certain courage and a certain resignation. Both men have been obsessed with the grotesque, both devoted to beauty, and the work of both is full of the unsettling quality, the potentially fatal dark shape of the secret life of things.

Imagine Roël d'Haese in his green shirt and blue trousers and polka-dot bow tie and hound's-tooth tweed jacket, studying a Flemish-language daily amid the deceiving tranquillity of his living room. Joseph the cat pads the wooden corridors of the seaside house, and, beyond the glass, the North Sea moves in quietly. Through an open window, the ocean wind blows a gauze curtain into an empty room and troubles the magazine pictures on the wall—photographs of Hugh Gaitskell, Bardot, Picasso, a rioting mob in India, *Playboy* pinups, the eye of a seagull. The house—wax studio on top, welding studio at the bottom—is a kind of geometric wooden cave, a shell. So is Roël d'Haese's Russian car, his Volga. "With a wife and three children, on these roads, I thought I'd best get a tank."

But that is, for the most part, the outside of things. The inside has to be approached obliquely. Call it a frank and open complexity. D'Haese would be the last to want to explain

completely, to himself or to anyone. His face explains a good deal, though, by analogy. One sees a great candor, and perhaps the direct astonishment of one who has just had a sudden fright; physically, a typical Flemish bulkiness; in the eyes, a quality of perception. And in each turn of the head, with each shift of perspective or angle, the visage changes considerably—just as the sculpture does.

D'Haese, his three children, and his wife Chris Yperman, a noted Flemish writer, came to Nieuport for a three-day vacation and stayed for good. From July to September he has to put up with the tourists who bounce rubber balls against the house. Striped and plaid parasols, bright windbreaks, complicate the vast regularity of the beach and its shifting sand patterns. But toward evening the fog—Flemish, English, northern—moves in steadily until the insistent clang of the buoys and an occasional foghorn are all that separate sea and sky and coast. The ocean-side houses, named with a desultory romanticism—Sympathie, les Mouettes, Mon Caprice, les Vagues—become shadows. The hard edge of circumstance mists over, and the imagination takes itself off at will.

"There is so much evil in the world, and so much evil in ourselves, above all in ourselves."

——And yet, art is almost automatically a purge of evil.

"That is possible. I don't know. But it's the thing toward which I have always been most drawn in art. It's not the pleasant side, though it's not that I don't like to live. But perhaps one has to do that in order to live,

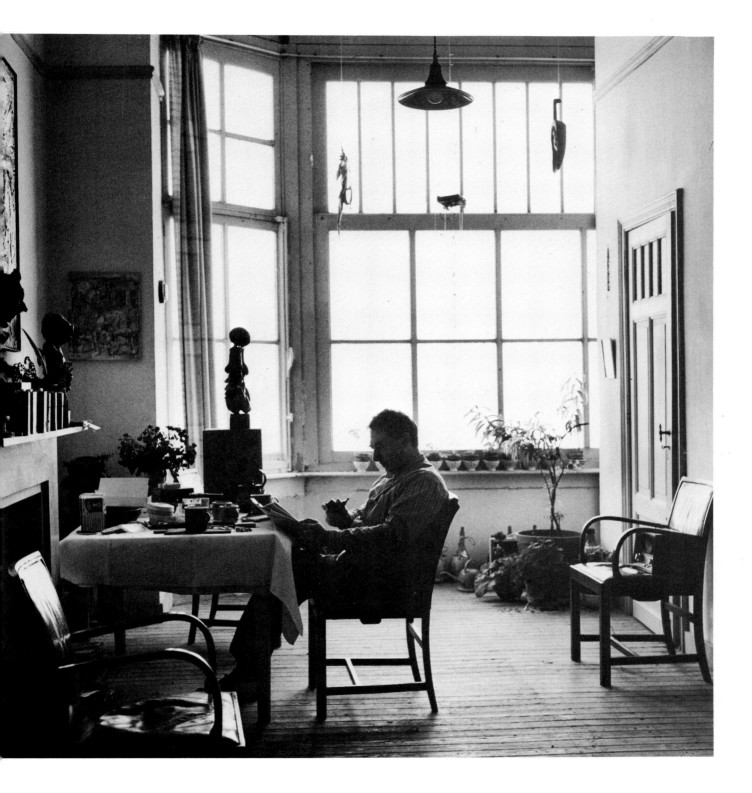

purge oneself of it in one way or another, of what keeps returning in the course of what one says."

——And then, in fact, you are in the tradition of Bosch.

"That's what the others say. I don't say it. I like Bosch enormously, but I understand nothing. I am very fascinated by Bosch, but for me it's an enigma—which is perhaps what fascinates me most."

——Well, there exists a debate over *The Garden of Earthly Delights.* Did Bosch intend a censure or a celebration of the theme, for example?

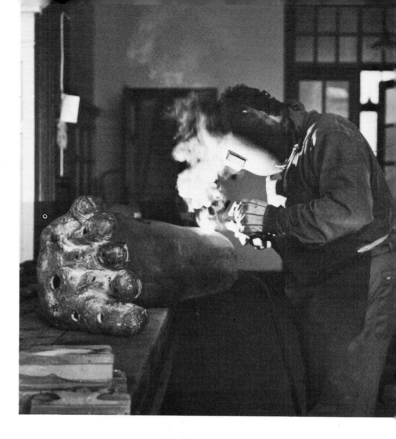

"I know. There are a good many very different interpretations. I have none. It fascinates me, but— Well, there is a Bosch at Bruges; sometimes I go to Bruges just to see it. It fascinates me. I have it in books, too, but the books don't give me the contact, I find. *The Prodigal Son* has long fascinated me, and that's simpler, if you will, since there is no aspect of torture, no deviltry. For me it's almost more Bosch than the others, than those with the devil and hell. In it the mystery is even greater."

And it was Michel de Ghelderode, down the coast at Ostend, who said: "*If I have a legend, I have had no part in it. It has been made for me. I have not contributed to it; but I shall not stoop to contradict it. . . .*" So

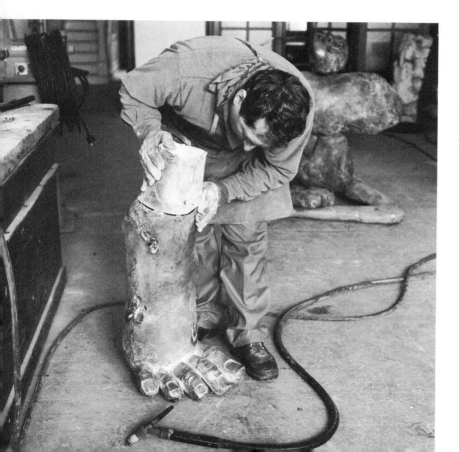

Bosch. So D'Haese. And yet, in each case, there is a certain cosmology, and one tries to penetrate it. D'Haese's earliest works were rather more abstract in the formal sense, leaner, certainly less baroque, far less drawn toward the specifically human statement. And they were also—to use an abused word— less synthetically *constructed*. Some of them were in wood, which D'Haese no longer uses.

"It interests me less. I find metal to be closest to my nature. One can do such different things, so very different— One can assemble— With wood it's not possible. For purely technical reasons—because it cannot be soldered. Perhaps if one could solder wood like metal. . . ."

The later works follow a more oblique and more complicated procedure. Often a given sculpture that seems quite complete in its form, its incremented movement, turns out to be the synthesis of two or more entirely separate parts—separate, at least, in time, perhaps by as much as several years. And D'Haese has become accustomed to this diverse pattern.

He was at work on a great foot, in metal, an immense, bloated monster of a foot which he pounded into precise shape and put to the fierce tongue of the welding torch. He was adding a length of leg to make it more vertical and so improve its proportions. But he was not sure whether the foot would remain a foot or would become part

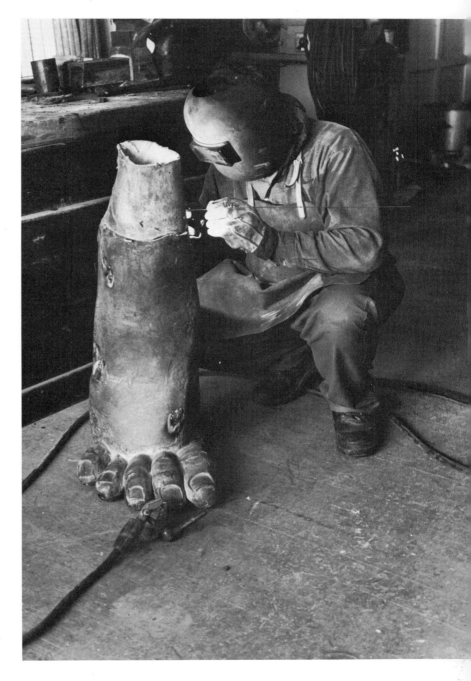

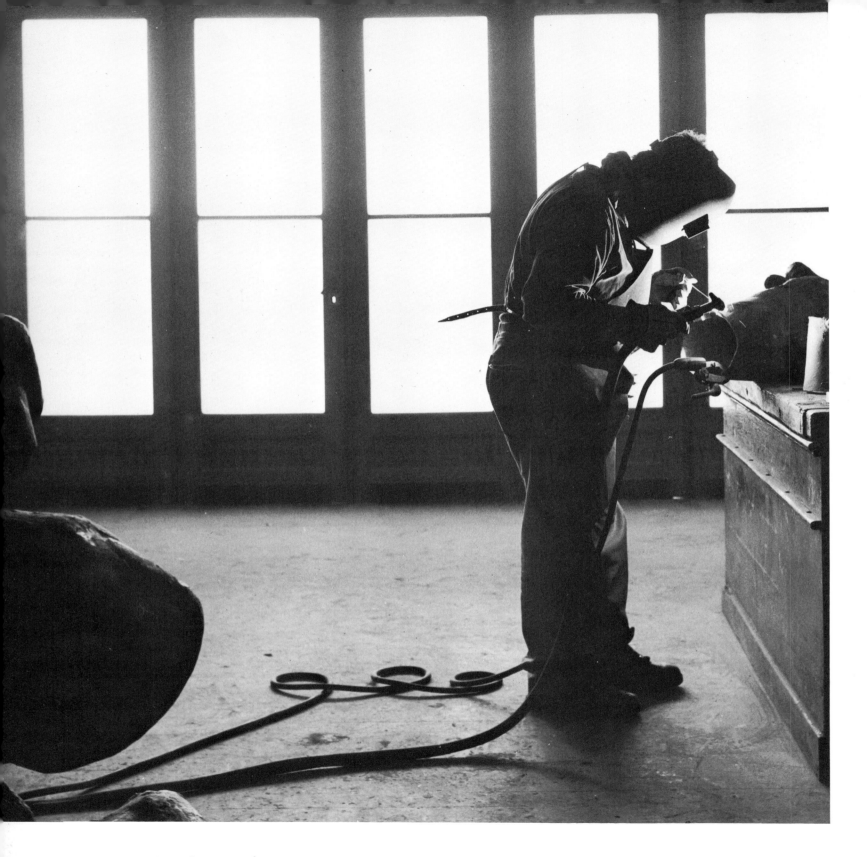

104 / ROEL D'HAESE

of a greatly more extended unit, perhaps a whole figure. The process is extraordinary, given that most sculptors would never dream of such a method. Most would begin with some conception of the whole and then work down from the larger conception to the detail. To complete an entity and then imagine its inclusion in something bigger is almost unheard of, but strangely appropriate to D'Haese's pattern. It is surely a very innocent procedure, and yet part of the species of innocence that creates fable. It implies a great capacity for freedom, for belief, and also a departure from egotism. It is in some ways almost childlike, and so begins to reconcile the man's stated indifference to plasticity with the great plasticity of his work. For a child who draws or models tries to 'make something'—a man, a house, whatever. He is not interested in plasticity, but his contact with plasticity is in fact total. His color is likely to *be* rather than to describe, though he is not thinking in such terms.

One might carry the analogy too far, of course, since Roël d'Haese is not a child. It would also be a mistake to equate this synthetic method with the idea of accepting accidents or of working at haphazard. No, it is something else entirely. I asked about the remarkable hand in bronze, with its tense, almost threatening stance. It has the quality of an armored sea creature out of the evolutionary past, treading the ocean floor, and I asked if it had been intended in that way.

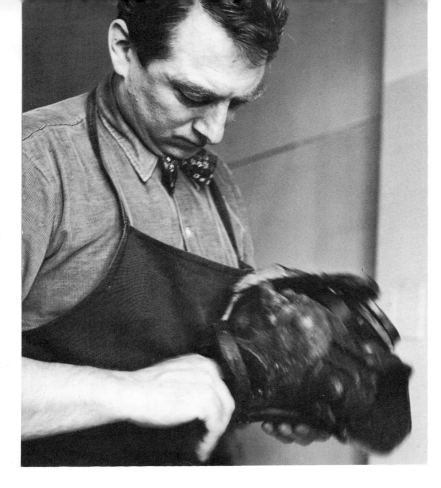

that escapes you. You have something in tow and suddenly it takes off. Well, it does what it wants to do."

Which is, for that matter, the very way of biological evolution, precisely the road from the sea creature to the hand that draws the gun.

Upstairs, in what might be called the wax studio—another bare room, a shell, that had been turned into a littered battlefield—D'Haese went to work on his *Lieutenant*, whose parts lay side by side amid assorted heads and extremities. The wax is particularly unsculptural and discouraging in the raw state, rather like a heavy, limp sheet of linoleum. But under D'Haese's wax iron it becomes something very different, the crucial step toward the lost-wax bronze which he will cast himself. The touch of the iron to wax is so different from the confrontation of torch and metal: a soundless contact, a plume of white smoke, the wax turning before the heat.

——The wax is very soft, almost the opposite of bronze.

"Yes, but you get so used to thinking in bronze. When you work in wax you have to establish the thickness, too, for the metal. It can't be too thick or it wouldn't be possible to make. It can't be too thin either. . . . It's black for a technical reason: because the wax is mixed with grease and fat—the fat is black and dyes the wax black. I like the color. In black it becomes opaque, and it's easier to think of it as metal than if it were transparent."

"No. I conceived it— Well, you know, when I made the horse and rider, *The Song of Evil*, I originally thought of a killer, a cowboy killer. And that's the hand that draws the pistol, and it's for that reason that it became so animal. Once I had made the hand as a step toward making the personage the hand escaped me, and up to the present I haven't known what to do with it. It's so much itself. I haven't been able to use it, to reintegrate it into something."

——Now that you tell me, I see it. But I hadn't guessed. It's very expressive but I hadn't guessed the connection.

"It happens that you sometimes do a thing

The Lieutenant was coming along strongly, very crisp, almost linear. Its staring helmet-head peered along the floor, tangent to its abdomen which wore a *sacré coeur* beneath its medals. I asked about the theme of *The Lieutenant*.

"It's because this region is a vast cemetery. In Nieuport, during the First World War, there was fighting here for four years. There was nothing left here. On the spot where this house stands there was nothing. For four years the artillery pounded away, and one knows very well that in the military cemetery—they have them everywhere in this area —there are Germans, Belgians, French, English. And one knows that the people in the cemeteries died in the hospitals or fell swiftly, a bullet through the head, or something like that. But others just disappeared. The enormous number of dead here—I can't rid myself of this idea, that this is a real cemetery——"

——But as to the sculpture itself——

"At a given moment, suddenly, I *feel* just what I am about. I had thought of doing something else, but I never began. It's very bizarre. I first made the shoes. . . . And I put them there. And I knew it was *this* that I was in the process of doing."

——The shoes actually came before the idea itself. That is, the specific idea, *The Lieutenant*.

"Yes. There was no idea, at heart. But I understand this story because it keeps happening to me. Sometimes I make drawings also. Because when I make drawings I don't

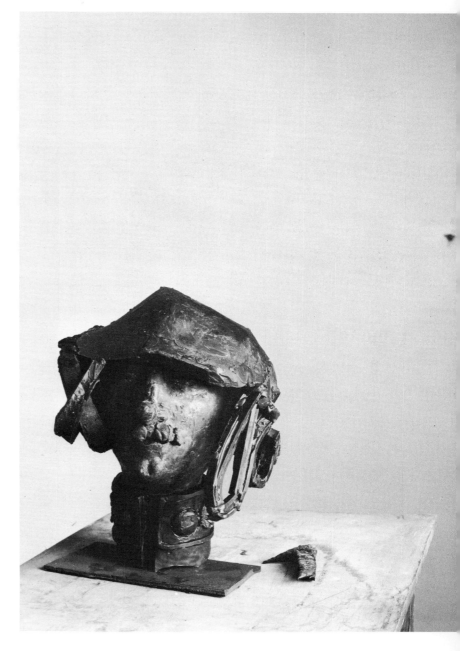

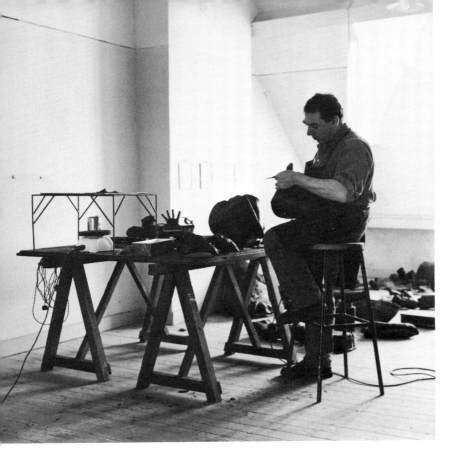

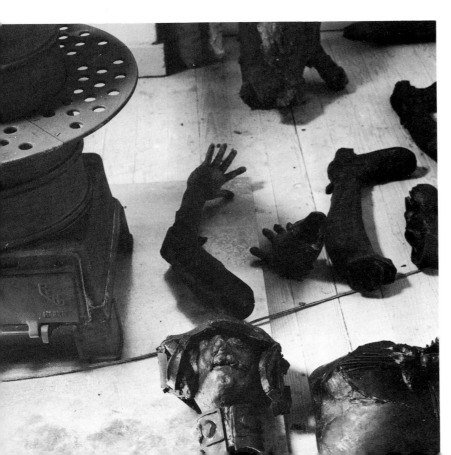

think of it as drawing this or that. It's when I'm involved that, all at once, I feel what is coming about, although there was no very precise idea at the start. And in this case I had no idea. I made the shoes."

——Which is to say that when the idea came it corresponded to a tendency that had been there before. It all came together.

"It all came together. Which is the most pleasant moment: when it isn't necessary to search, when it comes of itself, and when it goes very quickly."

——And can one say that there is a religious side? The *sacré coeur*——

"There is perhaps a religious side, although I am not certain about being a believer. But sculpture is a religious art. It's a scarcely intelligent art, I find. Anyway, sculptors in general are not intelligent. As for me, what I lack most is lucidity. I think that if I were more lucid I would never arrive at doing sculpture. I would do something else."

——But when you speak of intelligence, perhaps you mean rather an analytical quality.

"The analytical quality plays a part in intelligence."

——Yes, but sculpture itself is certainly an intelligence, perhaps a greater intelligence than a purely analytical lucidity.

"Yes, that is possible. But it's as though one were very rich and didn't know it, and so lived in a hut—and very happily."

And so the fact and the idea meet from various points, not a sequence in which one element precipitates the next directly, but rather a magnetic field in which susceptible particles are trapped, directed, fashioned.

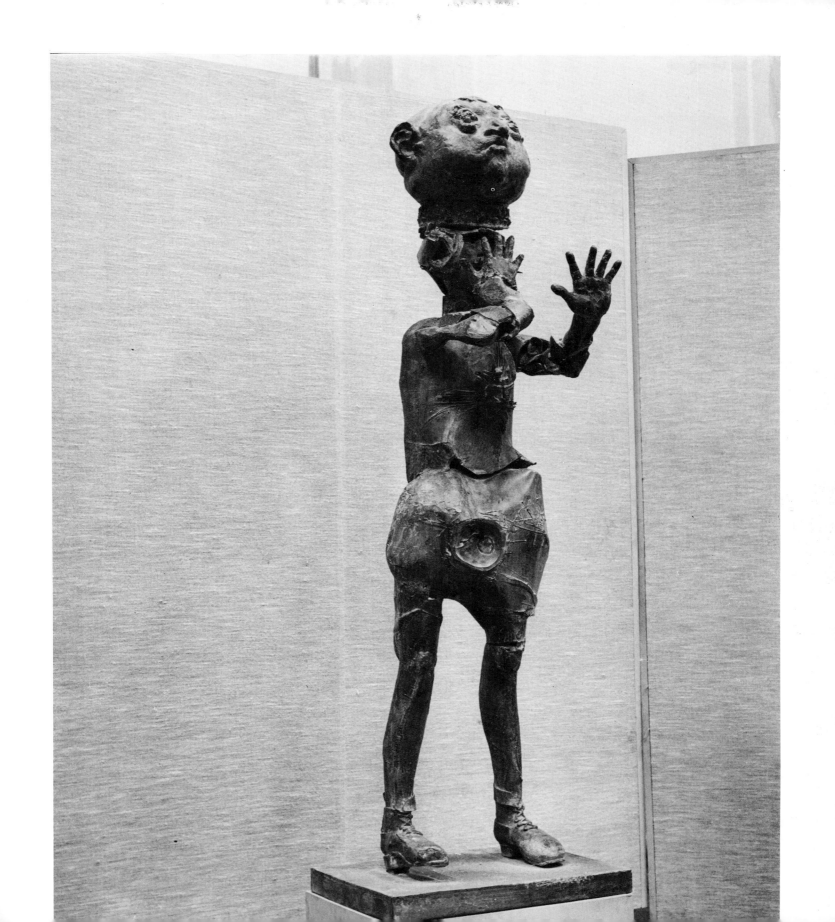

And there is nothing in the sculpture, physically, to contradict this. The synthetic procedure often yields a highly baroque form and an incremented effect, with frequent surprises in balance.

"That one was many years in coming. It's made up of four different pieces that I put together. It took a good four years. The head I put on top only a month or two ago. It was the other way around—what is now the bottom was then the head, the fat part. The present head didn't exist. There was no base either. Before, there was only the middle part, which was a small animal walking with two small paws in front and two big paws at the back—a little like a grasshopper—and then I added that, the head. It got turned about—like that."

——And yet you draw often.

"I do make drawings, but I never draw sculptures. I make compositions which have nothing to do with the sculptures directly. You can see, certainly, that it's me. These are drawings with an enormous number of people, architecture, landscapes, atmosphere, but never with any direct relationship to the sculpture."

——The sculpture is born with the material.

"Perhaps. And yet, sculpture in general doesn't interest me much. I always regret that I am not a painter, because I like painting much more than sculpture. When I go to a museum I always go to see a painting. It's very rare that I go to see a sculpture in a museum. . . . What interests me most is the painting from this area—I'm thinking of

Bosch, of Brueghel—and, in addition, Goya, and so on. What is being done now in painting interests me very little. Perhaps still the Surrealists, still a bit, but they are so disappointing from the point of view of expression—even though I find Magritte a very great painter. . . . Picasso? I find him a better sculptor than painter."

——Which comes back to Bosch and his expression. You have a religious quality, but do not profess to be a believer. And you are fascinated by evil. And here is Bosch whose position touches upon the same points, and is impossible to decipher save in its richness.

"I don't know how to decipher my position either. In literature, when I see what I read and what I like to read, I see that it has no connection with my aspirations. When I read Kerouac, what I like in Kerouac are his characters. Earlier, there was a time when I drank a lot, and I hung out in seedy cafés, which I found fascinating to watch but which had nothing to do with my aims. I think that what I like in Kerouac are his characters—which has nothing to do with the literary quality of his work."

——And yet it is a glimpse, an opening toward other perspectives. What especially interests you in literature apart from Kerouac?

"So many things. What I love is to go into a bookstore and browse through the books—above all in English, books I am not acquainted with and know nothing about—and leaf through. . . . I've read like that. I no longer remember who wrote *The Memoirs of a Sword Swallower*. That fascinated me."

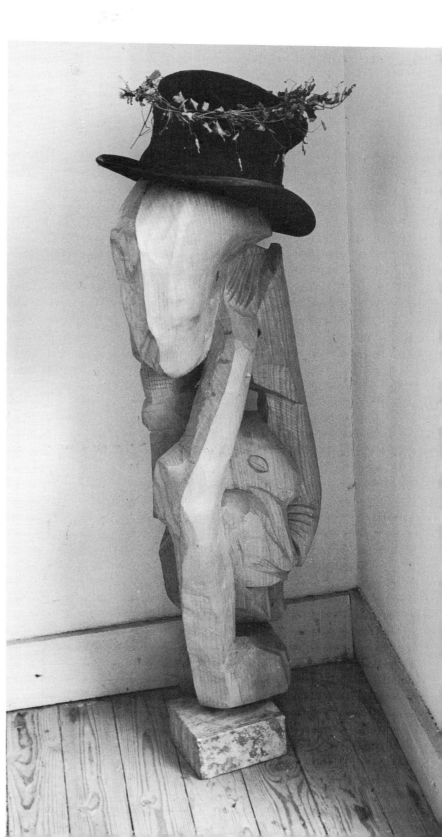

either Diderot or Voltaire, someone from that epoch. I began by looking for the head, and I was very impressed by Diderot's head. And then I made a nude figure on one foot . . . obviously there is no connection—it's very disrespectful."

——And you do many portraits.

"I have done. Yes, several. But only during the last year or two. I have always had a desire to do it, but earlier I hadn't the courage to attack it."

——And that wide head, almost flat—what is the origin of that?

"You know, I detest the swelled-head type. In this country they call it *une grosse tête*, meaning someone who takes himself to be better than the others. A very swelled head is always, for me, a sign of viciousness. I made two swelled heads like that."

——In general, you read contemporaries, or——

"Contemporaries, yes. Yes, which is very bizarre, because in painting I don't at all like what's being done now. Perhaps it's out of ignorance. I haven't studied. In fact, I went to school very little. I read on my own. If I read Goethe, for example, I find the language very beautiful, but it doesn't interest me at all. I sense the richness, the beauty of the language, but it doesn't interest me."

——And so, when you began your portrait of Goethe, it was because of his face.

"Yes, because of his head."

——And your Diderot?

"A friend spoke to me about Diderot. This friend is a writer, and he said, 'I would like you to make me something for an alcove'—he owns a farm, and there is always a *bon Dieu* in the alcove. He wanted to put in instead

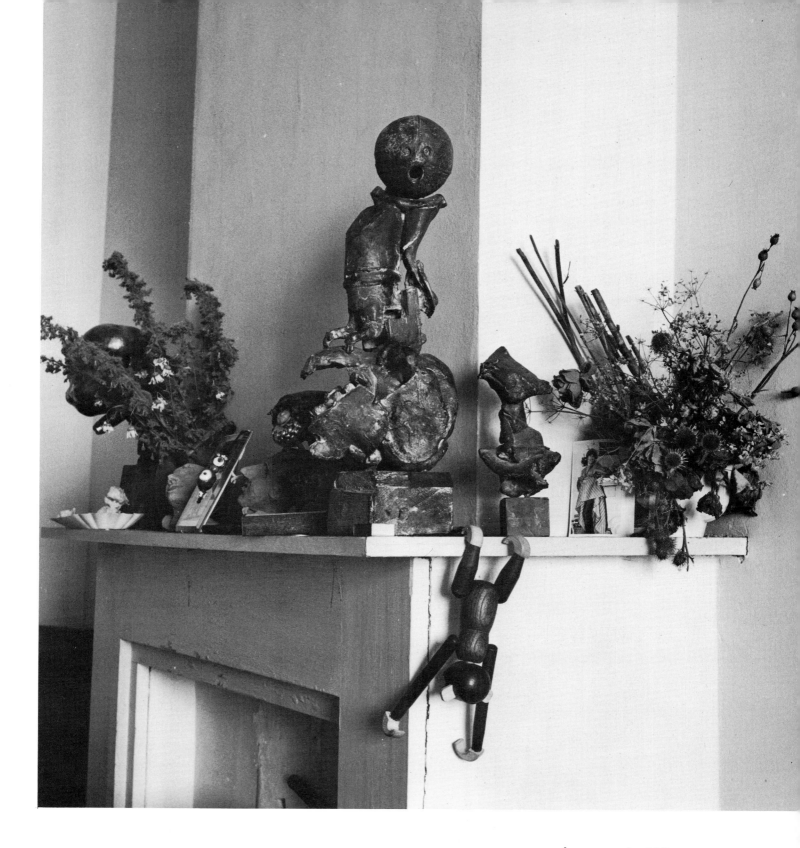

During the past fifteen years, there has been a counterpoint of tendencies in D'Haese's work: a formal if baroque structure, an urge to satire, and a very biological, often sexual, frame of reference. And D'Haese has accepted each of these in its demand for fulfillment. Call it, perhaps, a passionate acquiescence, certainly an absence of dissimulation. Which is the more difficult course for the paradoxical reason that ever since Paul Klee, the preconscious and the subconscious and child consciousness have been canonized in art, and a good deal has been done in that direction, including a good deal of abuse. But in D'Haese's case the impulse is authentic—that is, original, in the purest sense of the word. And it has not been intellectualized.

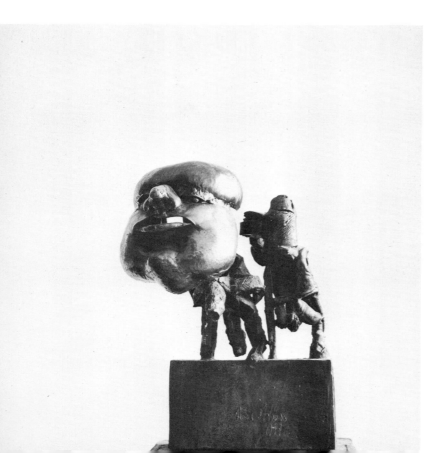

"I don't think about painting, nor about sculpture when I do a work. The formal side of things doesn't interest me. There are people who always talk to you about sculpture. For me, that doesn't exist. You make something that is painting. You make something and find that it is, in fact, sculpture. But you cannot make sculpture. You make a work, you say something, and that is sculpture. But you can't make sculpture, you can't make literature, that would be no good at all. . . .

"One has this gift, if you like. This Christ, for example, was done by a peasant. I know it very well. I didn't know the fellow, but I knew people who knew him, and this peasant had undeniable gifts. From the outset, you have it or you don't. You can't sing if

Promenade dominicale

you don't have a voice, and you can't sculpt when you don't have certain aptitudes in that direction. I think it's not something you have to try to cultivate, to arrive at something within. It must be there at the outset. If not, it's no use to try to begin."

As to this conflict between the plastic impulse and the psychological or thematic intent, D'Haese said, "I think all that very much blends. I would almost say that the one doesn't impede the other, at least not in my case. There are people who make sculpture, and who end up being interested exclusively in a play of volumes—which can happen. But I am always involved with many other concerns, which push things along in my work—I would almost say by amusing me, by captivating me, by remaining alive for me during my work. I cannot conceive of making a sculpture, a painting, in which the idea would weigh so heavily, so primarily, as almost to dissuade one from making it. With Magritte, for example, there are days when he must get sick of doing that. Which does not destroy the fact that when the thing is accomplished it is fascinating. But I think for him—and obviously I am sticking my neck out, because I really know nothing about it—but I believe there are moments when he must

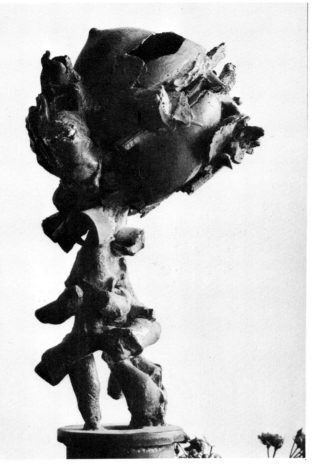

The Little Blue Man

hand, which is good to make and to see coming along, and at the same time one hopes that it will suggest others, here, and there. It's in playing these two things——"

——Well, you are now, say, making a leg, a foot, but you are not certain to stop there. It may even end up becoming part of an entire figure——

"There are endless possibilities. When you leave the house, you may very well be going to have a drink, or to break a leg going downstairs. You can meet a friend by chance, or simply walk in the rain and maybe catch a cold, or maybe no cold at all and be very happy. In the long run there are endless imaginable possibilities. And with certain sculptures, it's almost with regret that I go in one direction. Because certain sculptures are capable of going anywhere, and the one path kills all the others."

——And yet, on the other hand, one is perhaps tempted in art to evade the possibilities that weigh in life. Have a drink or break a leg. In art, one *can* choose.

"A little. So little. There are things that do not leave you a choice. There are things that impose themselves, and then you must proceed, using what imposes itself."

The titles also follow a synthetic route, at least very often, according to certain impositions, sometimes direct, sometimes tangential. *The Little Blue Man*, not inappropriate to its form, its presence or bearing, happened because of a song sung by Petula Clark. D'Haese heard it repeated incessantly while working on the sculpture, and the title began to seem quite integral. Another title, *Promenade dominicale*, is actually a relict. Before

get good and sick of painting a window that slavishly, for example, with a landscape behind it that has nothing to do with what you usually see. He does a species of collage. For me, that would be absolutely impossible. I have to amuse myself— well, that's not the right word. But I only experience a great pleasure when it all remains alive. And perhaps it's that there are these two sides: at the same time, a certain pleasure in the form at

the addition of a swelled head that completely altered the personality and proportion and even theme of the work, it had to do with figures walking.

I asked about *The Song of Evil*, which is D'Haese's largest single piece, a mounted figure of evil, singing or laughing. (It was not then at the studio.)

"There I first of all wanted to do a killer, a man on horseback. Because formerly men took to horses in order to be over others, to

be strong, and also to impose themselves. The knights, the bandits, and the saints, everybody mounted. That was the point of departure, this history of evil. I wanted to do a cowboy at that point, and then they assassinated Kennedy. I even almost made a head of Oswald. But then— I wanted to forget the precise fact of the murder of Kennedy, and then I didn't want the title to refer to it directly, because I didn't want people to say, 'He's making money with the death of this man, pretending he is going to touch people,' and so forth. Well, I wanted to do something much more general, and not cast a stone at the one who did that, but to cast a stone at everybody, and at myself. I think that one is not so far from being as bad as that."

A harsh judgment. Surely a pitiless self-judgment. Yet perhaps quite just in the broad, objective view of man. In terms of a self-judgment, one thinks again of Ghelderode and his voluntary exile bounded by

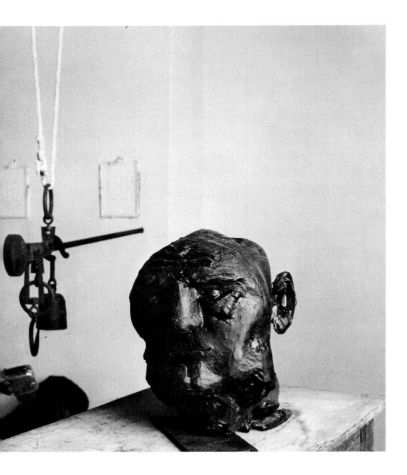

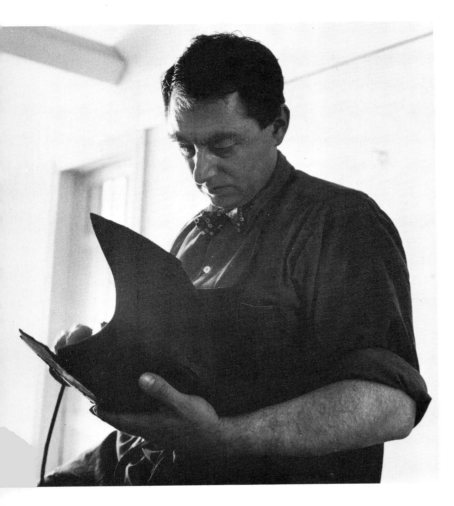

numerous worlds. And one thinks of Bosch and his sonorous ambiguities: self-assertion and self-accusation.

To complicate matters, the prodigal son is Hogarth's as well as Bosch's, Gide's as well as the Bible's, self-constructing as well as self-destroying, tied up, even, with a central surge of hope and regeneration.

D'Haese claims that he lacks an analytical capacity, that if he had one he would not sculpt. But an analytical solution would be partial. It always is. Insist upon a clear answer, a reasonable answer, here and now, and you get only a very fragmentary answer. Whereas browsing through strange books, contemplating possible forms, yielding to plausible harmonies, at least invites a whole answer, and prepares a susceptibility to its language.

Consider Ghelderode's conclusion. One might, perhaps, take it to be Roël d'Haese's conclusion as well: *"Am I lovely? And you? Men are not lovely, not often, and it's very well that they are not even more ugly; but I believe in* Man, *and I think that this can be felt in my work. I don't despair of him, and I find him very interesting, capable of everything—and of its opposite."*

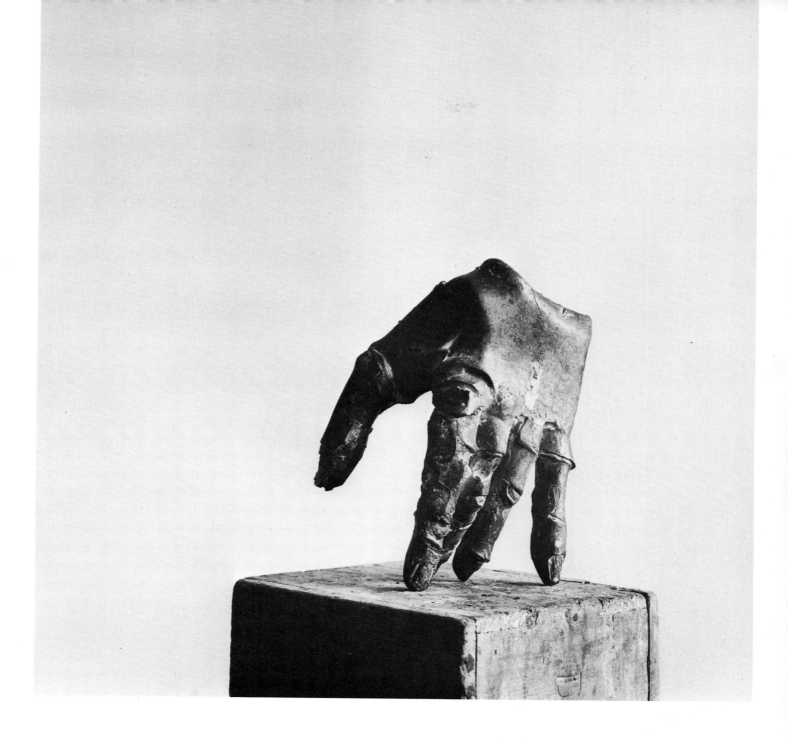

Jean Ipousteguy

JEAN IPOUSTEGUY WORKS in a spare, taut-muscled quarter of Paris, a world of work-men and forges and plaster and the ring of hammers. The narrow, well-scrubbed, peeling streets wind up and down steep slopes, and their names—like rue de l'Espoir and rue de la Providence — resist time and circumstance.

In fact, Ipousteguy's home and studio used to be a food-processing factory. The living quarters were the offices and the studio, whose ceiling is all skylight, was once the plant. Frequently, 'Ipous' works on a little square of roof that links the two, a crow's nest over the mansards, inaccessible except by ladder. Ipousteguy likes that. He used to be a sailor in the French Navy, and he finds ladders and catwalks perfectly congenial. *"Free man, you will always cherish the sea,"* said Baudelaire.

And, indeed, Jean Ipousteguy is a free man —given that no man is free save in his abiding consciousness of bondage, in his will to break away, and in his willingness to negotiate the painful labor of the great escape. He is a genial man, but in no way an extrovert. His magnified consciousness of the presence and weight and vulnerability of the self has much to do with the shape of his sculpture. Imagine a suit of armor that contains its own susceptible nervous system.

"I believe I feel things in form rather than in color. For example, I express myself better in line than in color— up to the present moment. That can change. I may suddenly set myself to painting if I feel I can find an outlet there, or feel I can fulfill myself better in color than in form.* But for the moment, I say what I want with sculpture; it seems to me that I best arrive at my thought with sculpture. When it doesn't work, that's because I can't go beyond a certain point."

——But fortunately it does work.

"Ah, well that depends."

Perhaps any man's rapport with his world and with the world that is himself can be

*The change did in fact take place, though to what extent remains to be seen. In the winter of 1966-67, with the studio cleared for a large exhibition, at the Galerie Claude Bernard in Paris, of work done during 1964-66, Ipousteguy did temporarily turn to painting.

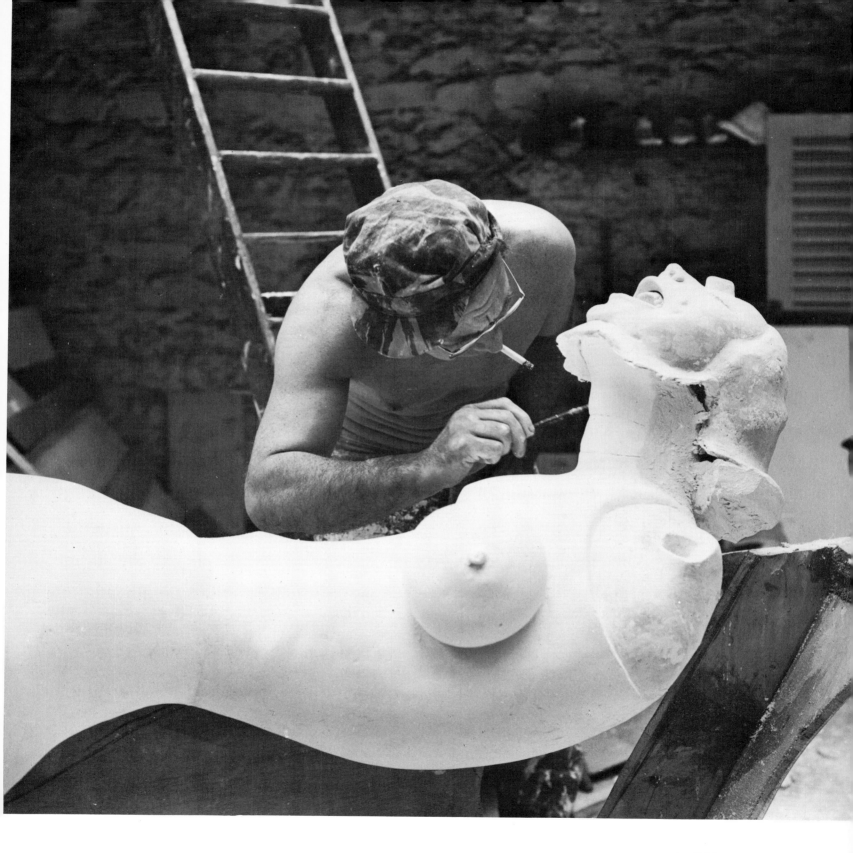

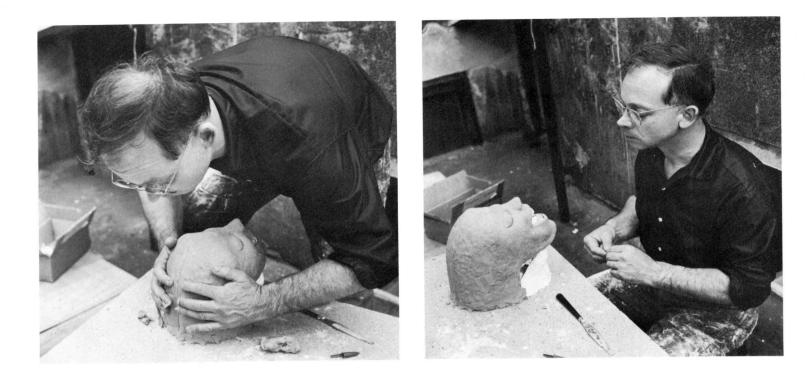

spoken in terms of distances and proximities. With distance you have perspective, the shape of things, a certain sense of the relative proportion of things. You also have the benefits of detachment, enlarged possibility, the incentive of an undefined promise. The distant hills are revealed, yet disguised by the earth's atmosphere. The suggestion is rather more real than the fact. Yet a man lives also — in fact primarily — in a state of proximity to world and self: the present moment, the present place, the immediate fact. And, ironically, progress has made this the more so in creating an era of supersophisticated and superspecific communication, with photography, television, and the like.

The medieval world was dominated by a psychological reality in which distance was preeminent. The Renaissance managed a unique balance of distance and proximity through a passionate and successful devotion to form. The Romantics erected their own, rather more fragile myths. For us the question remains open, subject to conscience and consciousness, ingenuity and moral stamina.

Jean Ipousteguy's sculpture assumes a special character in relation to this enigma. It has its place in respect to objective reality and myth, to classicism and primitivism, to the external and the internal. This is a sculpture of *presences*, which may be an ambiguous term but which seems appropriate to Ipousteguy's response to outer shape, inner reality. Can one say that for him reality is

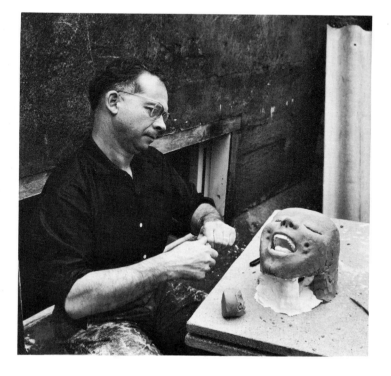

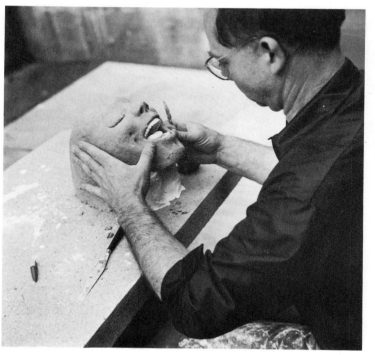

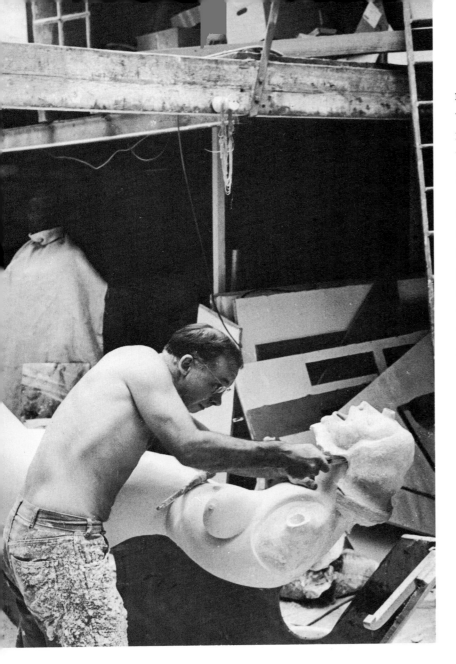

masked by the forms it assumes; that he is willing to draw upon the poetry of those masks; that he is as willing to accept the weight and texture of their presence as to plumb their 'meaning'?

One has to be careful about drawing lines of cause and effect. Ultimately, no connection need be sought beyond the plastic, formal fact of the work itself. But often, in juxtaposing one phenomenon and another, a certain rapport becomes evident, like the attraction between two celestial masses, the tension that influences the trajectory and atmosphere of each. Here, on the one hand, is the personal element, the vulnerability of the self, the impulse to bind and fortify; on the other hand, the specifically formal impulse, relatively detached, susceptible to magic, gratuitous. A perfect balance between these two would automatically suggest something in the way of classicism.

Like Moore and Chillida, but in still another way, Ipousteguy concerns himself with the coexistence of internal and external form. I mentioned the suggestion made to me by Reg Butler that Moore's preoccupation with the idea may have something to do with the fact that his father was a miner and had gone down each day into the pits. Ipousteguy said: "Yes, but I think it's not because his father was a miner but, above all, because his mother carried him, which goes back to his prenatal existence. He must have been happy at that moment, a kind of lost world— Yes, and then every man is made to fit himself inside something— his structure."

The last phrase is particularly striking—the

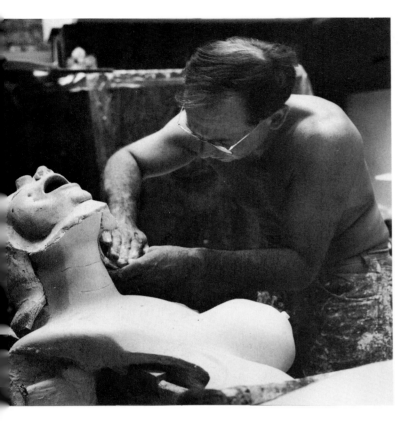

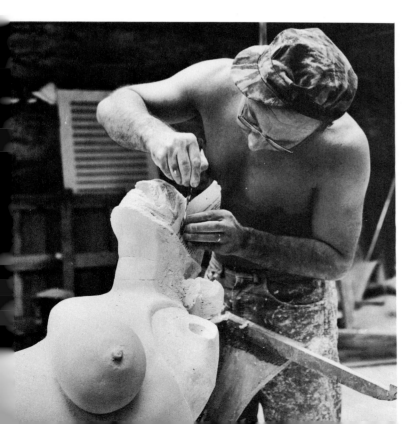

implied distinction between the self and the structure that houses it—and quite typical of Ipousteguy. The shell houses the tortoise and protects the tortoise, but the shell also *is* the tortoise, and impedes the tortoise. Ipousteguy's sculpture is his expression, the extension of himself, but it also shapes his thought and confirms his self. One feels a biological-metaphysical dialogue that could not possibly be as vivid if his sculptural statements were more nonobjective (as in part they used to be. And that in itself testifies to his evolving power as a sculptor.)

I found him at work on two major projects, one in an advanced state, the other at a preliminary stage. The first is the great *Femme au Bain*, the other a standing male figure passing through a wall, which Ipousteguy later entitled *Le Sas* ("The Lock," in the sense of the decompression chamber used by an astronaut as he passes to or from outer space). The woman in the bath is a single entity composed of meshed elements, the ambitious projection of Ipousteguy as sculptor and formalist; *Le Sas*—which then existed only in drawings and as an incomplete bronze maquette—is conceived of as a complex of Ipousteguy as sculptor and as maker of fantastic objects. Both articulate the metaphysical aspect, but the second phrases its message in a specifically ambiguous and perhaps ultimately more fragile form. The bather explicates; the standing figure implicates through a meeting of various objects held in concert. Fleshly yet spectral, he appears to melt into a chamber which Ipousteguy intends to populate with fantastic and science-

fiction constructions done on an entirely independent basis, and some of which have figured in films. A producer saw them at the studio, suggested a film idea, and Ipousteguy did the scenario himself. One film, featuring the head immersed in a tank, was made through an endoscope, the tubular magnifying instrument used by doctors to photograph the interior of the stomach.

——But do you conceive of a connection between these objects and the sculpture—the science fiction and the figures—or are they entirely separate?

"No, they are the same. It's just about the same universe, as I see it: there is an exchange of forms, there are confrontations of forms. One is perhaps lighter, more of a

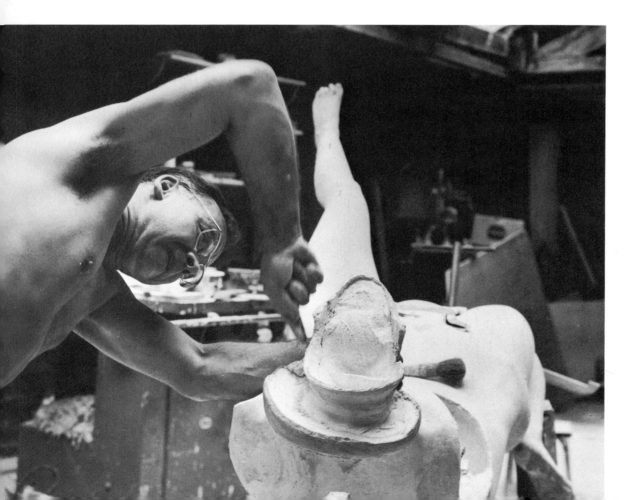

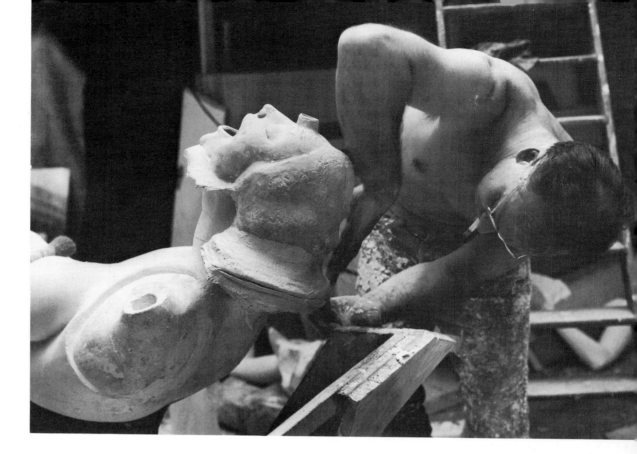

game, less grave than the sculpture perhaps — But I don't think one can leave one's temperament whatever one does."

The rapport is difficult to pinpoint, but a real connection may reside in Ipousteguy's strong sense of organic shape, of structural dynamics, of skeletal power. Plastically, his is very much a post-and-lintel, ball-and-socket, gear-to-gear temperament. We spoke about one of several staring heads done in cast iron, a skull constructed of a number of units juxtaposed and locked. Ipousteguy later 'boxed' the skull into a black framework so that it stared out of an oval aperture, giving the illusion that it was being held—a half-revealing, half-concealing mask—by its own

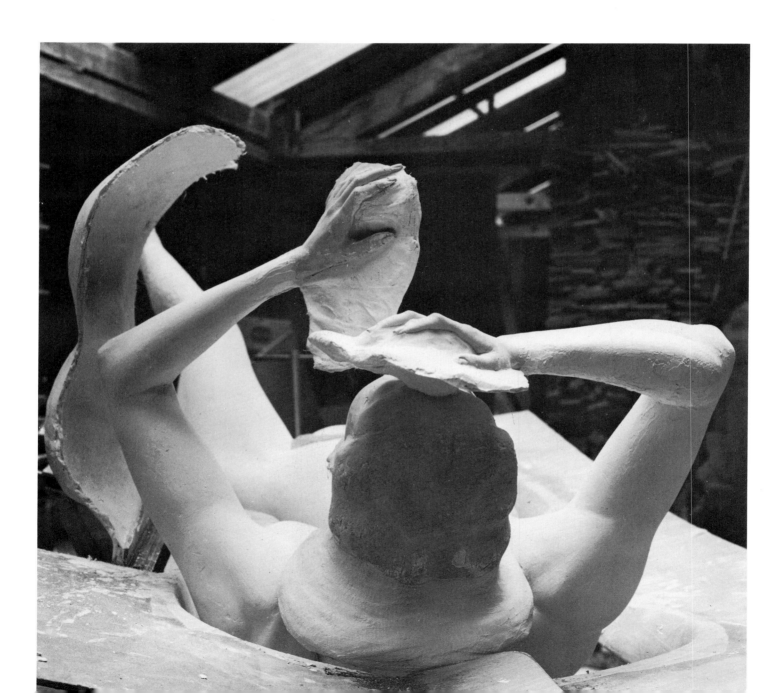

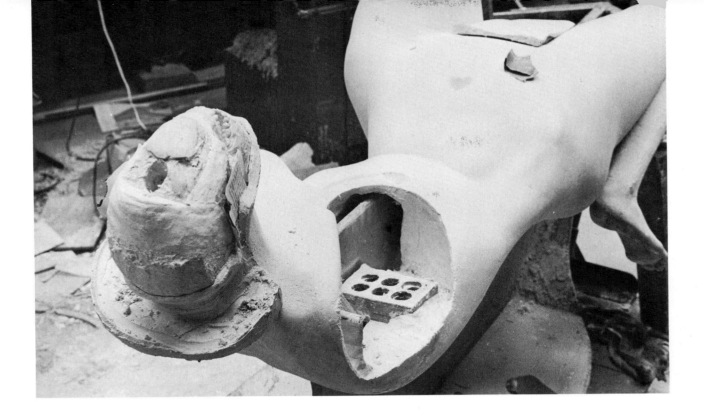

hand. He told me that this was a death's-head and I remarked that he seemed to be fascinated by the theme of death.

"Yes, all Latins are. I think it obsesses everyone. Death, woman, man, hunger——"

——But also from an organic point of view——

"Yes, it's bone, it's the fossil of man. Yes, there are many traces of death, of bone, of the skeleton."

——And do you think that, perhaps, some quality of death exists even in the bather?

"Yes, I certainly feel there are disquieting aspects——"

——Perhaps not so much in the torso, but the head and the legs and the arms give an impression of the grotesque.

"Yes. The disquietude stems from the way in which I make my figures gesticulate. I rather make them dance, I inscribe them in air. And a disquietude arises from that—my own disquietude, surely."

——Almost a species of Surrealism—without attaching itself to Surrealist formulations, to the formulations of the movement.

"Yes, but everything is surrealism. If one were to make molds of realities themselves, that would still be surrealistic. But it seems bizarre that you haven't asked me one question: Why are the sculptures capable of being disassembled? Why are my sculptures made in several parts? Doesn't that strike you? It corresponds to a need I have to dissect things and to reconstitute them. I think my first

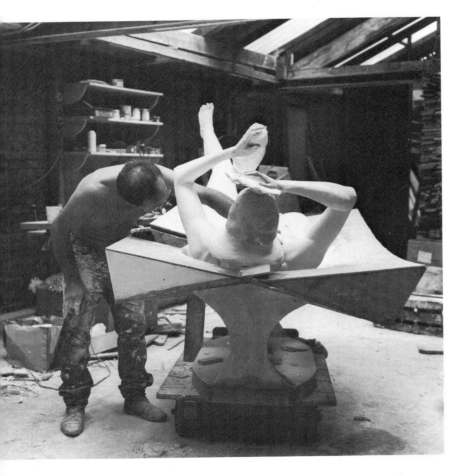

sculptures done in sections arose from the fact that I worked in a small studio but always had a taste for big things. Big things can't pass through a little door, so I had to dismantle them. It was simply a practical problem that had to be resolved in this way, and so I made dismountables about as early as 1950, when everyone else was making sculptures out of one solid block, all of a piece.

"But at the same time I found a sense of satisfaction. If you will, while walking in the street—if a parallel can be drawn between architecture and sculpture—you'll notice that what draws the houses, the architectural masses together, is in fact the streets where people walk, the spaces which are in fact great magnetic forces between the masses. I felt that the same is true in sculpture: there is this quality of magnetism. Space permits me to magnetize one form with another. This is the kind of 'love' that exists between two molecules, which tend to draw together though in fact they never actually arrive at intimate contact. There is always an 'interstellar' gap, even between the infinitesimally small. I found a sculptural—even more than sculptural, metaphysical—truth there which holds for the entire universe. Spaces have an enormous importance."

——And there the metaphysical and physical meet.

"There you are. Which is why my sculptures are so constructed. They never actually articulate—one scarcely feels the sense of articulation. And the joints are not made to fit precisely. On the contrary, there is a space, a fairly big space, between two masses— and perhaps certain spectators can feel that. The two forms must touch, but they never will touch. There will always be something that prevents them from joining, even though they have infinite reasons to want to join."

The translucent glass skylight of the studio, which diffuses the June sun's light and magnifies its heat, forced Ipousteguy to work naked to the waist. His pace is rapid, decisive, punctuated by still moments of reflection and calculation. Somehow the long, white, nude bather suggested the live immensity of a great vessel lying in port, tensed for movement in unconfined spaces; also, more immediately perhaps, a human at some point tangential to humanity—either beyond humanity or just short of it, as a patient, or a victim. It was wholly at the disposition of this diminutive, muscular creature in a peaked cap, darting about, covered in plaster, bearing pertinent ritual instruments—the trowel, the chisel— probing into a cavity between neck and

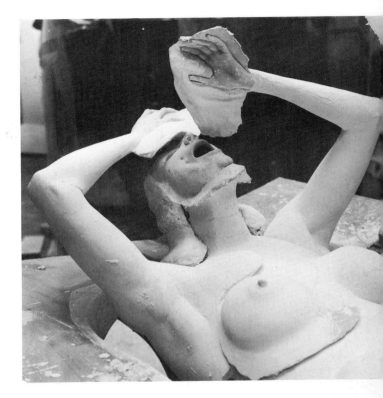

shoulder, between torso and thigh, jabbing, cleansing, smoothing, paring. In fact, a disturbing spectacle in many ways, the effect of it accentuated in photographs, instantaneous recordings that seize moments out of continuity and offer intermittent evidence.

Ipousteguy once published a number of notebook observations, in poetic form, in the review *Quadrum*, among them the notation:

> Figurative? Never
> have I taken man
> figuratively,
> even in his image*

Again, the duality of plastic, formal perspective and the immediacy of flesh. Early in the life of *La Femme au Bain* Ipousteguy worked on the head, up on the little square of roof, and I watched as he carefully etched a vertical incision down the cranium to the neck, in effect dividing the skull into two lobes. Later, I asked about it.

"The furrow? That's perhaps a line that permitted me to balance my sculpture more effectively, to get a sense of its being in equilibrium. It's also a mass of hair, a kind of line of demarcation. My sculptures are often cut in two, in the median sense. You've noticed that. If the line is discontinuous it always has points of reference, median crevices which run the length of the sculpture from base to summit. All men have brains made in two parts. When you look at a man you see it, you notice that he's sewn, really sewn together from top to bottom along the

Figuratif? Je n'ai jamais pris l'homme pour un figuratif même en son image (1963)

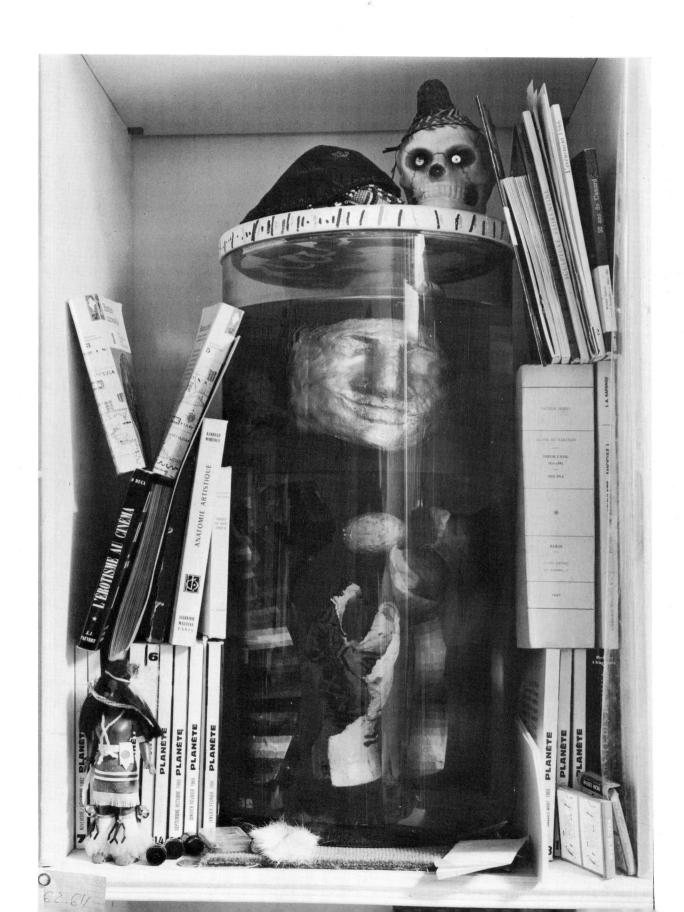

middle— the mouth— or there is a feature there, or there, or there— wrinkles, the nape, in the back, under the belly, he's sewn— like a seam——"

And the teeth—an unsettling effect—are in fact cast from Ipousteguy's own.

"Yes, I wanted my teeth there. I hadn't the time to mold others, and then it irritates people to have to mold teeth, so I used my own. There's also an access into the person through the open mouth. There are holes of entry in my sculpture. In the bather, even in the form that suggests the tub, there are holes you can put your hands into, and things inside to touch as well. Physical contact with my sculpture is very important for me. I would like people to touch it—

"I make sculptures which ought to be seen at close range, while sculptors generally make sculpture that ought to have the light of public gardens, be seen from some fifty yards distance. As for me, no sculpture is meant to be outside, and I don't make monumental sculpture. At least I haven't done so up to now. I don't know why. I visualize my sculpture in enclosures, in rooms, to be seen point-blank, without a great deal of distance.

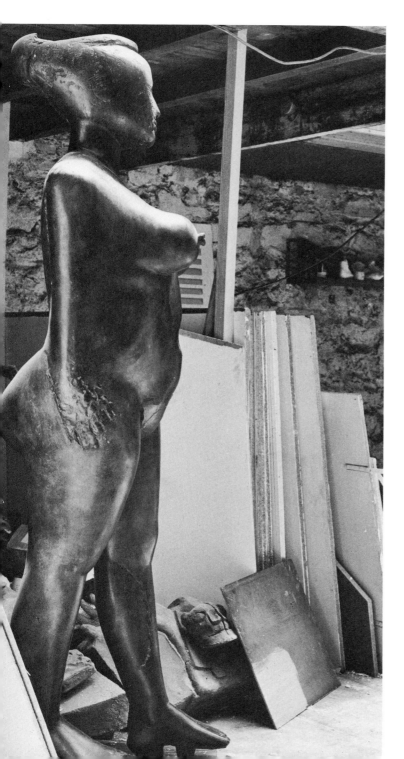

One of mine is in a garden in America; they put it in a garden— but you can't blame them——"

——Which points to the problem of how to situate modern sculpture. There are no cathedrals, no context——

"True, because art is perhaps the last religion of man, the true one. One can treat of death, life—it's the last religion of the individual, art."

——There are museums, but that cuts the impact.

"Indeed, it's not made for museums. Sculpture is put in museums to let sculptors go on living, but it's not the right place. There is no room for the religion there either. It has to belong to everyone and be absorbed by everyone.

"The museum is a device: it puts art in the public domain. But people pass by quickly. I hope this won't be misunderstood, but I don't believe in art for the people. I believe that art is made *by* the people, which is another thing entirely. A chap who has been working at a Renault factory eight hours a day looks at the *Mona Lisa* and sees a woman less pretty than the one he's seen in his maga-

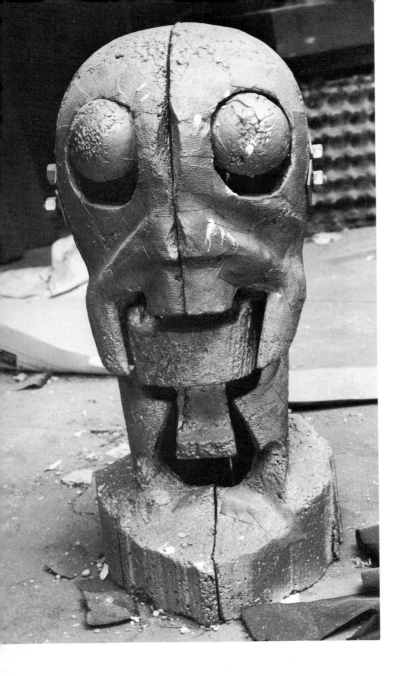

136 / JEAN IPOUSTEGUY

zines. That is, it doesn't interest him, he hasn't the time— It's not his fault—he's been brutalized——

"Just think, when you go to the movies or watch television, you spend an hour and a half in front of a film. But do you see anyone spending an hour and a half before a sculpture that demands as much time, as much energy? He sees it in five minutes. Well, if the chap is religious (I mean in the sense in which I say art is religion), then he'll stay, he'll return."

——And in a gallery, the atmosphere resists an hour and a half. In a theater, all is arranged: there are seats, darkness, the stage is the one object of focus.

"And then a film takes place in time, while works of art, painted or sculpted, take place, you might say, in eternity. So people devote a few instants, because the thing will always be there. If they return in five years, in ten years, it will still be there."

——Of course, one can experience eternity in a few minutes, a few seconds.

"Yes, but there is no chronological sequence to a sensible work of art. You go to a concert, you are obliged to stay in your seat to hear the concert, and the same for the movies— But for these works, no."

Iphousteguy wrote, again in 1963:

My perception is that it is necessary
to determine man, my opinion is
that it is necessary to determine him
 in a certain
way exclusive of all others,
in the hour of my present.*

*Ma conscience est qu'il faut établir l'homme, mon opinion est qu'il faut l'établir d'une certaine manière exclusive à toute autre, à l'heure de mon temps.

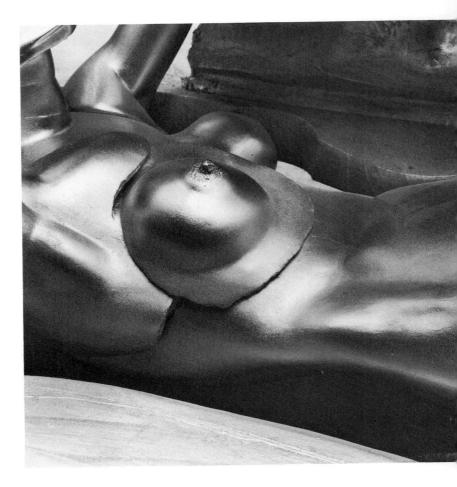

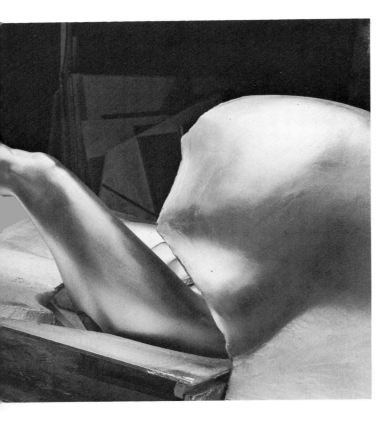

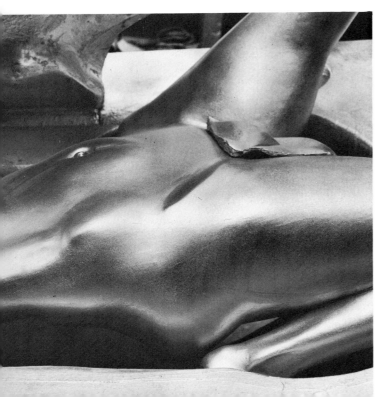

Again the problem of time, intersecting with the idea of reality seen in distance and proximity. Why not teach, say, the history of Italian Renaissance art in reverse? From Raphael as a painter in space and time, under the burden of visual, humanistic realities— to Masaccio, who begins to find the forms and symbols of an interior reality, a formal light—to Giotto, a full-fledged magician and formalist—to Duccio, who transmutes the heavens from blue to gold and at last throws off the actual and arbitrary limitations of terrestrial perspective. Perhaps that sequence would be ultimately truer in terms of painting than the one history sanctions on the pretext that it happened to occur that way.

In Ipousteguy's case, one sees that his work has become, with the years, less rather than more abstract. Instead of proceeding from countenance to form, Ipousteguy, without relinquishing form, has proceeded from form to countenance. And so, in the bather or in the standing figure yet unmade, you have gesture and glance and action which did not exist in the earlier work. In fact, Ipousteguy mentioned that he has been accused of being 'baroque.'

"People keep saying that. I say, 'Fine, perhaps I am baroque.' They say I have a turned-up nose. Well and good, I have a turned-up nose. People do see you. I look in a mirror, but I see myself in reverse. In life I never see myself right side round, but always in reverse. I see myself right side up only when I don't see myself. When I speak, since that comes from the center and goes

toward the exterior, I hear myself in reverse if I listen. But people see you otherwise; reflection comes afterward. I don't know exactly how to express myself—that's why I can't say exactly what I am, because even if I hear myself in your tape recording, I hear myself in reverse— A part of the truth exists in the thing reversed, surely, but nevertheless it's not my breath projected in a natural fashion, coming from the depths of me— And so it's difficult to explain myself—which is the importance of the critic, who sees you right side round."

Which perhaps explains, even if obliquely, why Ipousteguy made molds of real hands and feet for the bather.

"You know, in the bather, I really wanted to be the slave of certain anatomical particulars—the hands, the feet. I even made molds of them to render me the slave of a certain anthropomorphism. I know it was deliberate, but why I did it, I can't, at heart, explain."

In reference to the bather, the subject of time arose again. He said: "I named it *La Femme au Bain*. It could just as well represent Aphrodite or a swimmer at St. Tropez——"

——Perhaps the birth of Venus from her seashell——

"Venus, yes, surely.— I experienced a great shock when I came in contact with Greece. I felt a great rapport with the Greeks, something I had never felt before."

——It seems you've won both worlds. You have the 'primitive' and the classical as well.

"I don't know. There are those who may

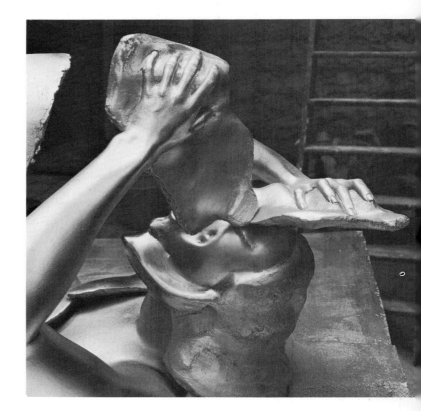

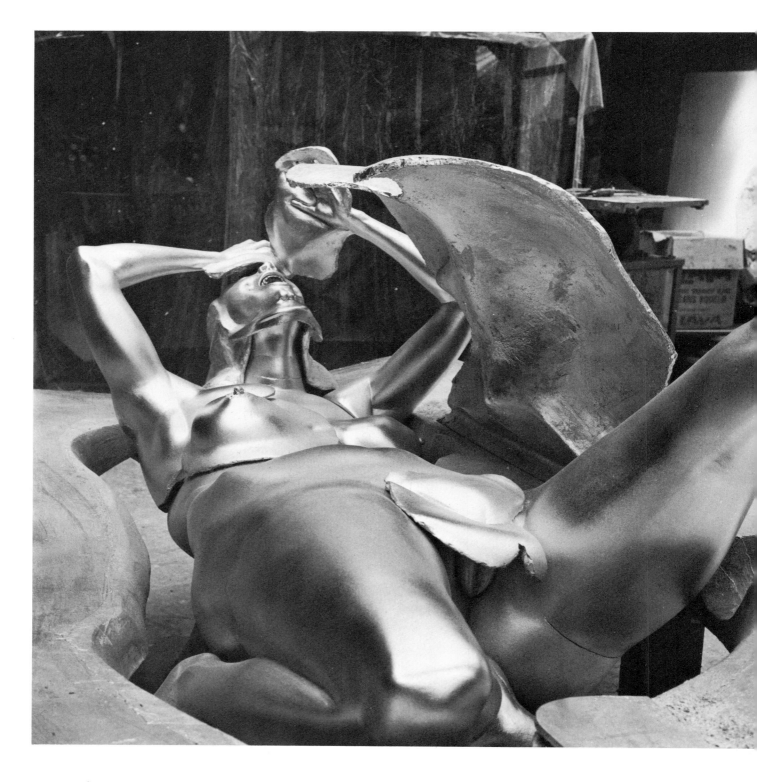

find these things decadent."

——Why? I wouldn't say so.

"Because there now exists a taboo on anything that seems related to the Italian Renaissance. Obviously, generations have been saturated by it. Now they vomit it up. When you've been saturated with chicken you can no longer stand the smell of chicken. You'd rather have sausages.

"At the age of twenty I had masters who were involved with 'black sculpture,' Negro art, up to their necks. Picasso had already done *Les Demoiselles d'Avignon,* which had become a classic. To speak against Negro sculpture was almost blasphemy. And if one rediscovered the Greeks, it had to be not the fifth-century Greeks but the Greeks of the Cyclades, the primitive Greeks, because that corresponded to the whole current of primitive arts. Well, let's say I'm like Stalin, who was educated by the priests and in the end felt compelled to strike out at them in favor of something else. My way of reacting against Negro sculpture was to come to see the Greeks, at heart the Greeks of the fifth century. I was able to recharge my batteries as much as Picasso did when he left a universe dominated by the academicism of the nineteenth century by discovering Negro masks.

That way, he was able to recharge his batteries, to find something new. For me, the innovation was Greece. Now I utilize the Greeks along with the twentieth century to shape my mind and to say what I want to with sculpture."

——There is also a great sense of frontality in your work, so that one thinks of the Egyptians, too.

"Indeed, I travelled along that road. That's true. I left Negro masks via the Egyptians, and arrived at this species of Mediterranean spring. I went all the way up to the Italian Renaissance.

"There are a heap of books coming out on Oceanic art, the art of New Guinea, but find a chap who will put out a book on the Parthenon. It would make everyone snicker. But the artist is a sniper. He always reacts in contrary fashion."

At last, Ipousteguy transposed his *Femme au Bain,* by means of paint, from the luminous white of plaster to a gleaming metallic silver, this in preparation for casting. The metamorphosis took a bit of getting used to, but to a great extent the change helped sharpen the line, delineate the shape, and project the figure a degree further from humanity toward something totemic and de-

tached. It was a suspension between two worlds, the classical world and another world open to definition—the primitive, perhaps, or the fetishistic, the surreal or the purely formal. (For the final cast state Ipousteguy chose a very highly polished bronze, gold in finish, which again altered the presence of the work.)

Along three walls of a small room adjacent to the studio, Ipousteguy had tacked up a long, white, mural-size sheet of drawings, a continuum in time and thought. These are the sketches for the bather and for the standing male figure, along with functional, physiological, dynamic details. In one corner was a curious configuration which seemed to be a segment of hillside, massed with foliage—perhaps prehistoric ferns—and bearing a dark, mysterious, reclining shape. Ipousteguy explained that this was something he'd jotted down one morning after waking up and seeing, with one sleep-misted eye, the hair on his own thumb.

It was not a distance at all, but an extreme proximity that had been turned into distance by something like free will.

Giacomo Manzù

THE EARLY SCENE of much of Giacomo Manzù's career was Milan. Today he works outside Ardea, a small village of the *campagna* near Rome. Electronic gates seal off his domain: the silence is total. In the village, Manzù is known as *'il professore,'* as the man who made the doors of Saint Peter's, as someone who has actually spoken with Pope John XXIII. He is clearly something of a mystery —and he is not one to dissipate his privacy.

Manzù is content with Ardea. "The light here is strong, alive, very beautiful. And I am undisturbed." The place is hot in summer but, because of the nearby sea at Anzio, not too cold in winter. In summer the color is yellow and red and white—very hot—the foliage is scorched, and the only cool note is the green and black of lithe, quick lizards, faster than the eye but sufficiently trusting to slither up to Manzù's porch and present themselves as impeccable living sculpture.

The house, which Manzù had constructed for himself, is magnificent. The shutters are closed to exclude the blinding summer sunlight. The floors are splendidly tiled and the place is filled with antique sculpture, Japanese prints, modern graphics, an important painting by Bronzino, and Manzù's hats. He loves hats—straw, felt, what have you. They conceal a powerful bald dome surrounded by ringlets of hair that seem to have come directly from Etruscan sculpture.

Just a few yards from the house are immense studios which Manzù also had constructed to order. His friends have described them as hangars rather than studios, and the point is well taken. Both studios are immense and their immensity is put to use—they are filled with finished sculpture and drawings, with materials for painting, and with current projects in various stages of completion. Among the latter is a great mask from the decor and costumes Manzù designed for Stravinsky's *Oedipus Rex*. This will be followed by work for a Roman production of *Histoire du Soldat*.

In one studio is the huge African totem given to Manzù by John Huston, the film director, and around the totem are a variety of Manzùs, finished and unfinished: a black

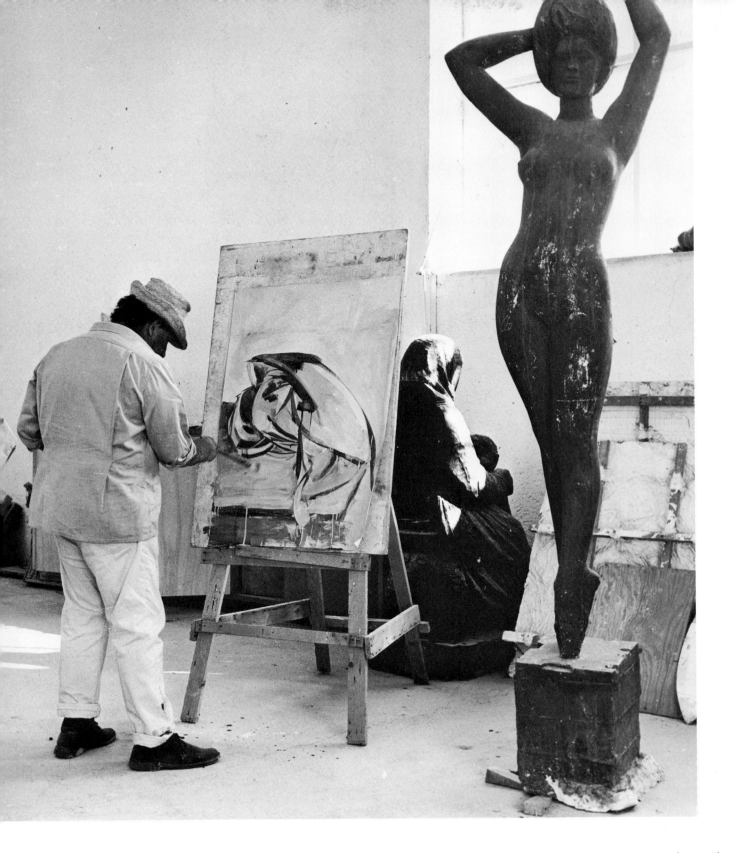

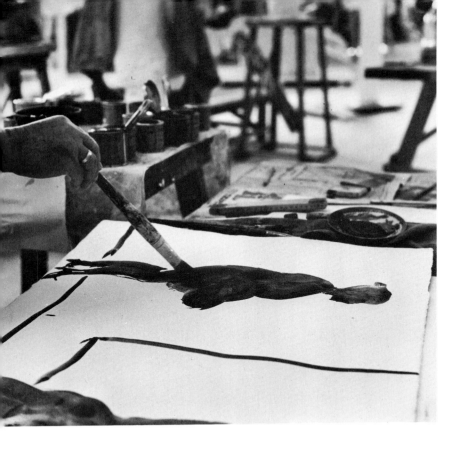

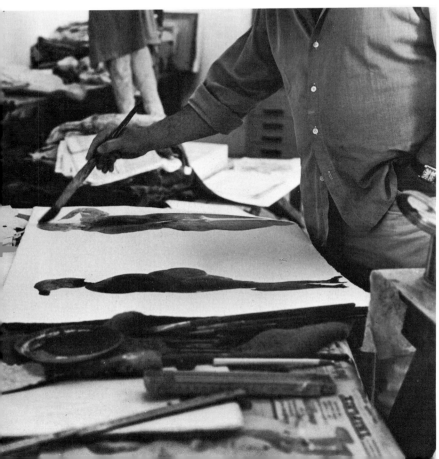

ebony *Mother and Child* that had just been completed after ten years of work; a tall, austere *Cardinal;* and over a half-dozen pair of lovers.

Manzù moves about this forest of life in clay and wood and bronze. He tugs at his straw hat. He throws a troubled glance at something that demands attention, that threatens to become difficult. He looks at another piece with satisfaction. Each day there is this confrontation, this determined circling in to one point of work. There are still signs of the great Vatican project about, the doors of death Manzù completed for the basilica of Saint Peter's after eighteen years of contemplation and exertion. And there are still the cardinals, the subject for which Manzù is perhaps best known today. And, amid all this, the lovers, *Gli Amanti.*

"The idea for *Gli Amanti* came to me while I was working on a *Painter and Model.* I was never able to do with that sculpture what I would have wished. Then one day I took the two elements, the man and the woman, and I united them to compose a group, a pair of lovers. It's a contemporary theme, sincere. It's a theme, in sum, which is at the center of my present work. But they are scarcely begun, *Gli Amanti*——"

And yet, the results were already prodigious — six diverse maquettes and a large bronze.

——It's beginning to blossom.

"I don't know— it's impossible to reply because it's simply a theme that I have in my hands at the moment. It's also, for me, an adventure. I don't know where these lovers are going to lead me."

——In your work, there is a distinct spiritual side and a distinct sensual side——

"I would say so. But when I work on these lovers I don't think at all of the sensual or sexual theme. No, no. I think— of the union of two beings, which must express itself in a certain form, and with a— certain something of life. I don't think of art, either, when I work. I think only of life, and that's sufficient."

——And yet, the Vatican doors express an idea——

"Yes, the idea of death. But that was also done in the same way. I never thought that I wanted to do a bas-relief, beautiful or ugly. I always thought that what guided me at work was— my inspiration. In short, it's life, even for *Gli Amanti*. Whether it's a question of the Vatican doors, or of a cardinal, or of a child, the theme has no importance for me. No, the theme of the lovers simply furnished me with two figures which, put together, and according to the way in which they will be put together, can give a certain form. Well, these are difficult things——"

All of which applies to the great series of variations that inevitably accompanies each of Manzù's ideas. In his case, one might speak of a relentless tenderness. In his work, he fights

with great power to articulate something that has definite physical weight and yet a delicate, elusive breath. In other words, a certain equilibrium must be present. The problem is to find it among a host of possibilities, and the finding is only in the doing. That equilibrium might be identified as the best expression of what Manzù refers to as life, sensual or spiritualized, but what is most basically a current, a living presence of authenticity more fundamental than any of its attributes.

Which brings up the whole problem of style, since the breath of life Manzù pursues has to be approached along some channel—in this case, through the medium of external

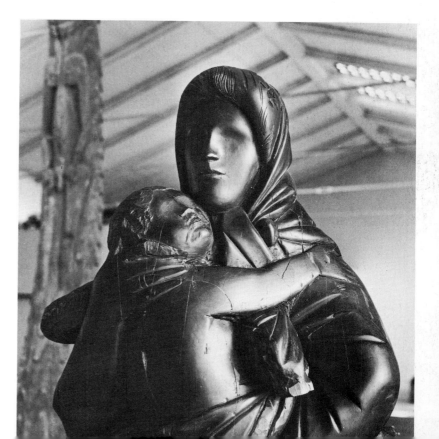

forms. For a classicist such as Maillol, for example, the external physical revelation expressed the spirit and he was happy to work his way inward from that satisfying point. But for a classicist such as Manzù the problem becomes more complicated: on the one hand, the life image of Manzù's work tends to be invisible, but on the other hand, the external and tangible image remains essential. Manzù seems to accept the external form, the physical presence, as a superb insight rather than as a definitive conclusion, but he cannot or will not give it up. In principle, he might work

from the inside out, as is the case in Brancusi's work (and often in Moore's and Picasso's). But in practice, there are certain dictates of temperament and intellect and environment.

And so, the search. There is a certain line of inquiry in purely physical terms, and another in metaphor. The cardinals become flat, disembodied, analogous to buddhas of the Chinese Fifth Dynasty. The nudes, and even the ebony *Mother and Child,* take an opposite path, while the sculpture of one of Manzù's children in a chair (described by him as "a game" rather than a true sculpture) shifts to still another and very graphic level. Metaphorically, Manzù's dialogue with form becomes complicated because of the synthesis he aims at in negotiating the classical ideal and the contemporary presence. Not that Manzù poses the question that bluntly or that theoretically. But it emerges in the course of work and it has incessantly to be solved. Perhaps it became most pointed when he tackled the Vatican doors.

Cesare Brandi has pointed out that whereas Ghiberti's doors are devoted to paradise, and the Rodin doors deal with hell, Manzù's doors have to do with death itself, and so with man and this life rather than with the afterlife. The shift in emphasis is in line with the spirit of the Ecumenical Council, Vatican II. But, aesthetically, it created obvious problems: how to update the concept and yet produce something in harmony with the Vatican? This is actually, at heart, the abiding issue of Manzù's work.

In this case the solution came in Manzù's

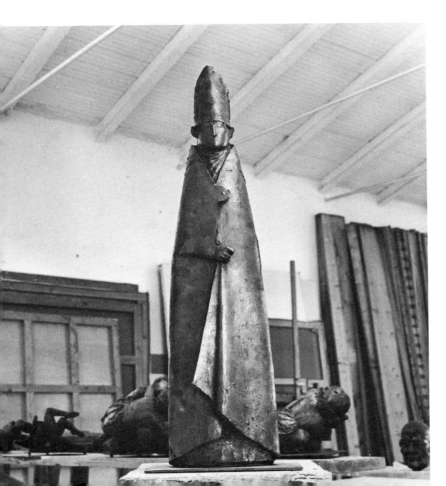

handling of space. From 1947 until 1962, he conceived and worked on panels concerned with death—death in the air or in space, death on earth, the death of Christ, of Mary, of the saints. And while Manzù drew and molded and incised, the real pulsebeat of the series grew out of the method of each panel, the plenitude of space that gave each its dimension. The very flatness of the panels is carried out with a great appetite, analogous to the pleasure in rich volumes that is so evident in *Gli Amanti*. The panels have a definite tempo: they are *andante moderato*, even *largo*. Yet in the line there is an electricity, a seeming swiftness, that counters with another rhythm. In other words, a counterpoint of opposites.

Which goes a long way toward explaining *Gli Amanti* as successor to the doors of Saint Peter's. The doors deal with death, the lovers deal with life and the procreation of life. The doors are flat, the lovers are voluminous. The doors keep to a restrained tempo, the lovers are far more rapid in pace. Then, too, just as one theme counterpoints the other, each contains within itself its own contrapuntal aspect. The small maquettes for *Gli Amanti* take the theme through a whole range of variations— one is truly baroque, another is far more generalized in form. And Manzù determined to retain this dialogue in doing, ultimately, a series of four large versions in bronze.

Of these, the first was complete by the fall of 1966, a great globe of perpetual motion in bronze. Work had just been started on the second, still a mass of clay in an embryonic

state. But its future had already begun to be evident.

Manzù approached the work unsmilingly. It was still a battle, muscle to inert material. He went after it furiously but with measure, pausing to consider his attack and then plunging into the clay, pounding it, slapping it—something, in fact, of the motion of a baseball pitcher judging his moves, winding up, and sending in a fast ball. Or perhaps Zeus hurling his thunderbolts—a muscular species of creation, very Mediterranean. This was an image of adulthood fulfilling the biological mission of the species, yet an image itself in embryonic form—a complex of biology and myth. Which is not so far from fact.

——The large *Gli Amanti* is altogether different from the maquettes. Will the theme continue to change with each successive version?

"Yes, and it will change more and more. It's always the same theme, the same gesture of the man and the woman, but completely different."

——And the work in progress? Do you have a very precise idea at this moment about just how that will evolve, what form it will take?

"Yes— but for now, I'm just working a great deal."

——But how do you conceive of it—more baroque, or perhaps rather more simplified?

"Richer, I think. Many more folds."

——And then, no doubt, the third one will be quite the opposite.

"Yes. It's difficult, this theme. But these are

eternal themes, just as man himself is eternal——"

——And the result is very beautiful.

"In America, they are a bit perplexed about *Gli Amanti.* They consider the theme a bit taboo. The director of a Canadian gallery told me it would be impossible to exhibit all these lovers in the United States. That, I don't understand."

——But here in Rome the police confiscated half of a Gustav Klimt drawing show a while back, on charges of obscenity.

"Yes.—I haven't seen it yet."

The exhibition Manzù hadn't seen yet had been over for months. Time takes on a different perspective at Ardea than at Rome, a special perspective within the gates of Giacomo Manzù's domain. And with that shift in time comes a shift in vision that helps make possible a successful union of opposites.

An easel stood a few feet from the sculpture in progress, and after struggling with the clay for a while, Manzù stepped up to it and began to paint, on paper, with a heavy brush. He made rapid progress, delineating a compact oblate shape turned in upon itself. Within a few minutes that shape took on the character of the lovers—not in a descriptive sense at all, but in the sense of movement and weight and direction. It was another avatar of *Gli Amanti.* Manzù was living with the theme, digesting it, exploring its possibilities.

"I don't know what I'm going to do with these lovers. It's something very close to my heart. And every morning I come here with the hope of finding something. I don't know if I will succeed in doing something good. I'm not very happy with the first group. The other group, which you photographed, will be better."

——Well, the big one is much more specific than the maquettes, much more specific in its parts, whereas the maquettes are so immediate and expansive. They move. It's perhaps inevitable.

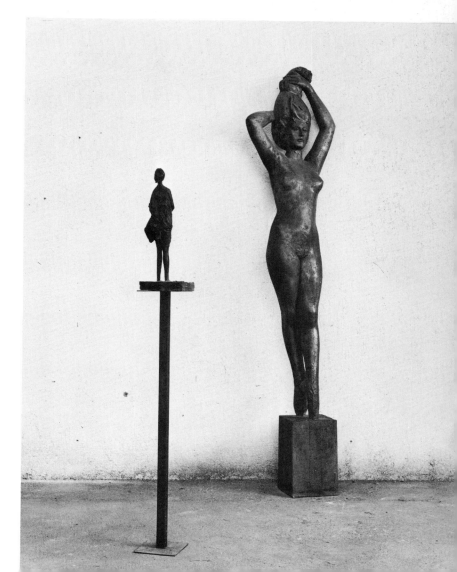

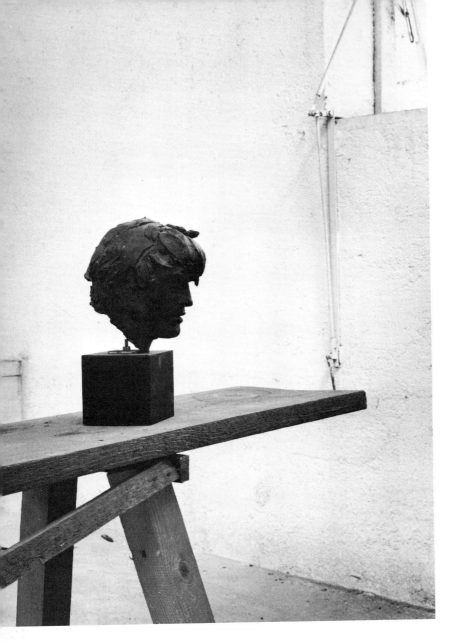

"I agree. From the maquette to the large group, everything changes. When I am working on the large group I don't think of the maquette. I know how I want it, and I do it."

——Not at all a matter of enlarging a maquette?

"No. The proportions are different, and the space as well. Everything is different."

Manzù was then preparing a large exhibition for Moscow, where the Soviet government was planning to give him the Lenin Peace Prize. I asked if the lovers would go to Russia.

"Yes, I'm sending the six maquettes and the first large group."

——You have both the doors of the Vatican and the Lenin Peace Prize. You have the best of both worlds.

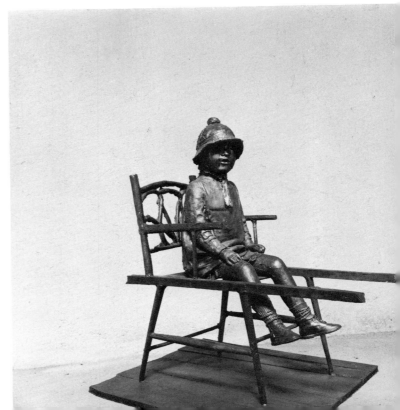

Manzù smiled and turned up his hands in an Italian gesture of resignation before the inevitable. Each step in his work is a natural procedure, even if difficult to solve and resolve, and the life of each work is manifest, its motive ineluctable. The relative points of view of New York, Rome, and Moscow appear rather less substantial. Manzù is a man with an internal compass, an internal mechanism that reduces the circumstance of time to a minimum. He is not afraid of following certain impulses that might ultimately be dangerous. For example, a man who had arrived at the stylistic rigor of the late cardinals might well balk at returning to a baroque form. Or, on the other hand, a man who found a baroque metaphor natural to his temperament might balk at pursuing more streamlined suggestions.

I asked how Manzù felt about present directions in sculpture. Is he interested in any of today's younger sculptors?

"I willingly look at what they do, but I don't understand. I agree with Matisse, who said that he knew everything that was done before him, but that nothing done after him interested him. Actually, what the young people do *interests* me a good deal—but I don't understand it all. I don't say anything bad about it. I can't talk about it because I don't understand it, and since I don't understand it, I can't judge it either."

——At the moment there is a very general tendency to internationalism. Surely your work is very Italian in character, but that's

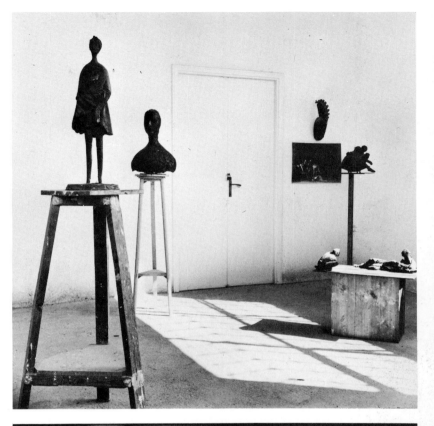

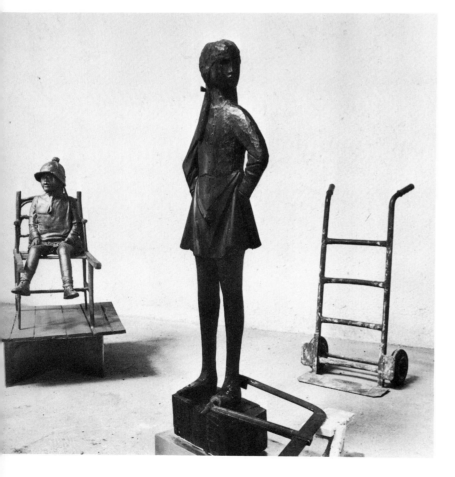

something that tends to be lost today.

"Agreed. But I think, I have the conviction, that in a certain light 'art' does not exist. I have always thought so. And I don't any longer believe in 'isms.' As for me, there are abstractions that I like very much, and there are those I don't like. There are figuratives I like, and others that don't please me at all. When there is something truly divine, then that makes me vibrate. And then, there is also the fact that my age, my culture attaches me to three definitive masters whom I recognize as such: Picasso, Braque, Matisse. And also Brancusi. I've always loved Brancusi. And that is what I think."

An interesting and objective appraisal in terms of Manzù's personality. His earliest great influences were Donatello and baroque sculpture. Later Matisse made an impact upon his work, especially on his drawings, and perhaps even on the most lyric of the maquettes for *Gli Amanti*. And that very day I photographed Manzù at work on a wash drawing of

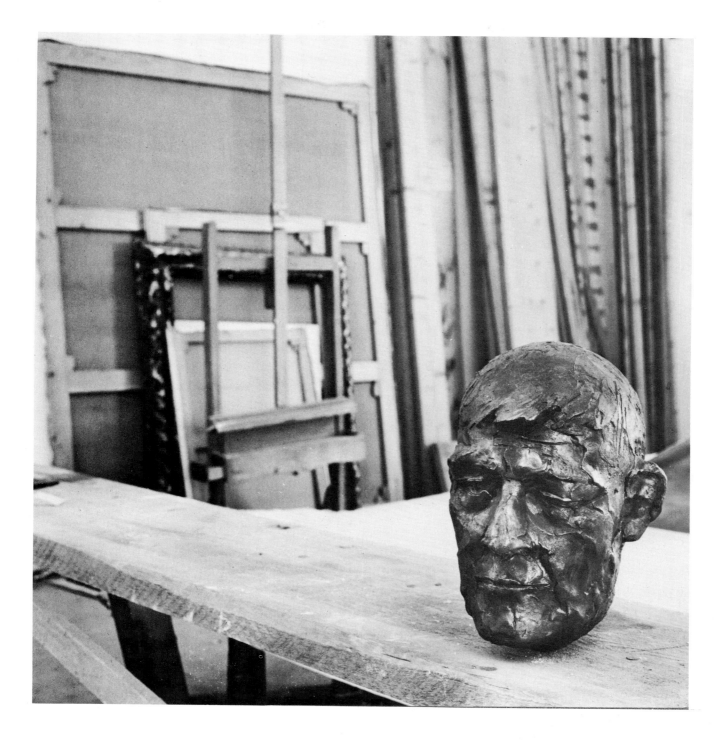

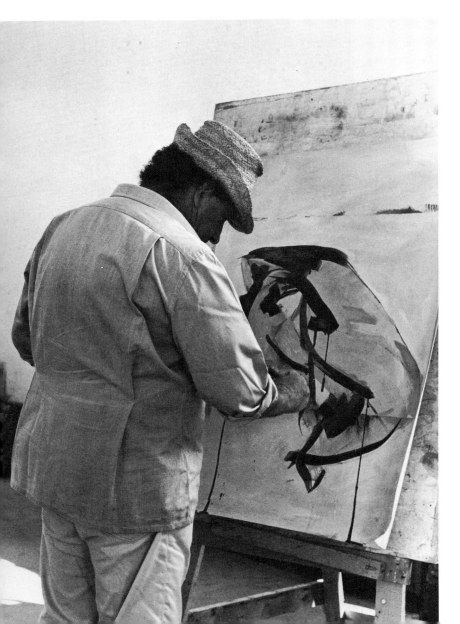

silhouetted figures which, without being derivative, might not have been possible without certain breakthroughs in that direction initiated by Picasso. On the other hand, the particular elegance of Braque, with its decorative magnificence, and the purist quality of Brancusi seem relatively far afield. So the connection comes in terms of an overall intelligence, a manifest authenticity that attaches to one age the verities common to all ages. Otherwise, in fact, the Vatican doors would have been an insuperable problem ending in anachronism.

——And will you continue to do cardinals?

"No. Finished. I'm not doing any more cardinals. That one I did last year. And now, that's enough. I'm not making any more——"

——But between the cardinal and the lovers there is the same contrast in material and in handling as in theme. The cardinal is completely spiritualized——

"But perhaps— who knows, after all?— it's possible that I am succeeding in making a little spiritual group——"

The austere prelate towered next to the African totem, above the lovers in their own

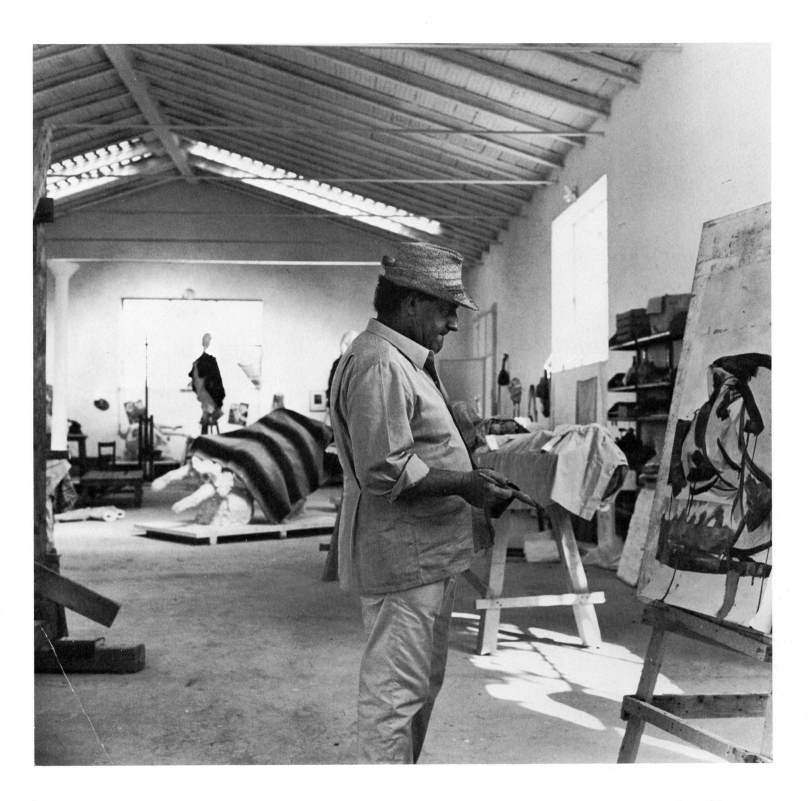

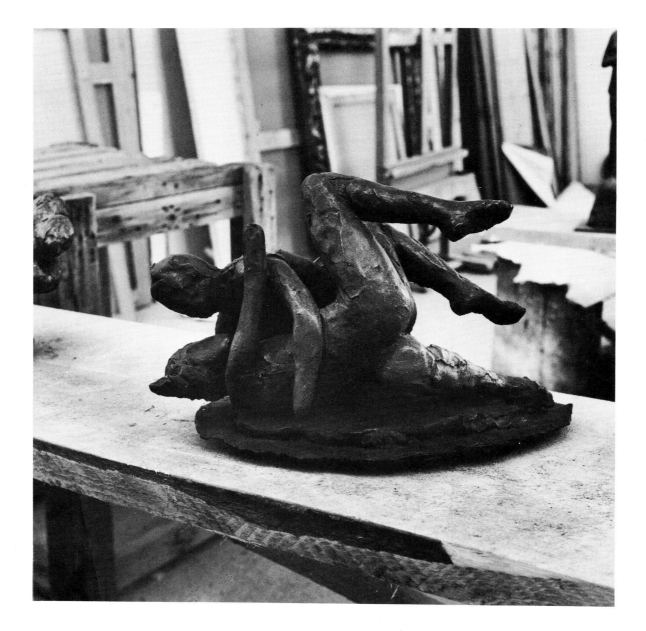

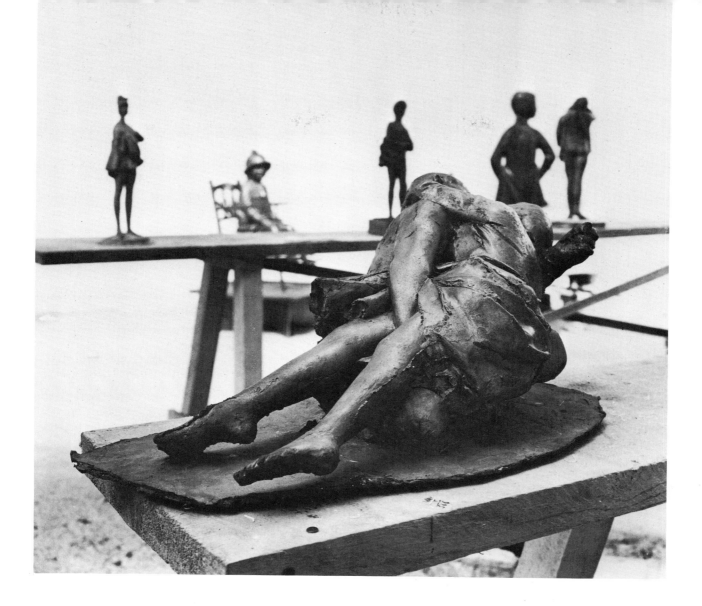

universe apart. In both cases, Manzù had arrived at a balance, and each balance complemented the other. The contrast was evident, but hardly to the extent of disproportion—rather a successful marriage of opposites that are self-sufficient opposites.

One of Manzù's favorite phrases is, "I had this theme *in my hands*——." I asked if, in formulating an idea, he immediately conceived it specifically in bronze or specifically in wood—if the material seemed immediately inextricable from the idea.

"No, when I begin a sculpture I invent. I am simply very attentive, and I am taken by images. But I don't think in terms of bronze. . . . Sometimes I do a sculpture in gypsum, but most of the time I do it in clay. Then, although it's difficult, I do it in bronze. It's also likely

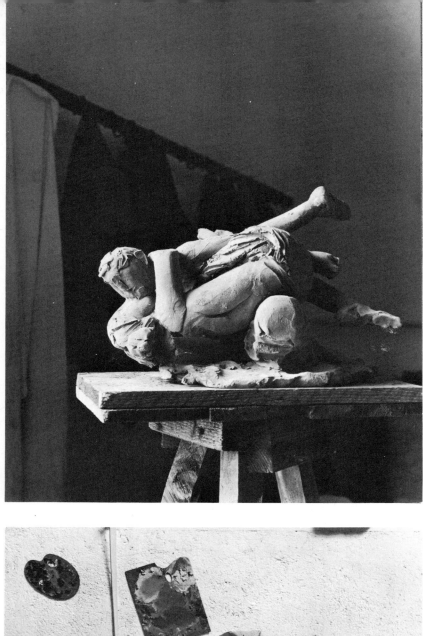

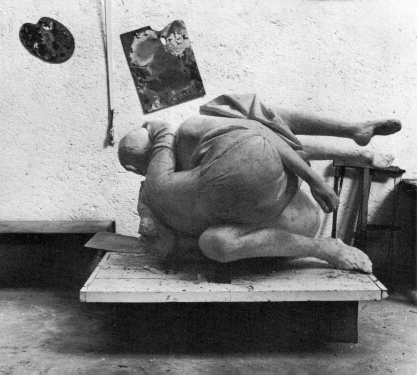

that I might do it in wood. In this large series of lovers, I want to do one in ebony. That's the way it happens. What is essential when you work is not to lose the image you have. It's like a dream come to the light of day. You have to hold fast to it, not let it escape. Then, if you succeed, the rest follows—whether you ought to make a terra-cotta, or else a wood, or a marble, or a bronze. But all that afterward."

——Bronze is the material you prefer, isn't it? Yet this *Mother and Child* is done in wood.

"Bronze is the material I prefer, but I also like ebony a great deal. I like marble less."

——Why did you begin this in wood? Because the idea led to wood, or simply because you wanted to work in this material?

"No, I used this wood because it's very 'plastic.' And form, in this wood, is always— brilliant. It's beautiful, it's very beautiful. It's definitive and— it's very strong."

——And, other than this, have you worked in wood recently?

"Always. I'm not like these sculptors who

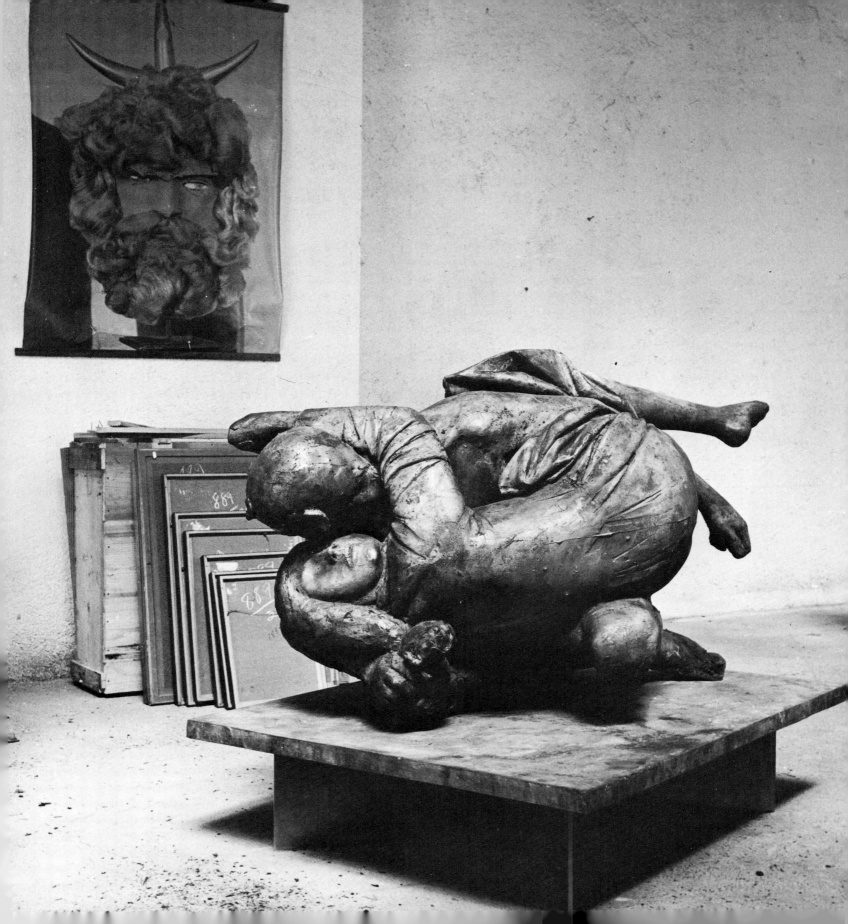

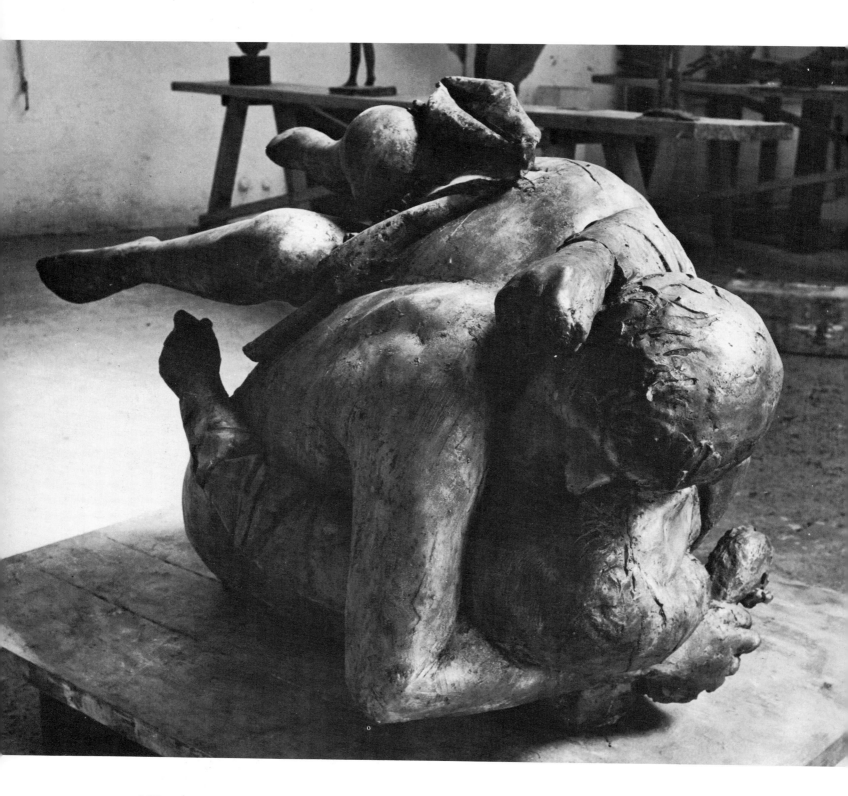

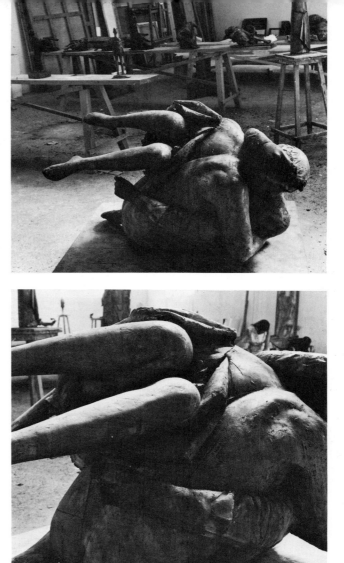

make a mold, then cast it, but don't continue to work on it. Because when one just makes things— without willing it, one falls into academicism. While the true sculptor, when he works, finishes by knowing what he has to do, and by doing it."

——You draw a great deal. Do you usually draw to prepare a sculpture, or independently?

"Always independently. I can't draw this group of *Gli Amanti*. I can make a little rough draft, and then, immediately afterward, proceed right to the big one. I don't really prepare the work—that's difficult. I take it, I do it. If it succeeds, it succeeds. If it doesn't succeed, I begin again. But I don't prepare. I don't prepare by doing difficult drawings. The drawing is rather part of the amusement."

All of which is modified by the fact that in Manzù's way of working each step is in some way preparation as well as consummation. Each moment is a moment of dialogue, and so each point of arrival is also a point of transition.

——But in the Vatican doors there is such a strict quality of space——

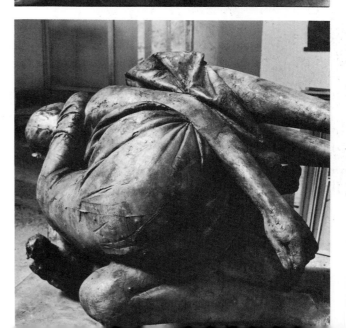

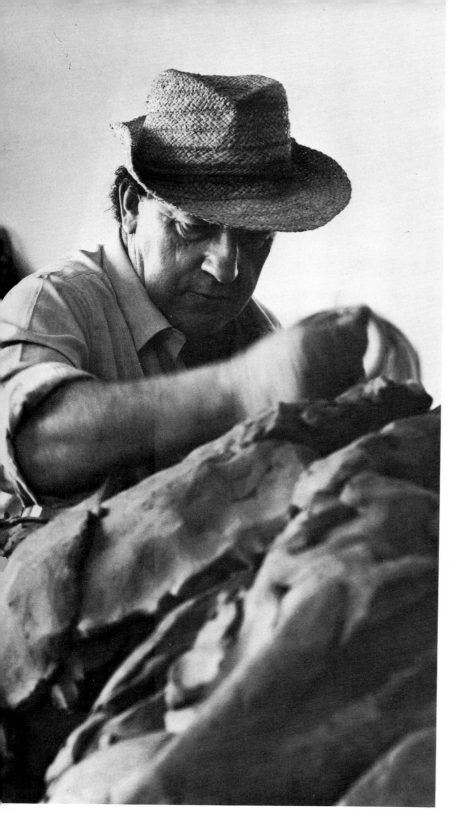

"Yes, for the doors of the Vatican I made numerous drawings to determine the partitioning of volumes and spaces. But later, for the panels, no—I worked directly in the clay."

Outside, the profile of a kneeling woman in bronze alters as the sun works its way west. In theme, this *Harvester* is perhaps halfway between the spiritual poles that have absorbed Manzù during the past few years. In handling, the work has a bit of both the flatness and the volume—not a compromise but a point of equilibrium that has its place in the *campagna* and the studio alike, temporal yet spiritual, the substance and symbol of Manzù's work. Perhaps his dialogue—of past and present, of classicism and innovation, of life and death, of passion and resignation—is reflected in the words of Ecclesiastes: *"One generation passeth away, and another generation cometh: but the earth abideth forever. The sun also ariseth, and the sun goeth down, and hasteth to his place where he arose."*

The medium is motion, but the end is stillness.

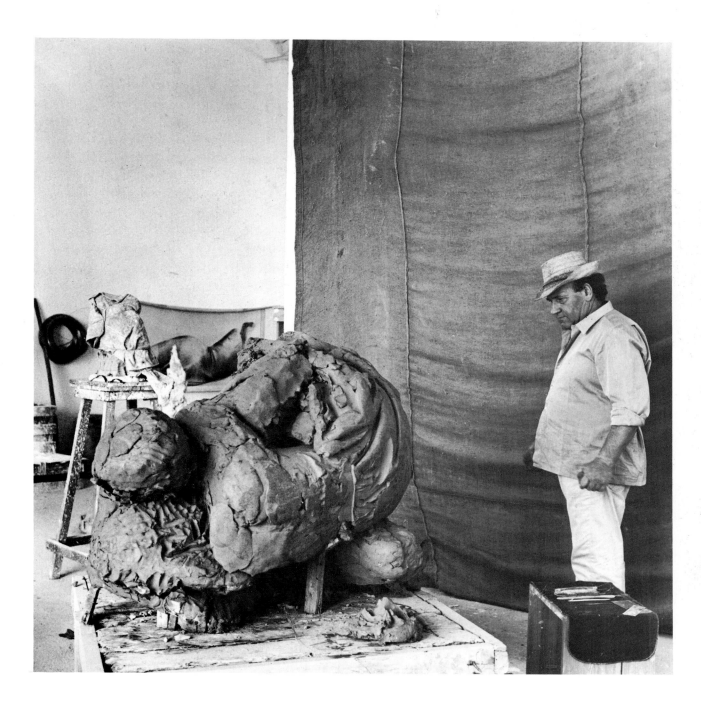

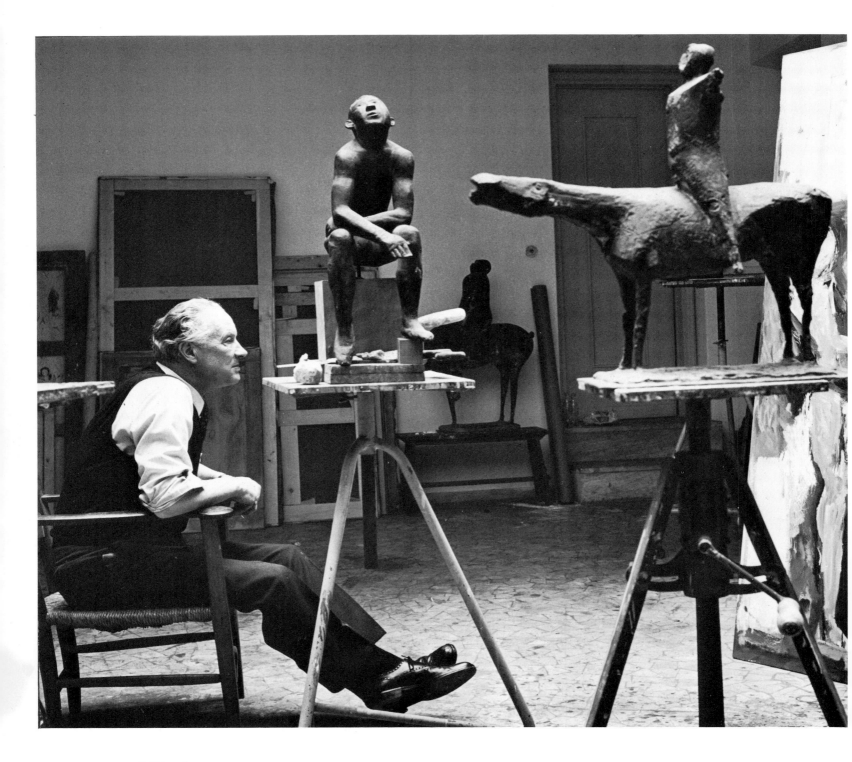

166 / MARINO MARINI

Marino Marini

THE CITY MARINO MARINI has chosen as his home is a nervous and heterogeneous and largely ambiguous world. In the eyes of the Mediterranean south, Milan is the north. In the eyes of the north, Milan is the south.

One would hardly call it a likely ambience for art, this industrial womb with its relentless disorder. The Milan Cathedral of pale towers and pinnacles and spires ripples up and up toward a disk of moonlight. But at the cathedral's base, the newshawkers cry, *"Ultime! Ultime!"* and the catastrophes, scandals, and sundry events they peddle are universal and precipitant.

The arcades opposite the cathedral dip into the now engulfed Milanese past. The towering glass-and-steel vaults, the frescoes out of Giuseppe Verdi, the admirable if redundant rhythm of the sculptured friezes create an elegant northern Casbah of the south. Outside, past La Scala, the city rambles through interminable passages of business incentive and neglect. Both the incentive and the ne-

glect breed dust. The city grows at a half-intense, half-lethargic pace.

Marino Marini lives on a quiet piazza, in an apartment house that suggests nothing of the creative world inside. The apartment—despite the great living-room table heavy with drawings, projects, and catalogues, and despite the Marinis that are installed everywhere—is almost unnaturally sedate. Great bouquets of violets enter into dialogue with the sculpture. The atmosphere has a certain warmth and at the same time a certain distilled formality, perhaps a microcosm of the best of northern Italy.

But all the heavy work takes place in the actual studio, a former garage downstairs and across the courtyard. During World War II, bombs destroyed not only the garage but also the whole complex of buildings surrounding it. When the crisis at last ended, Marini got permission to extend his old working area into the adjacent rubble. So the studio now takes the shape of a great corridor that rises a few

steps at one point and then continues. The work it contains is the work of many years, early and recent. The portraits, the horses, the nudes take their place along an arc of ancient and modern vision. The air is very white—a skylight white, a plaster white—modified by bronze.

I asked if the choice of Milan was very deliberate, or rather more the product of circumstance.

"No, it's not accidental. I prefer working in Milan because Milan is a city that belongs, I think, to Europe, in spirit and in sentiment. Naturally Rome and Florence are far more beautiful cities, but in spirit I prefer Milan above all. It's independent, Milan. One can say that it's an anonymous city. It's not very light in character. It's rather a city without a precise architecture—half-modern, half-ancient, romantic—rather a Central European city. There are streets that have no names. I adore such things."

In fact, the world of Marini explicitly defies time. He is a classicist, yet also a romanticist, and at the same time a realist, each quality taking its place proportionately. You look into his portraits, into their humanity and their personality, while they in turn look beyond you

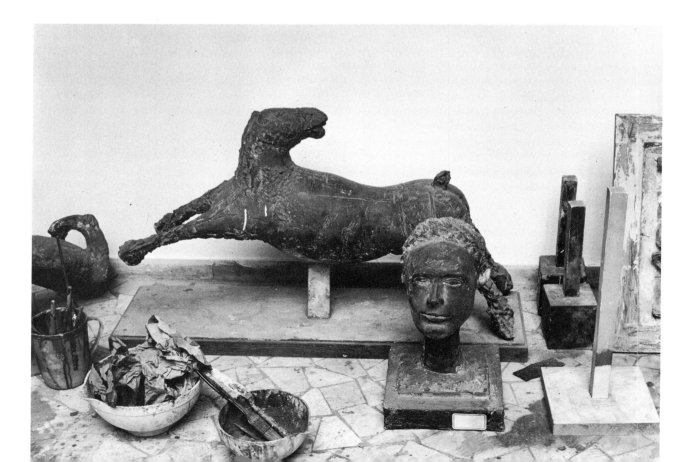

with the fixed serenity and focus of religious sculpture. Their expression comes out of a precise, firmly drawn contact with the subject: Henry Miller, Marc Chagall, Igor Stravinsky, Curt Valentin, Henry Moore, Jean Arp. In the studio, a group of the portrait heads—among his finest works—are likely to fill a nook, very like archaic monuments uncovered in some votive cell. They have a great immediacy, and yet a great detachment.

"I do portraits occasionally. When I was younger I did many more. Now, from time to time, I do portraits which interest me as personalities of our time. There are personalities of our age which mustn't be lost. They should be inscribed, because they are the story of our time."

——And do you feel that there is a direct correspondence to your other work in this need to return every so often to the portrait?

"Yes, at heart. One always feels a need, if one usually steps a bit outside of things—toward the heavens, and so forth — one has a need from time to time to touch humanity, to enter into the world and look at a personality of the world."

Which is, in fact, a significant, double-edged description of Marini's intentions and insights. It underlines the particular spiritual energies that generate most of his work, however sensual that work may be. It also amounts to a humble description of what he has done with his portraits. The intent, as Marini describes it, is almost a form of biog-

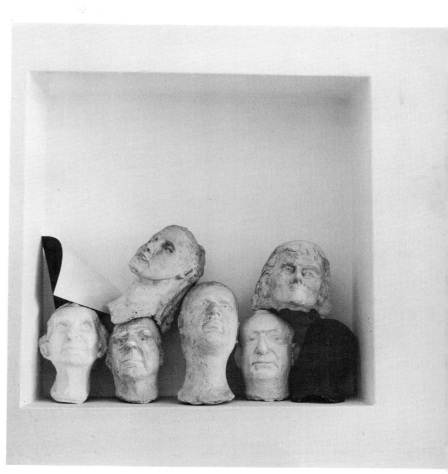

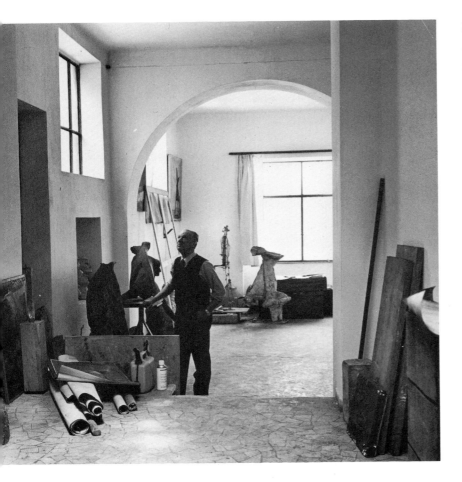

raphy, of documentation. The result is rather some form of hagiography, though the aim is humanistic.

Historically, the age of miracles has always been past. The books of revelation are always being codified and closed to addition or amendment. The good old days are always considered the most lustrous. The old town is never quite what it was. Whereas new perceptions have to cope with the cold light of the present. But in Marini's portraits, the lapse in time that mysteriously and artificially separates calculable time from time transfixed in memory is eclipsed. The move is made with great physical and perceptual and technical effort, yet, one senses, with psychological ease.

Marini surrounded by his studio and its inhabitants—flakes of charcoal in his silver hair—he caresses a sculpture, scrapes a surface to modify its line. He steps back and smiles, and his smile is the smile of a child on Christmas morning. He takes great pleasure, and pleasure is perhaps the key to his work, which is a celebration of sensual virtues balanced by formal virtues. His attitude is that of the pure poet, who always feels that he is dealing with the clear, the obvious —that is, the manifest—in unravelling clarities from the ambiguities that ensheath them. *"We hold these truths,"* said Jefferson, *"to be self-evident."*

Marino Marini is in fact the true Mediterranean sensibility. His connections with the Etruscan and Greek and Roman past are biological as well as intellectual, established in blood as well as in circumstance:

"I was born near Florence. So I am, to be-

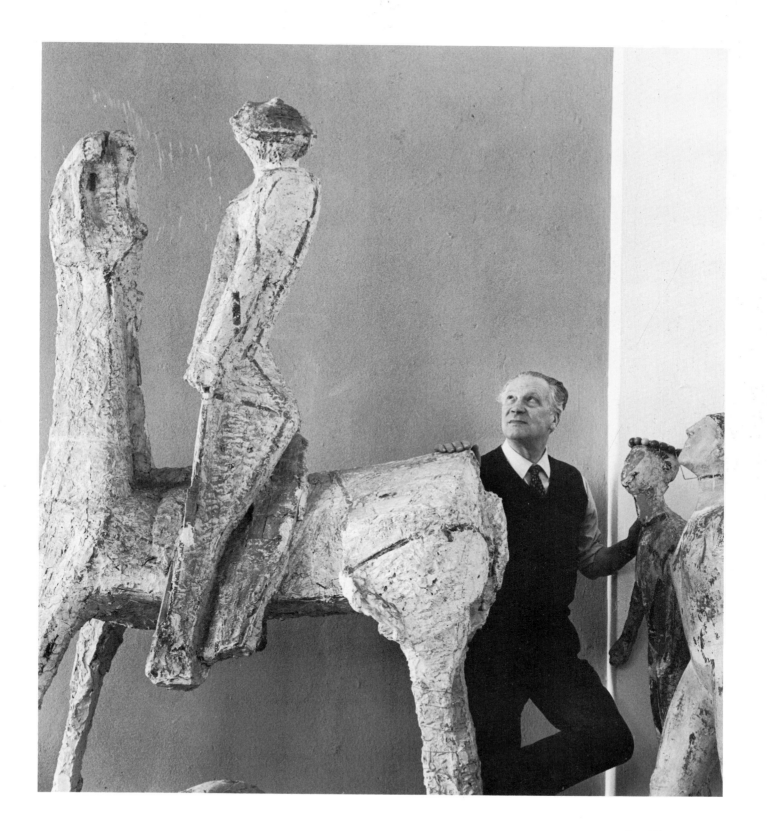

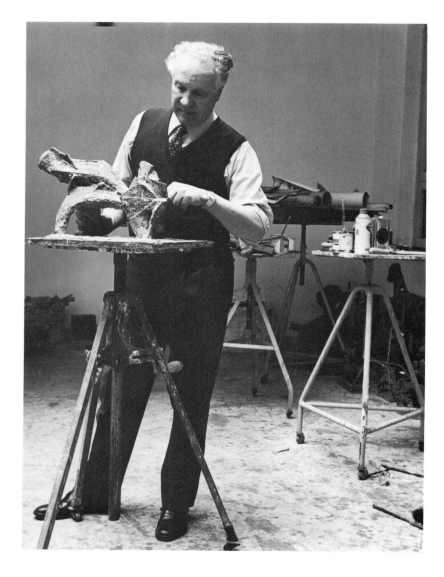

gin with, in the Etruscan spirit, where the old Etruscan generation still flourishes. My spirit in art is the same. Naturally, this is what I guarded when I was young, in school. It's the only thing. I always kept it, this spirit and expression of sculpture that was so interesting and so alive. And then, also when I was a child, I liked the Gothic—in Germany, in France, even in Italy—very much—the Gothic—like Pisano."

For Marini, painting and sculpture have always been inseparable procedures. I asked which came first.

"That's a long story. I always need to begin with colors—a fantasy of color. It isn't sufficient to think immediately about form. I need to have colors between my hands, to touch these colors, to begin to put them on paper or on canvas, to let myself enter into a certain aesthetic atmosphere. The emotion of colors brings me to the emotion of forms. And then, even when the sculpture is finished, I still need to add color.

"When I was at school I still hadn't fixed my sights on painting or sculpture or architecture. I did a little of everything, even graphics, to search out an interior verity. And then *voilà*, I fell on sculpture: it was the thing that satisfied me most.

"Even when I was very, very young, at home, I had no desire to go to school, but I was always making drawings. I was always trying to reproduce certain things. I was above all surprised by the things of life—the

country, the landscapes, the men. I was very moved by these things. And then, afterward, I began to reproduce these things. And, at heart, I said to myself, 'Why not?' One can't say, 'Be an *artist*,' but architecture and painting just interested me. I looked at the things one looked at during that period, and *voilà*, it came to that. I found myself in Florence, at the academy."

——At that time it was difficult to say, 'Be an artist,' yet today that seems to have become quite an acceptable idea.

"Ah, yes. Today there are endless schools, possibilities in art—and alongside art as well. Many young people take up the idea, but they are not convinced at heart. The scope of these things has become very much broader. There are even possibilities in posters, in decoration, and so on."

——And as to contemporary trends such as Pop Art, which have drawn in commercial artists, and others? (Surrounded by Marini's work in a studio in Milan, the very existence of Pop Art seemed remote.)

"Modern tendencies always exist in the world—periods and completely extreme tendencies—but that's very good. It's necessary. Young people have to be pushed along in things. That always adds a little spice, *un poco di pepe sulla minestra.*

"Naturally. It's not easy to enter a life of art. I worked a very great deal for years, for

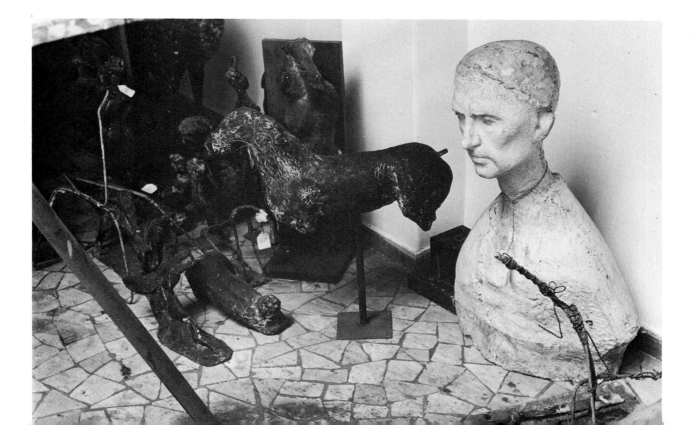

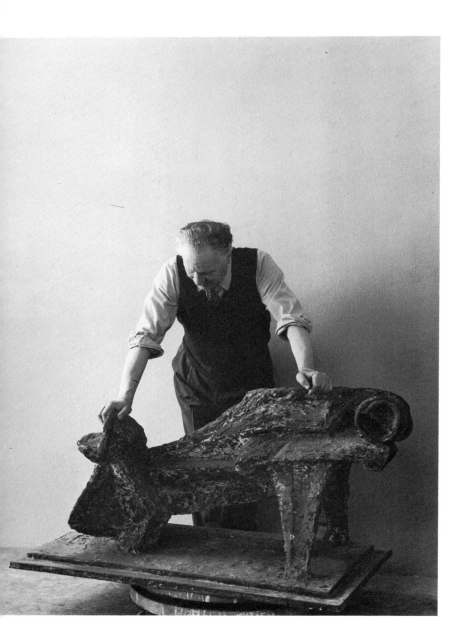

years, without accomplishing— almost anything. It was only after the war that I began to enter into a somewhat more vital atmosphere, and to have results. But before that, it was terrible."

——Because of the atmosphere of the time?

"Because of money, because of everything. It was difficult to sell at that time. I lived in Paris. It was something of a miserable state of affairs—but that's necessary for artists. Those who don't have the strength die, the others remain."

It was during the war years and the years following that Marini's vision reached perhaps its fullest expression—or, to put it another way, arrived at a new vocabulary in respect to the man's own temperament and conviction. The Mediterranean language had been there from the beginning—the Pompeiian warmth, the Hellenic fullness, the

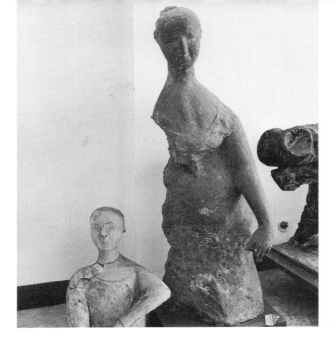

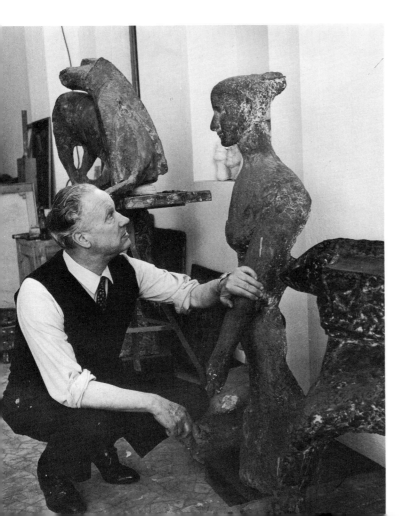

sensate devotion to a tradition — but with time, Marini allowed other personal promptings to alter the balance of his work and give it a new harmony. The great vehicle of that transition—even beyond the nude, most potent symbol and vehicle of the Mediterranean vision—was the theme of the horse and rider, the motif that has become inextricably associated with all Marini is and does.

The first riders, done in the thirties, are rather more Roman than Greek in origin. They have a certain bluntness, though a grace, even in the relative proportions of the man and the horse. At least the two are divisible: there is a rider mounted on the back of a horse. But later, the rapport changed. The horse and rider became, from two entities, one. Their rhythms united. In some cases, the human figure is reduced radically in size, so that it appears to be the crest of

MARINO MARINI / 175

a great muscular wave. In others, the motion of the horse and the motion of the rider oppose each other and create a tension. There is, in the series, a whole scale of values—formal, emotional, observational, and symbolic. I asked Marini about the origin of the theme. The answer was surprising.

"The idea of the rider came out of a trip I made to Germany. The most curious part is that instead of noticing the rider here—there are so many of them here in Italy where it's in the old tradition—the impression came to me when I was in Germany, in Augsburg, when I saw the great riders in the cathedral. It gave me the impression of something absolutely new, the style completely different from the Italian style. Less sensuality, but much more style and poetry in a literary sense. That was the first impression. And after the visit to Germany, I returned to Italy and I noticed that my development in sculpture began to be involved with this idea. Then I began to construct knights. . . .

"It's the knight with the long hair, between man and woman, that gave me a rather more literary idea, in a spirit that doesn't exist in Italy. It was a bit the contrary of me, and the surprise of it made me reflect. After this surprise, I returned to Italy, but the idea stayed in my head, this flash of poetry that I rediscovered in Italy, because here there are enormous numbers of horses, between Milan and Venice, Milan and Rome, and always have been."

In other words, Marini saw a way of opposing the natural inclinations of the self, and the suggestions of his own environment, and it was this that led to a new dimension.

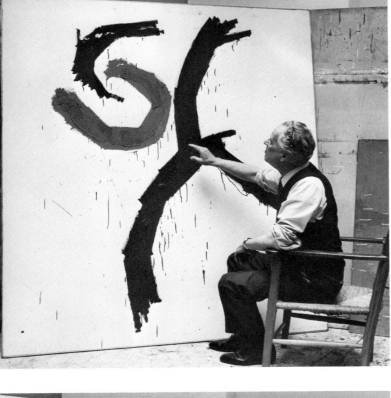

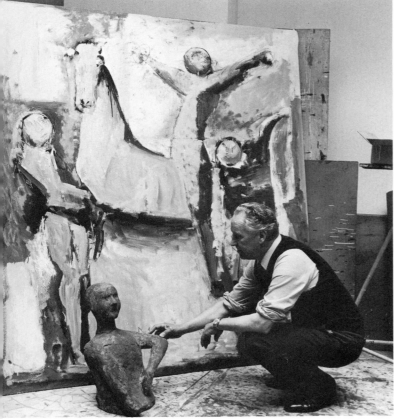

He did not turn against his self; he simply enlarged it by exposing it to its contradictions. Such an enlargement represents not an arithmetical but a geometrical progression.

——Interesting that you speak of a literary side. Just how did you see the Augsburg rider as literary?

"You have to think of the Mediterranean—that I was born in the center of Italy. My spirit is based upon sensitive and sensual questions. Well, when you cross the Alps the art of the other side becomes much more stylized, and it's this difference that impressed me: finding something far more stylized, less sensitive. That's what gave me the idea of working toward that attitude in Italy. All the sculpture born in the northern part of Europe has, for me, much more interest than that born in the light of Greece and Italy and Spain. The formation of the artist is very different. Here it's a man who has joy in his heart, which passes in turn to the head, and becomes a work of art; but in the north it's the head that receives the first impression of things, and then passes it along to the heart. In the Mediterranean, it's sensitivity and sensuality that count a great deal; on the other side, it's the head above all—and then comes the heart."

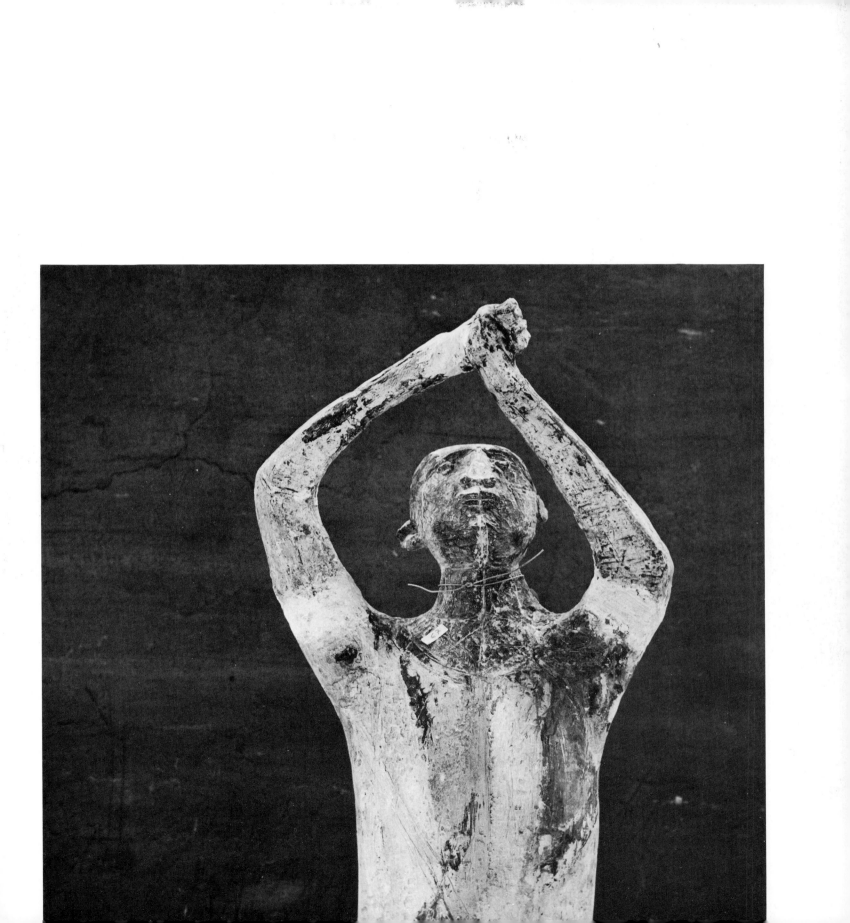

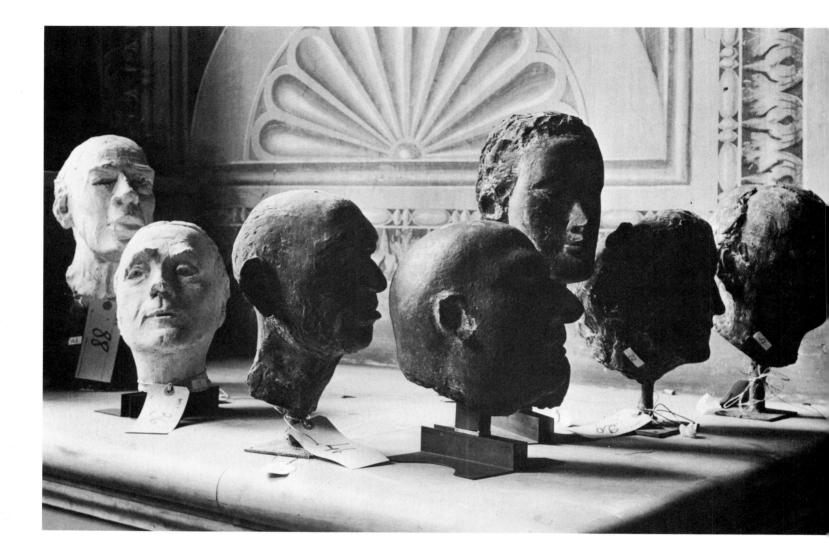

——But in your case, it's both.

"In my case, I am a Mediterranean. In my case, it always begins with the heart."

——There is a plastic and formal side to your work, and then there is a specifically human side, including a quality of sentiment, of attitude.

"Because, at heart, it is also important that the sculpture be alive in its material presence. The material is treated in a hot, volcanic way, like the earth here, like the mountains—which, on the surface, are far more hot than the mountains of the north. And so, one finds that difference again in the surface of the sculptures. Again and again I look at nature, at the mountains, to find the spirit of the material, to put it in the sculpture. It's the same thing."

——Do the sculptures in wood concentrate about any one period?

"The sculptures in wood come out of all the periods—from the thirties as well as the forties and fifties and sixties. From time to time a wood sculpture develops independently, but generally I first make models in bronze—one, two, or three. And only then, at the end, do I make a model in wood. It's a dialogue of material——"

One might expect the wood—direct, carvable, accessible—to precede the bronze. But it may be significant that Marini works first

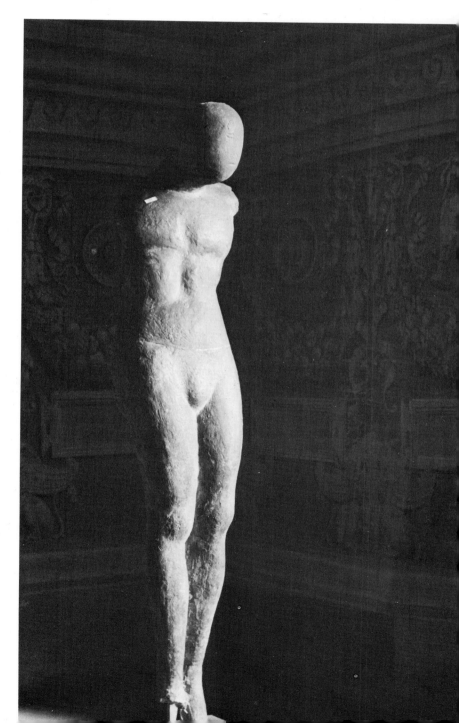

in the more distant, the more complicated material before tackling the uncompromising, face-to-face quality of wood.

Often the wood sculptures tend to be sharper, harsher, even more brutal than the bronzes, which are mellower in consequence of the material. And yet the wood sculptures are always painted, which introduces an additional lyric element. Often there are painted stripes or even diamond shapes that introduce a theme in counterpoint, though not in dissonance, to the line and volume of the sculpture itself. In part, this element belongs to the transition from painting to sculpture that Marini likes to put into practice.

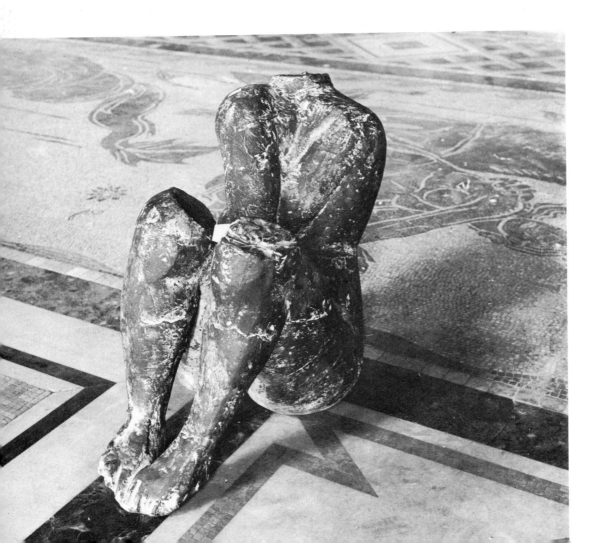

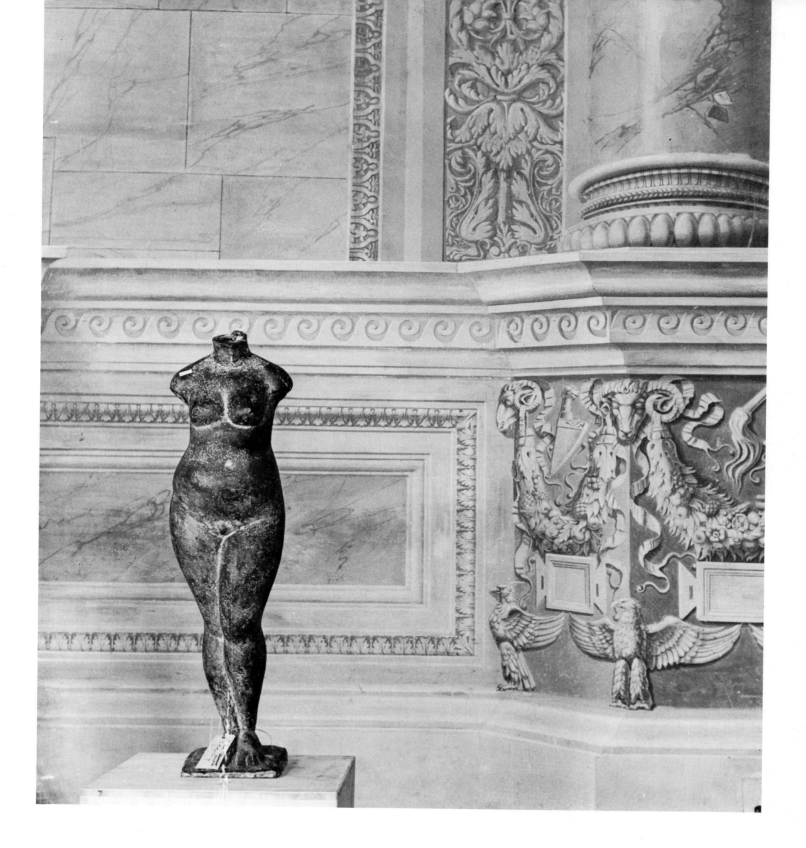

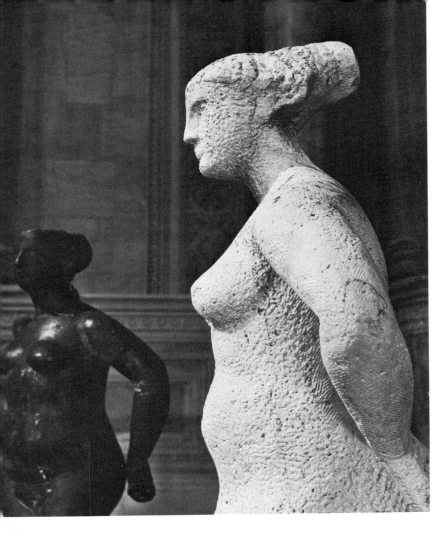

The colors of a Marini painting are warm, effulgent, lyric. And they tend to establish the form and volume of the painting even more than the line itself, which is unusual in the work of a sculptor.

"The painting always comes alongside the sculpture. I always begin with drawings in color. It's the beginning, the entry into the spirit of the thing. After I search for the color, I search for the form, the line inside it. And then, when I am very sure, I begin the sculpture. I always begin with the drawing, or even a painting. Of course, when they are finished, some of the sculptures are also colored. First of all, sculpture has always been colored. The Etruscans, the Greeks, the Romans, the Gothic sculptors, all of them colored their sculpture—but in a scarcely realistic fashion. Colors might appear unexpectedly, just like that, on a face—

"And time also adds a mysterious color. The colors of Piero della Francesca at Arezzo, for example, were once far more vivid, but time has lowered them in key. He used incredible colors: reds and very strong blues. And time lowered them in key. I, too, have dared to put down fairly strong colors."

In March, 1966, the Palazzo Venezia in Rome organized a large Marini retrospective

exhibition. Marini spent several weeks in Rome helping to set it up.

The palazzo, which stands opposite the blazing white monstrosity known as 'the wedding cake,' the monument to Victor Emmanuel, is a Renaissance palace far grander in architecture, if less cherished in memory: this was the home and office and ranting ground of Benito Mussolini. Marini showed me around.

"That's where he had his desk— that idiot! This was his office. The works of the later

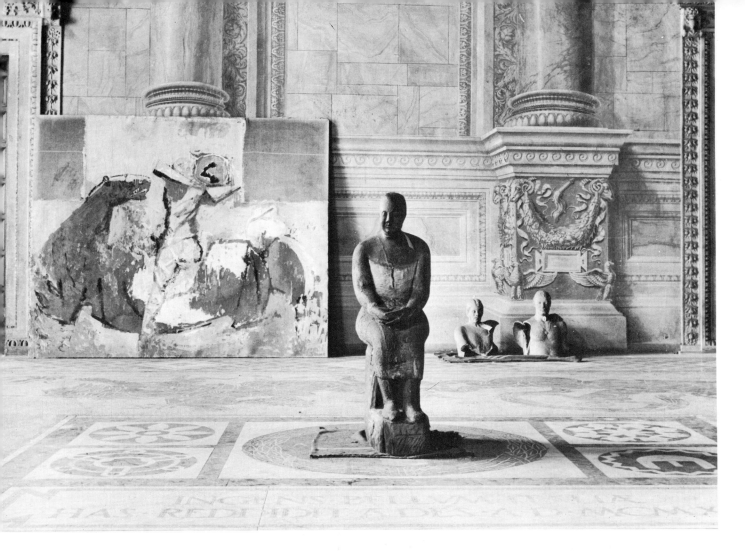

periods, the middle and recent works, are in
the rooms that used to be the living quarters.
Once there were soldiers stomping about
here—boom! boom! boom! And that's the bal-
cony where he declared war on the world."

The exterior of the palazzo is pure and
strict and architectural. The interior tends to
be a stage set, rather more appropriate to
Fascist pomp than to the great humanism of
Marini's sculpture. In addition, the towering,
painted walls seem to absorb light as they
climb, and to exude shadow. The sculpture

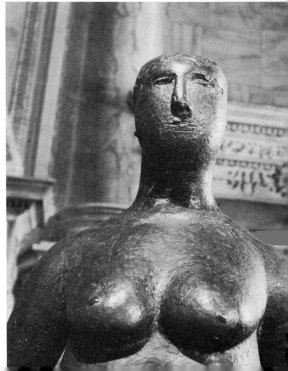

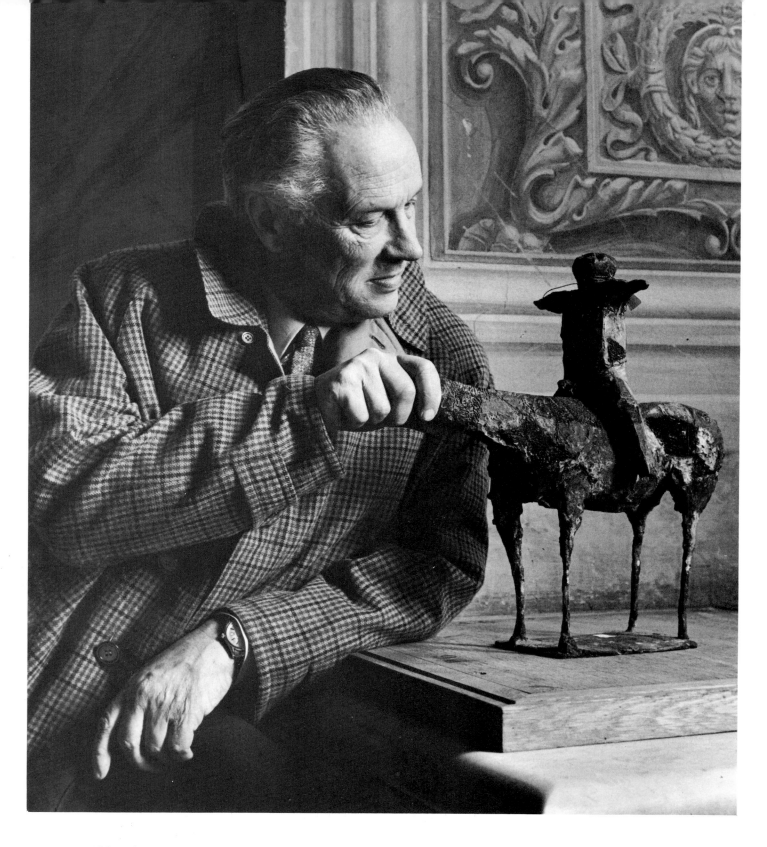

was being hauled about, tried and retried, and for the moment the place was neither palace nor museum but a kind of superstudio where finished works from Marini's place and from an international variety of collections were being tested against each other and against a new, almost inimical environment.

The great nudes, the riders, the portraits were clustered in arbitrary groups, numbered exhibition tags indiscreetly tied to their necks and legs. In one deep window niche Henry Miller, Marc Chagall, and Henry Moore stared helplessly into the dark while elec-tricians, moving men, Marini, and Giovanni Carandente—the Palazzo Venezia's director and organizer of the exhibition—struggled to arrive at a solution to a diverse problem.

The last of the three great halls contained the most recent works, riders similar to some that Marini had just been finishing and study-ing at the studio in Milan. The change from all his previous work is considerable. The volumes tend to be flattened into planes. The color is also flattened, not only in hue but also in resonance. The rhythms have become rather more abrupt and staccato. In sum, they

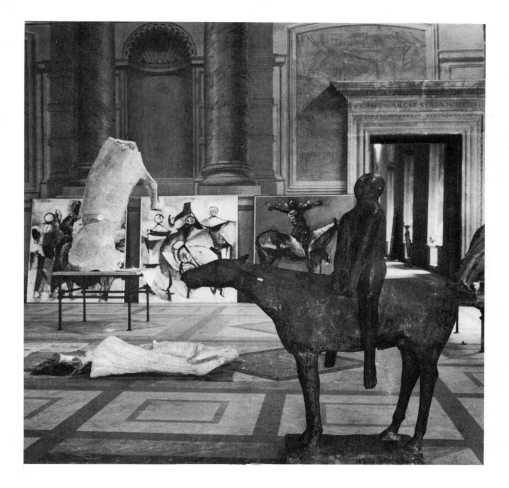

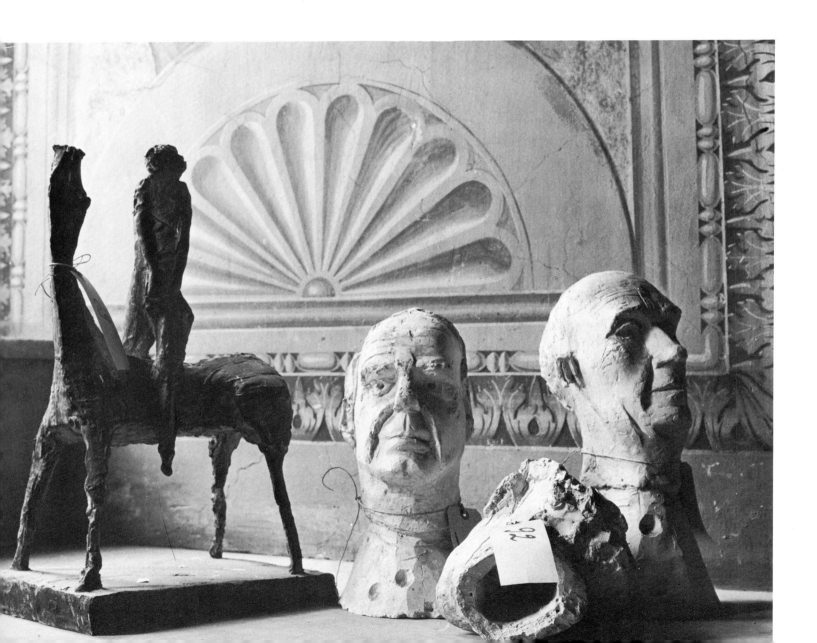

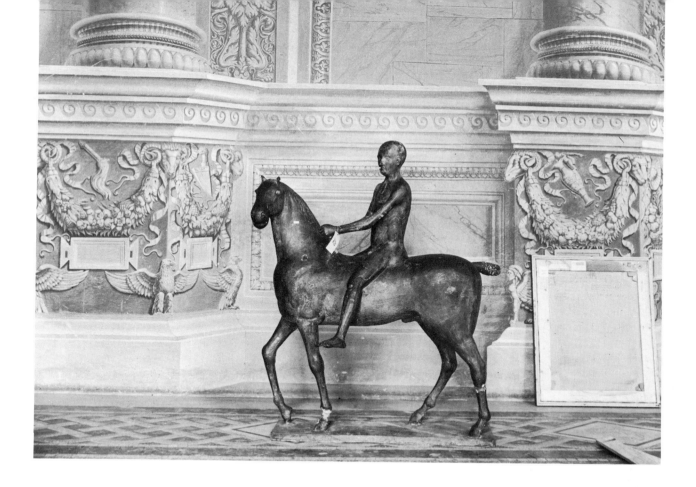

are far more abstract. Are they an extension of the path Marini has been following, or do they represent a new departure, a new direction, even in temperament itself?

"I would say that I was born— like an apple— that is to say, natural. A natural man who loves nature. But of course life has changed. The first period is therefore more sensual, natural, sensible. The second period is rather more of an expressionism. And the last of the groups is architecture. It's still the theme of the rider, but changed in its form. Instead of having a realistic head, it has a flat head. It's still the same idea. Only the form has changed. It has been given the liberty of being flattened instead of being round. But even in virility—if the figurative things are virile, then the others, which are not figurative, are also virile."

These works, then, are seen by Marini as new transpositions of a consistent impulse. But are such transpositions strictly possible in the world of Marini's particular humanism, with its characteristic warmth, its relationship to the savor of nature, its color (in the special sense that a voice has color)? There is a particular warmth to the greatest works of Cubism, too, but this is not the world of Marini. His architecture, though real—or virile, to use his own word—has always been

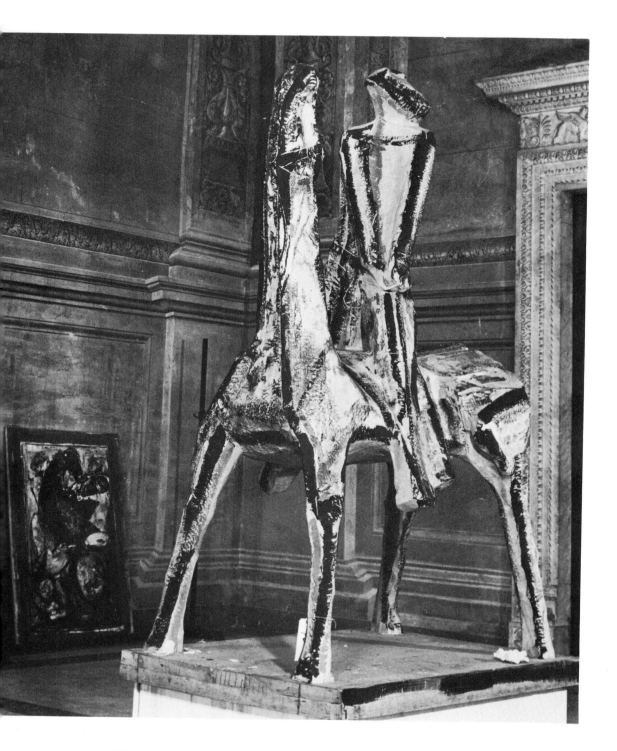

fluid. He has always allowed life to rise up through his forms in the way a warm spring rises from some concealed point deep in the earth to the calm surface of a lake.

In fact, these newest things do veer from that consistency. And yet, on the other hand, the approach Marini has taken in these recent works does rather resemble—at least in its outline—the process that first triggered the horse-and-rider theme in Augsburg: the application of a formalized—or, again in Marini's words, a 'literary'—impulse. In that sense there may be a direct parallel.

As decision followed decision and the show began to take shape, sculptures and canvases changed position in a continual quadrille. "Everybody wants his picture to be here, but I'll have to eliminate a good deal because the museum isn't big enough. If there were another room it would be better——"

It seemed a good moment to slip out of Rome and take a train up to the beaches of the Lido. It was splendid, cold but not too cold, with a blunt, almost wintry sun over the black sand and the lambent seashells that glimmer in the tide. The bathing cabins were empty, most of the cafés were closed, the beach was deserted. The only sound was the sound of the sea— until a voice called out. It was Marino Marini, with his wife Marina. They had had enough for the time being. At the beach, shapes are simple and spaces infinite, where the architecture of the world began.

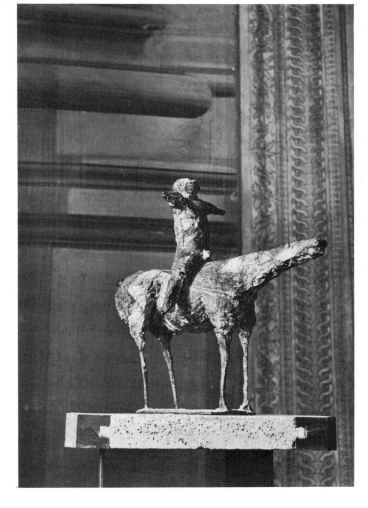

Henry Moore

HENRY MOORE HAS BEEN GRANTED the best of two worlds—the world of recognition and the world of exile. He is recognized as England's first sculptor and as an important influence in modern art. And yet, current trends in art, trends tending toward a spirit of spiritual alienation, have freed his own balanced works from the highway of fashion, from merciless imitation, from institutional assault. In other words, Moore is now the elder statesman, yet still the outsider and full-fledged revolutionary.

Seen in retrospect, his work describes an evolution remarkable in its scope. Giacometti's expression was honed to a fierce and metaphysical intensity. Arp's was directed toward a consistent and formal purity. Moore's is as searchingly broad as it is precise. His grasp is wide and his poetry is developed with a huge conceptual generosity.

Not since the earliest works, with their several influences appropriate to early works, has Moore's expression been diminished by external fixations or temporary fidelities. The Underground-shelter drawings of wartime are directed outward toward a situation as well as toward life itself; yet the 'disassociated form' carvings of the mid-thirties are distinctly interior. The early family groups of the mid-forties stem from specifically human associations, and even the 'abstract' ones remain so in spirit; but other human forms done even earlier, during the thirties, have a distinct rapport with Surrealism. The 'standing motives' of the mid-fifties suggest a fascination with 'primitive' art; on the other hand, the most recent works, such as *The Archer* and *Locking Piece*, are in many ways highly urbane. Yet none of these paths can be called digressive, none of them represents a momentary polarization. Each reflects the shape of Moore's creative intelligence in its fullness.

Moore works incessantly at Hoglands, Perry Green, his estate at Much Hadham, Hertfordshire. He has arranged his own effective exile, has not waited upon circumstance. Celebrity hovers beyond the gate, and occasionally filters in by telephone and plane and train, but it is kept at bay. Silence prevails, at least enough silence for uninterrupted work keyed to a devastatingly accurate schedule.

Turn up at the Bishop Stortford railroad depot with a camera bag and tripod, and someone will step up and say, "I know. 'Enry Moore." And the cab ride will include a critique: "Nice chap, ol' 'Enry Moore. Kind word for ever'body. 'E 'ad me in once. Showed me all aroun'. 'E asked me what I

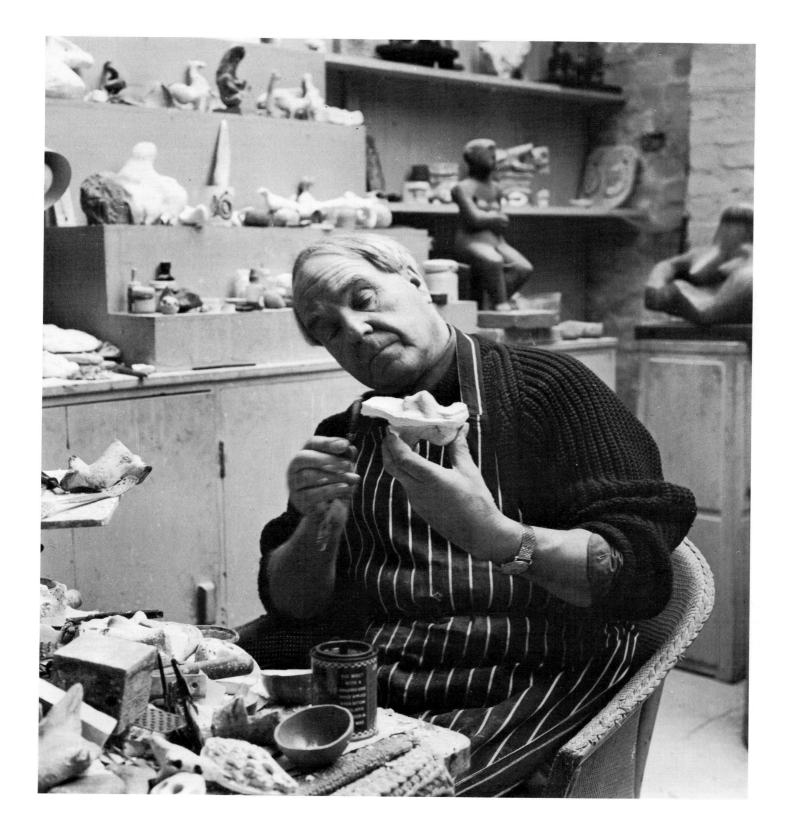

thought of 'is sculpture. An' I tells 'im straight away: ''Orrible.'' And then, the people next door have a white, imposingly banal garden faun poised between their estate and Moore's. One day that chimera may preserve the exile of Much Hadham from archaeologists.

The house is Elizabethan. In the living room —a modern attachment—there are two Courbets, a small, wonderful Cézanne *Bathers,* and a Vuillard, along with a number of small works of various periods by Moore. Just beside the house is a studio building, which includes the maquette studio where ideas are originated. There Moore works in plaster, surrounded by a world of forms, some em-

bryonic, some beyond the period of gestation, and some—pebbles and shells and wood fragments — which are indicative objects found, caressed, studied, and kept about in cardboard boxes. Moore said, "The impetus for working comes from outside, from nature, from looking at people, from one's knowledge of the human figure, from natural forms . . . trees . . . bones . . . pebbles." The walls, the shelves, the tables, the chairs, the floor pullulate with sculpture and sculptural objects. You might call it a state of deeply organic disorder.

There is very little real disorder, however, in the world of Henry Moore. The day answers to an astonishing precision. An hour

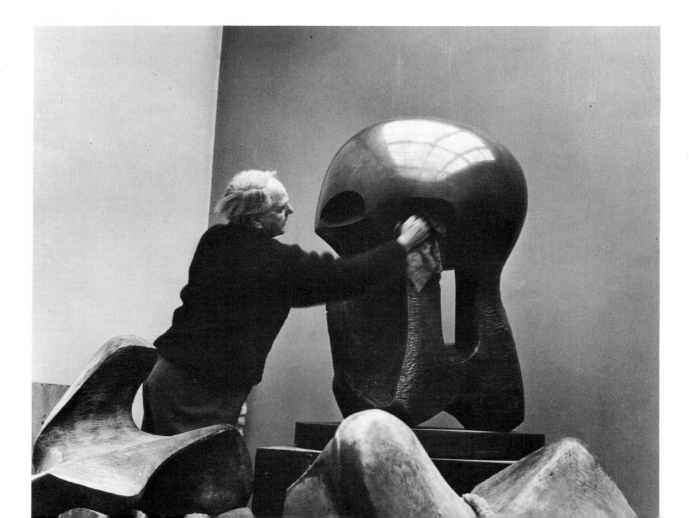

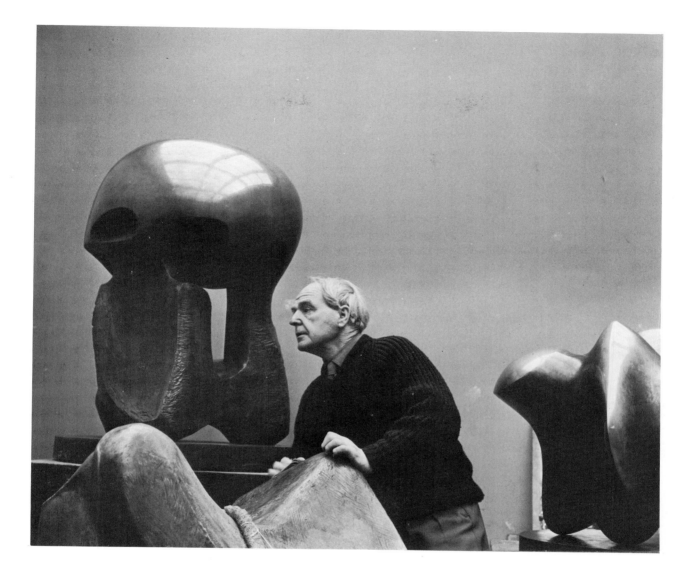

and a half of work before or after lunch is an hour and a half before or after lunch, and teatime is teatime. Moore has been known to state that a given work will be completed in two more weeks, or three more weeks, or whatever. Thunder grumbles over Hertfordshire; Moore glances out the window and pronounces, with the splendid certainty of a Dr. Johnson, "There will be a storm in three minutes." Perhaps any Yorkshireman can do that. At any rate, in three minutes there is a storm.

Next to the maquette studio is a transitional studio where sculptures arrive en route to or from museums or when in need of repair. And so this long rectangular room becomes something of a museum itself. There are sculptures of various periods about,

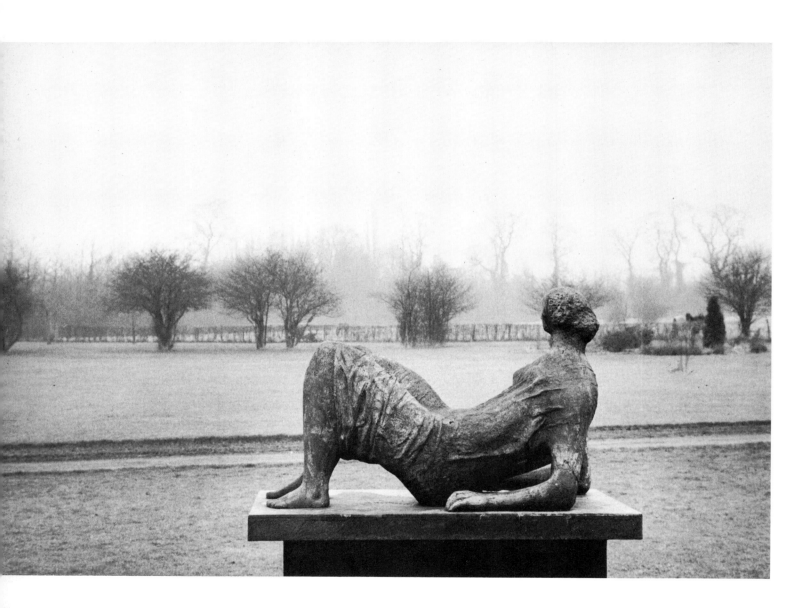

mostly bronzes, in interesting random juxta-position.

The 'garden studio,' where the very big projects come and go, is far down the sloping lawns, which sprawl over acres and which might themselves be considered part of the studio. Sculptures turn up here and there, against the gray sky or sheltered in a grove of trees or proffered by a long, portentous lane. Moore explains that he insists upon working outdoors on projects likely to be installed outdoors in a light and space and perspective that have nothing to do with studio confines. At the time of his work on *Reclining Figure, Lincoln Center Piece,* he ordered construction of a great hangar, an iron frame covered with plastic, to maximize daylight in winter and in bad weather.

During the cold months, great plaster forms shrouded in plastic dot the lawns. They hibernate, like acorns, in stiff, frosted shells. And then, in late spring or summer, they come alive again. During the summer of 1966, there were two such at Much Hadham, *Three-Way Piece No. 2,* known as *The Archer,* and the great *Locking Piece.*

The Archer is a tense, almost pelvic form. A lateral thrust unites with two other forms, the one hemispheric as in a distended bow, the other rather more grounded and distinctly vertical. Moore remarked that one of these longitudinal forms seems to suggest a female

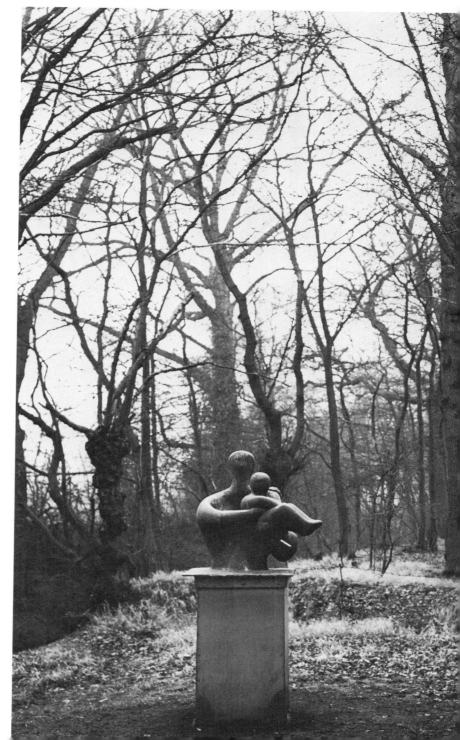

role, the other a male role. But, if this is so, which is the masculine and which the feminine seems rather to depend upon the angle of vision. Moore said that in fact the man from *The Times* had referred to the sculpture's forms as "androgynous"—that is, possessing the attributes of both sexes at once. And to some extent that fact typifies the resolution of opposing forces and of ambiguities that is characteristic of Moore's work.

Moore sent the plaster cast of *The Archer* as his contribution to a posthumous tribute to T. S. Eliot, held in London. Though the piece had in no way been conceived with that in mind, there could have been no more appropriate a salute to Eliot's poetry and thought. Classical in its heritage, classic in its balance, precise in its articulation, *The Archer* might be thought of as a parallel to Eliot's deep sense of redemption and resolution:

When the tongues of flame are in-folded
Into the crowned knot of fire
And the fire and the rose are one.

There is no need to plumb ulterior, psychological motivations behind Henry Moore's sculpture, yet his work is very human, and in the fuguelike appearance and reappearance of certain themes and forms there is an almost obsessive pattern. Moore spoke of one of these:

"The helmet idea has been a persistent one in the background, and about every ten

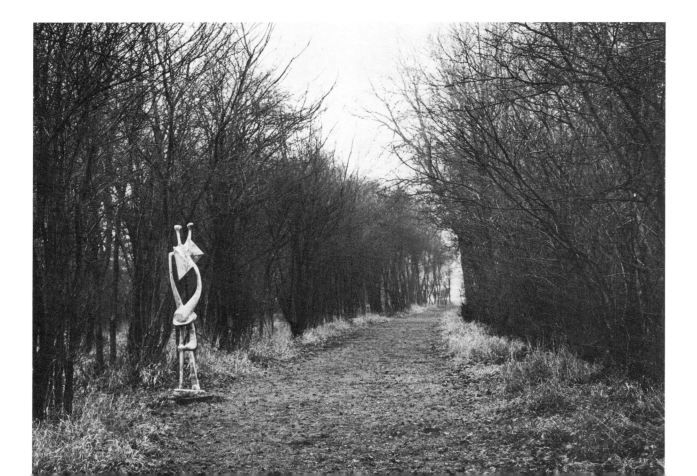

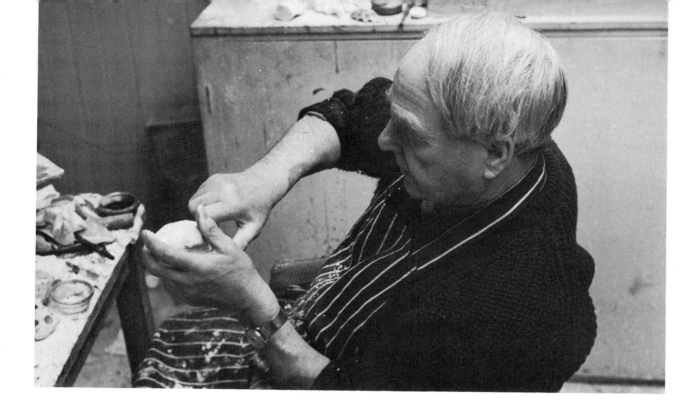

years, so it seems, I go back and do some variations on this form inside another form, which is the helmet idea. It's mixed up with one's liking or response to seeing armor, which is the outer shell enclosing something. It's also mixed up with the mother-and-child idea, where the mother is the big form protecting the smaller form. It's also probably mixed up with a kind of protection of an embryo in the womb. And this idea, to me, this form inside another form, is a theme that could be almost never ending. But one doesn't want to exploit a particular theme just for its own sake. I wait until the interest comes back, and then I do some more. But it is the kind of idea that one could quite easily— well, although far more profound, something like the string figures that I began doing in 1938, and which others afterward developed. But I gave them up because it became, for me, too easy to make variations on this theme. One could be ingenious and produce interesting things, but not something with the real germ of an idea in it. I think that the interior-exterior idea, or the helmet idea, has much more fundamental human depth for me."

And yet, what of the large commissions directed toward specific ends, such as the recent *Atom Piece*, a tribute to Enrico Fermi and the atomic energy 'Chicago Project'? (An intermediate-sized bronze maquette was then in the garden studio.) Much has been written about the sculpture's mushroom con-

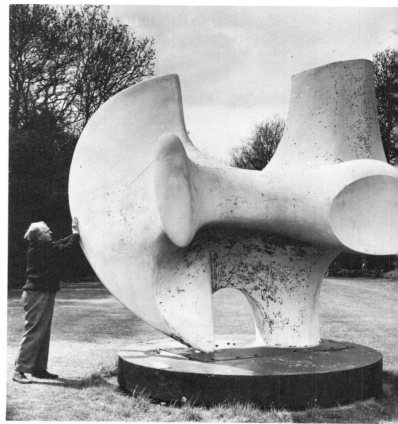
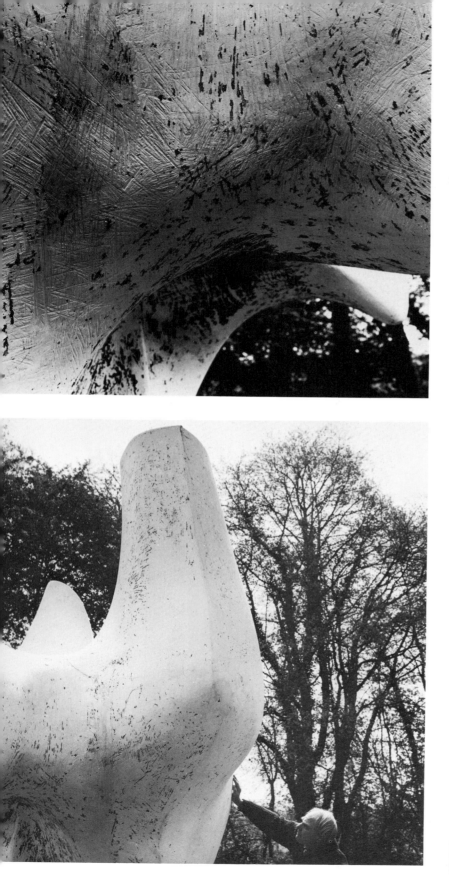
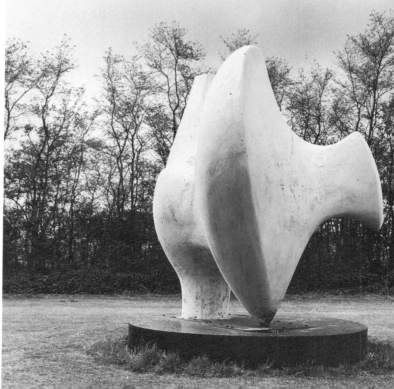

struction, its menacing skull shape, and its simultaneous suggestion of atomic energy harnessed for peaceful purposes.

"In this case, in most cases where a sculpture of mine is used or finds a public position, I prefer not to do a commission, trying to make something fit a place that I haven't thought about. I prefer that something I'm doing, or a direction I'm working in, is found to be suitable. . . . In the case of the Lincoln Center piece, the actual idea would anyhow have been done half the size that it was, and for me alone, and would have been shown in exhibitions or gone to a museum. Instead of which, when the Lincoln Center people approached me about doing a sculpture, I realized that the size, the scale, was very important, and I welcomed the fact that I was being asked to try out a much bigger piece of sculpture than I'd ever done before. And again, the problem of its coming out of a pool was one that I'd thought about

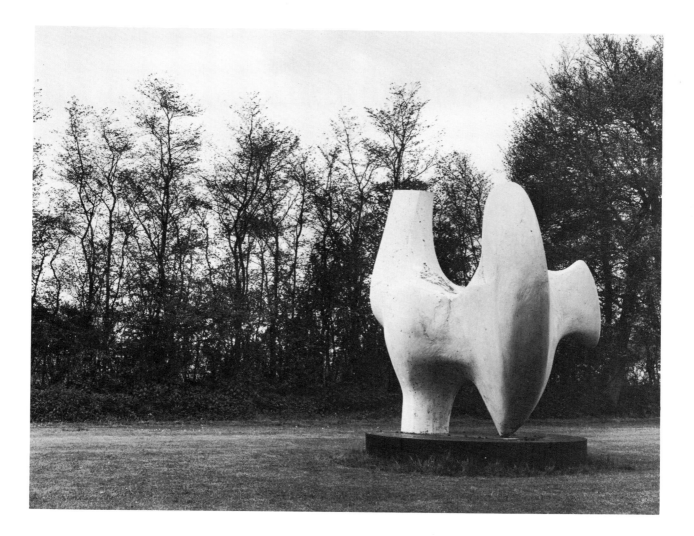

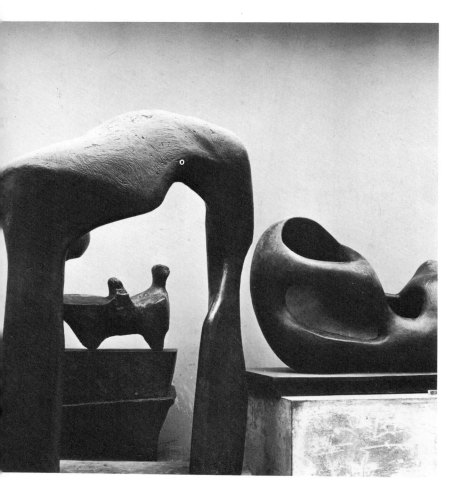

but never had the chance of really carrying out. But the sculpture itself is a piece I would have done anyhow. It isn't that it was a commission I hadn't thought about.

"Now the same applies to the nuclear energy piece. It happens that I'd done a very little maquette three or four weeks before the people from Chicago University came and asked me if I wouldn't do something as a memorial to Fermi and Fermi's discovery. In this way, I think, you produce better work—through its being a natural development in your own direction—than if you try to stop and think of something special. I prefer not to do commissions. I like my work to be used, but I don't like to make a piece for a special purpose I hadn't thought about. And then again, the UNESCO sculpture is a stone reclining figure, something of the sort I would have done, but I was able to do it bigger for

Final study for *Reclining Figure, Lincoln Center Piece*

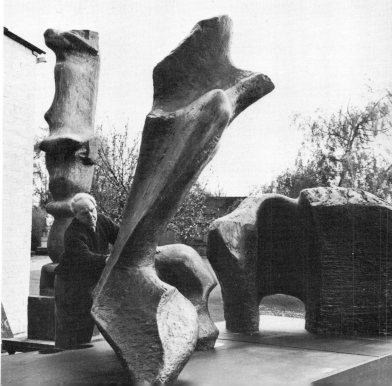

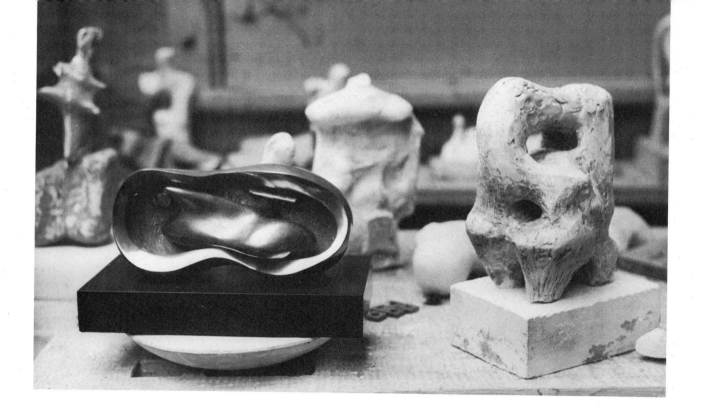

UNESCO than I would have done for myself. That's the main difference."

But the problem of scale, emotional and physical, is of course a major one. I asked if the little plaster maquette he had just been modelling, calculating, envisioning in the small studio was in fact a study for a larger project.

"Well, my general way of working now is unlike what it was when I began my career as a sculptor. In the early times, I used to make drawings, lots of drawings, before doing a sculpture. . . . Now I work much less from drawings— I like to work direct, on the little, solid, three-dimensional object. And as

I am doing it I have an idea of what size I mean it to be, in the same way as if making a sketch in a sketchbook, a sketch for a monument. The sketch might only be an inch big, but in your mind it's meant to be over life-size. Well, the same way with these little plaster maquettes. As I do one, I sometimes lift it up and look at it, and I can see it against something else, in scale, as twice, three times life-size, if I wish. So that these are only ideas, and I prefer to do perhaps ten or eleven little maquettes, only one of which may ever get carried out as a large, full-scale sculpture.

"But then again, when one begins to work

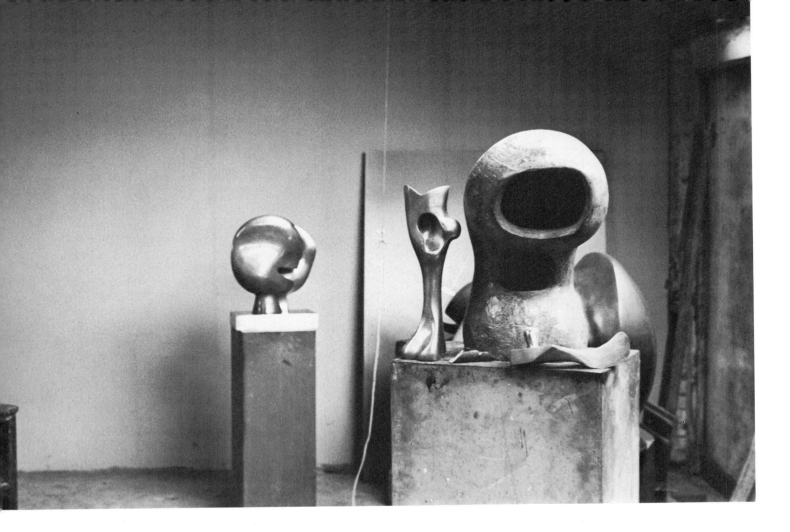

on that one, if it's going to be very big like the Lincoln Center or the nuclear energy piece, then I don't jump from that little two-inch, three-inch maquette straight up to two or three times life-size. I'll try out a working-model size in which alterations will take place. And then alterations will take place again as one does the big one, because the size of something— well, one sees it in perspective in a different way from what one does as a small thing. So that always one is prepared and ready to alter and make changes as one carries a thing on."

Moore covers the few hundred yards from the maquette studio to the garden studio with the long, determined strides of the solid Yorkshire workman, yet also with a tilt of jaw and solemn propriety of step rather more that of the patrician, the patriarch. He squints critically at a sculpture a way down the lawns, communicates with it across an instant of silence, while his work crew—who assist with the mechanics of large projects—turn up the BBC on their transistor. A rock-and-roll group chant something haunting and irrelevant. Moore's thoughts are else-

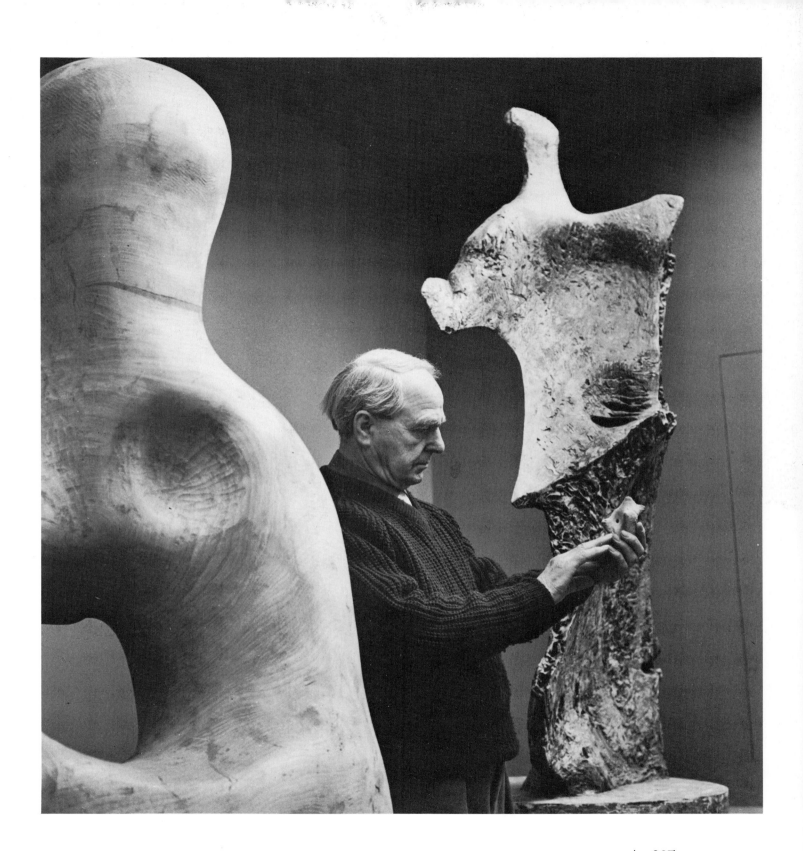

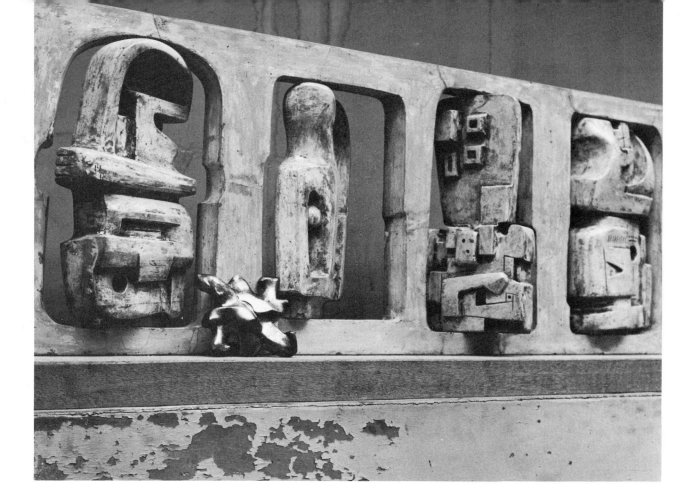

where. One thinks of Shakespeare's recurrent counterpoint of kings and gardeners, timelessness and time.

"Well, I've always believed—and still do—that the real basis of our understanding of form is ourselves, comes from our own bodies, from our own shape, from the way we have to stand upright, from the way we walk—all to do with the human form. If the human form were different from what it is, then the whole of our understanding of form might be different. If we went about like animals on four legs, then our sense of balance wouldn't need to be quite what it is when we are on two legs. And this sense of the upright is much more necessary for human beings because they stand on two legs than if they were like a table that can't fall down. . . . I have the belief, really, that even purely abstract forms can be understood because human beings are what they are. I mean we know— you can tell if someone touches you, if one part of you is touched, you know where that is. That means it gives you a sense of space because that is in a different place from another part. . . . All this is our sense of form. And for that reason I think we should never get away from the human form."

Which has never meant, in Moore's case, a subjection to the circumstance of human form, but rather a liberation through its biological truth and formal suggestion. The physical fact is always precisely articulated in Moore's work, and yet balanced, opposed, by a spiritual force, almost a denial of matter. Call it the flesh and the spirit in dialogue. Surely Moore's famous negative shape, the 'hole' that participates in so many of his figures, functions to this end. It articulates the fullness of flesh, the weight of wood or stone, interior and exterior; at the same time it opposes the finite limitations of all these entities. Again, in the case of the great Lincoln Center project, Moore produced a two-part reclining figure in which the lower portion—the legs—doubles as landscape. Moore has been quoted as saying, "I've a feeling that I'd like the sculpture to rise out of the water like the cliffs of Etretat . . . the ones Monet and the others painted. I had them in mind when I was doing the *Two-Piece Figure No. 2*, the one that's now in the Museum of Modern Art in New York."

Thus, flesh as flesh, flesh as spirit, flesh as earth: a reality expressed through metaphor, but, still more basically, a metaphor that is a reality. At Much Hadham, I phrased, as best I could, my idea of this opposition of physical fact and spiritual fact, physical weight and spiritual uplift. Moore was a bit uneasy about putting it that way. He rather preferred a plastic or formal definition:

"Well, if I do follow what you're meaning, I agree. I think that you do have to have opposition. I mean that everything holds its opposite. And if it doesn't, then it's character-

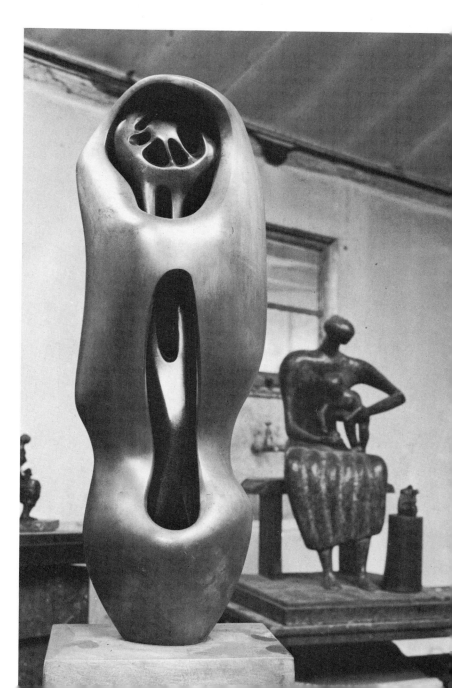

less. I mean that you don't understand what thinness is if you don't understand what bulk is. You don't understand what space is if you don't understand what form is. That is, the opposites should be understood to understand either of them properly. And you're quite right that there should be a sort of struggle or conflict that one is attempting to solve, and not for it to be tame and dull and empty. For instance, I feel that form shouldn't be approached only from the outside. One should approach it from the inside as well. And there should seem to be in a sculpture an inner structure, even in a carving, as though there's some force emanating or pushing or struggling to get out. And this, to me, is what gives it—well, even if it's a so-called abstract work it should have some force in it, and not be just arrived at by smoothing down an outside surface. And this is the difference perhaps from some natural forms which are produced just by rubbing, like some pebbles on the beach. They may be pleasant shapes but they have no inner life or force because their shapes have been arrived at only by smoothing from the outside. They are pieces of dead matter that have

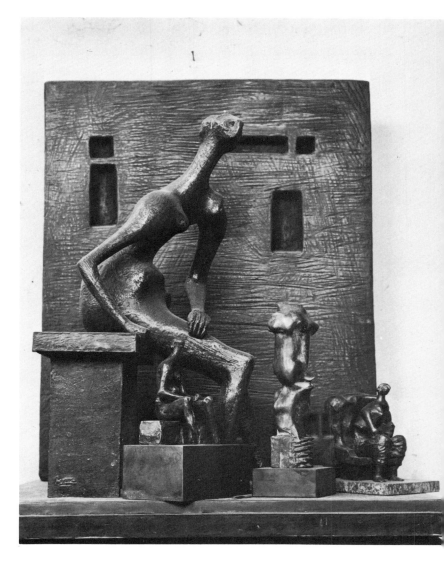

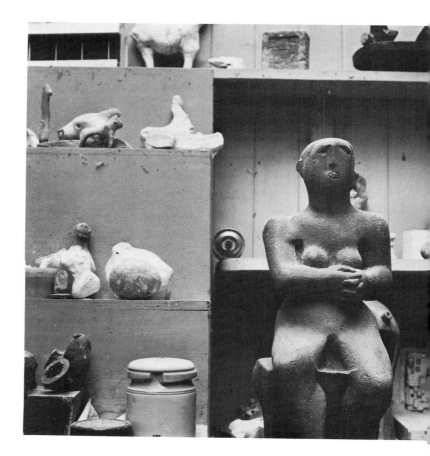

been rubbed smooth by other things. And this gives no vitality. And it's vitality, in a way, that I think you want in a sculpture. Because you respond. And it gives a kind of exhilaration if you look at something that is giving off an energy. Then it's an exhilarating response. But if you are looking at something which has been made by a process of attrition, by just being worn down, it may be a pleasant object, but it's dead."

Not that Moore disregards the living monuments of nature. He indicated a tree amid the hedgerows that mark a property boundary. He felt that the great trunk, while lost in the open, would surely kill any sculpture placed alongside it in a studio.

The large *Locking Piece*, then at Much Hadham in plaster, represents a train of thought that has seemingly taken Moore far from the specifically human frame of reference. At heart, the human element is still there in the prompting of natural forms: the indivisible integrity of bone and mineral, the unalterable logic of anatomical structure. But the resulting harmonies are rather more distant than those of most of Moore's projects —perhaps precisely because this particular

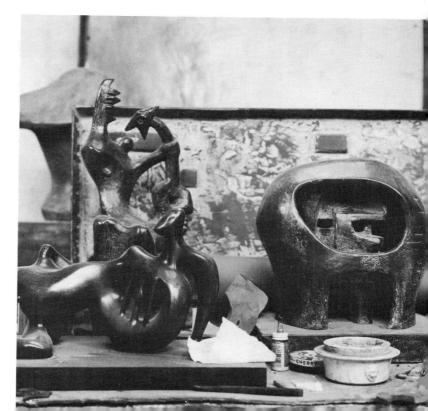

idea arrives at an elusiveness produced by its suggestion of hermetic perpetual motion, a suggestion that challenges admittance. Ought the closely meshed forms—almost cloves—of *Locking Piece* be considered an extension of the helmet idea, the womb idea, the internal-external idea?

"Well, it's connected in a way. It has something of the same kind of shape that the helmet-head has, the same proportions. And one form does fit inside another. One piece actually is held inside another one. And in making it, to begin with, one had to keep fitting the thing on to itself, trying it and seeing if it fitted properly— and then we'd take it off and alter it. . . . One side of the *Locking Piece* rests on the bottom piece, the top piece on the bottom piece. But on the other side, actually, there is one that seems to go into a bed, into a socket for it. So to some extent it has a connection. Yes, it has *some* relation with the interior-exterior—

"But, of course, any theme or any motive which is a fundamental one in one's work is likely to recur—even in a different form. That is, if an idea has got some deep meaning to you, then it's likely not to be just worn out in one or two periods. After a time one does change to other things, but then sometimes it comes back. For instance, there's the large reclining mother and child done about two years ago. . . . I didn't make it with this idea in it, but I realized after it was done that while this showed one's reclining-figure obsession, the child is resting inside the figure, so it's also connected with the exterior-interior. And it had this problem of openings that one can see from all around, which made it a more three-dimensional sculpture, which has also been one of one's aims: to try to make a sculpture interesting from all around, and even make the kind of sculpture that can't be explained through drawings. You'd even have to do several photographs to explain what it's like, and that it's not just a frontal idea, not a figure that you can put in a niche and know what it's all about. So, as I say, in this reclining mother and child there seemed to be three of one's fundamental, main, obsessional motives in sculpture, all combined in one."

The 1964 Surrealist International held in Paris listed Henry Moore as "England's first Surrealist sculptor," an epithet that seems defensible, yet oddly misshapen. Forty years and a world war after the Surrealist movement first bombarded Europe with its manifestoes, Moore's fundamental, obsessional motives prevail, while the body of Surrealism

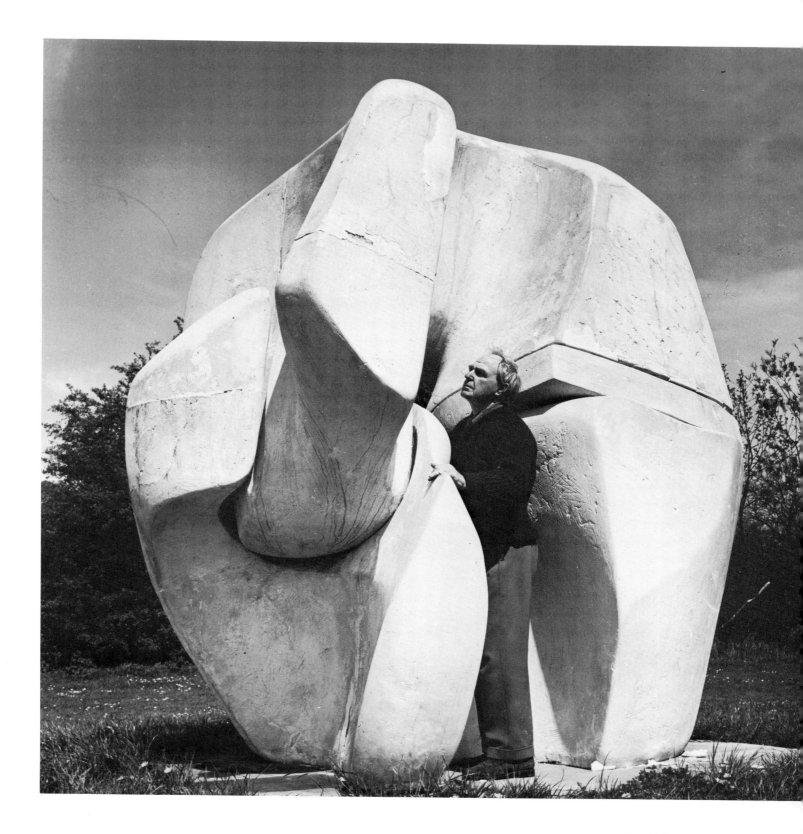

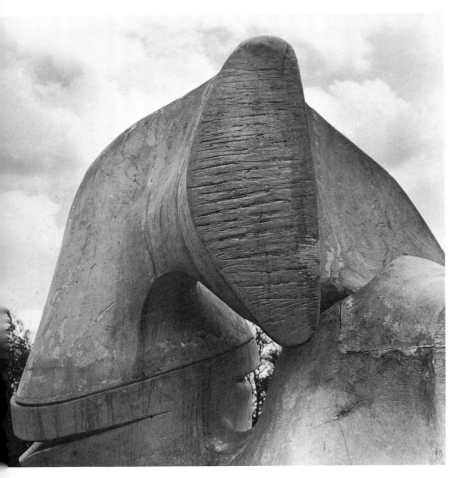

seems to have been trumped by the surrealism of present reality. One wondered about Moore's own reaction.

"Well, at the time of the early thirties, I was interested in the Surrealist movement. I knew people like Eluard and Breton, Giacometti, and so on. And perhaps, in one's work, one didn't consciously set out to subscribe to Surrealist doctrines or theory. Not at all. There was a Surrealist exhibition in London to which Breton invited one or two of my works, and of other people in England. But I never tried to be a Surrealist, just as I never tried to be a purely abstract artist, because the theories and doctrines of one particular direction are something that I've never believed in."

Again the resistance to polarization, to elliptical paths. Paul Valéry once wrote that a work of art is never finished, only abandoned. But one senses this far less in Moore's case than in others. If Valéry's observation is true for Moore at all, it is true only insofar as it can be applied to the conceptual process in which he, like any other artist, goes as far as he can and stops only at the perimeter of his thought and his senses. For the actual work is always 'finished' in its physical, plastic presence, which seems to have produced distrust in some quarters during the postwar years. The psychological and structural balance of Moore's work is so well founded as to persist in the memory after volume and vibrancy and total impact have been displaced in the nervous system by other impressions and shocks and events—which is perhaps the vulnerable aspect of a durable classicism. And then, the age—a surreal age of incessant

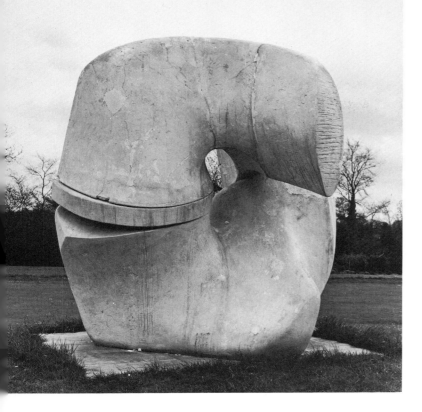

change, a time in which the inner ear has begun to adjust to turbulence—has come to question any hint of real equilibrium. Balance has perhaps become as much of a shock as imbalance was during the days of Surrealism's revolution by paradox.

"In my opinion, you see, you should be able to find unending explanations and meanings in a sculpture—not just one obvious interpretation, immediately you see it. Because if that's so, then I think you quickly lose interest in the sculpture, or in anything else. I mean, what is it in, say, *Hamlet* that has caused probably another thousand books to be written, much longer than *Hamlet* itself,

explaining what *Hamlet* is about? And it's just these multifarious and surprising variations in meaning to people that have kept interest in it alive. There is no literary explanation short-circuiting the exploration of the sculpture itself— I don't question how other people interpret one's work. As I say, I think there should be many, many suggestions in a sculpture."

The plastic, formal, haptic statement not only contains the conceptual statement but, to a certain extent, generates it and is, in turn, part of it. Moore spoke about stone and bronze and plaster, the flesh of the spirit.

"Well, I intend, this summer, to do some stone carvings in Italy. Because fundamentally, from the beginning, I was practically nothing else but a stone sculptor. From my student days up until the war practically all my work—well, three-quarters—must have been stone carvings, the other quarter made up perhaps of wood carving or a few bronzes — or wood, rather, in those days, because I couldn't afford to cast into bronze, and I cast the lead sculptures myself on a gas range, on a kitchen stove. But now, since then, as works have got bigger, as I've wanted to do larger works, I've made them in plaster, which is a mixture—or can be made a mixture—of building up, and then the plaster hardens and you can cut it down, like carving. So it's a mixture of building up, of modelling, and of carving, together. But it's very much quicker in time. And therefore it's allowed me to do in one year three or four very big sculptures. If I'd been carving I couldn't have done even one of them. And I don't any longer think, as I might have done as a young man, that stone

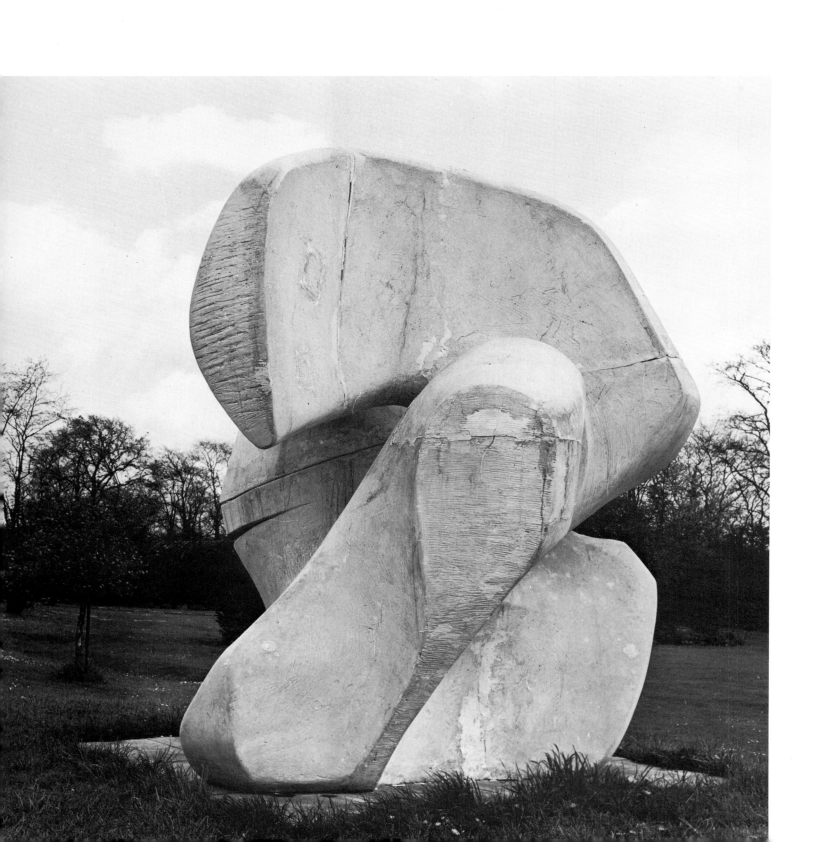

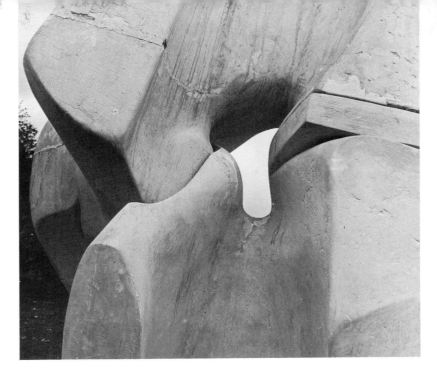

carving or carved sculpture is superior, just because it is carved sculpture, to modelled sculpture. I don't believe that anymore. I think of what the sculpture is like in itself, what is reflected of the mind of the sculptor. It won't make a sculptor better because he carves or models. The work is either commonplace and obvious or— Well, it doesn't matter, for instance, that Michelangelo painted. It's the same Michelangelo who did the carving. Yet he himself painted almost against his will. He preferred his carving, but the Pope made him paint, and I think the world ought to be very pleased, in a way, because it left a larger amount of work by Michelangelo than if he'd been left just to do carving."

So that in plaster or in stone, in concept as well as in matter, Moore's procedures describe a path toward the stillness of the work and a stillness suggested by the work. From one point of view, the path can be thought of as a means to an end; from another, it is the end itself. One work creates imperatives which will be operative in the next and which define the evolving consciousness, so that the means and the end meet and are inseparable. There is the contrapuntal rhythm of recurrent themes and there are the salient points of realization which describe the contours of the creative self. The crest and hollow of the wave are one and the same.

The continent tends to grapple with time,

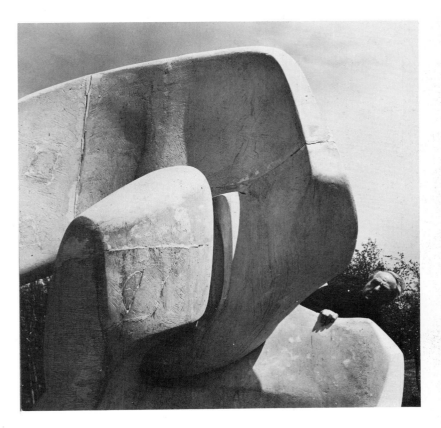

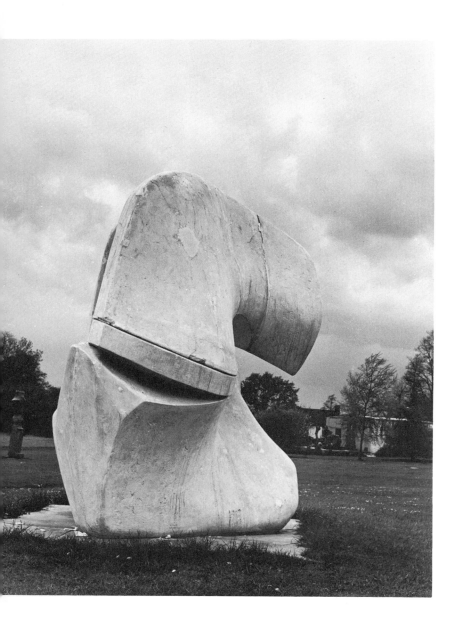

England tends to ignore it. France adheres to revolution, England perseveres in a taste for law, and each arrives at the freedom or partial freedom which its means afford. If you step into a café in Paris you bring the weather in with you, but if you enter a pub in London or Hertfordshire you tend to leave the weather outside. Which is so at The Hoops, the pub just across the road from Moore's place. Light filters through the heavy glass, excludes images. The low-ceilinged, heavy-beamed taproom encloses and protects. Miniature regimental penants define the past according to a heraldic timelessness, and the publican's resplendent red handlebar moustache is itself an insignia of permanence and well-being, part Santa Claus, part RAF. What does 'England's first sculptor' think of this milieu, of his own Englishness?

"Well, I think I know what you mean. This

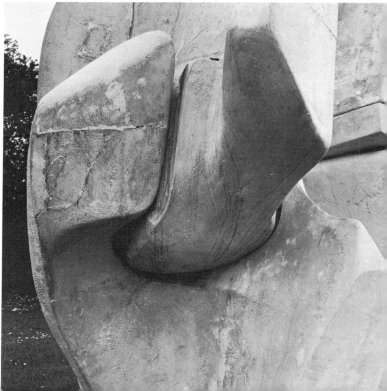

national quality is something that is perhaps there. Because I think that nobody can escape their heredity, their environment, entirely. But I would say that you should try not to nurse the little nationality you may have. I would say the greatest and most original artist England has produced is Turner. Now Turner, for the first fifty years of his life, was trying to improve in studying the works of Claude and of the painters abroad. He was competing, he wasn't trying to be English. But in the end, he winds up being more original, and more English, too, than any of the others. And this is because he wasn't attempt-

ing to do that. And I think you shouldn't try to be English. You should try to be a good sculptor. It's your own hour. There shouldn't be barriers. You shouldn't be blinkered by your own country."

——And yet, there now seems to be an opposite problem, a rampant internationalism. One can go to an international exhibition without finding indigenous traces, without having any idea which entries are from which countries.

"But sometimes one would only find these differences fifty years later. I mean, you know, sometimes two things seem the same

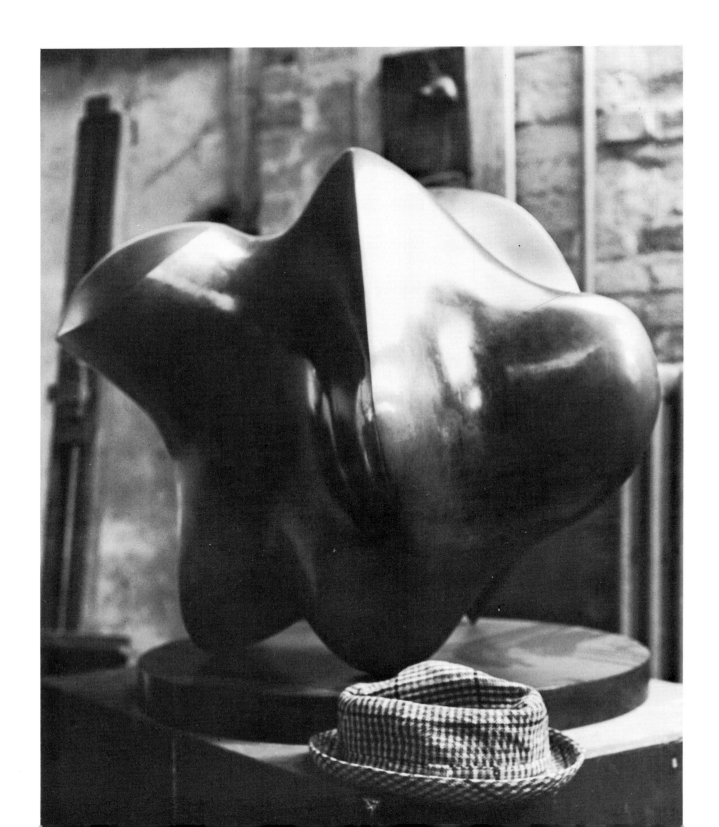

when they are contemporary, or they may seem very different. But a hundred years later you know it was of that period. Or the same with a country. Blake and Turner were in England at the same time. They must have seemed terribly different. But they have something in common which we can see years later."

Impossible to predict just how Moore's sculpture will seem a hundred years from now, but surely the *Hamlet* analogy is apt. At heart Moore is a classicist and a personal voice describing an affirmative path in an iconoclastic age. He is very much a formalist, yet his work possesses a symbolic richness, almost a literary richness—not at all in a narrative sense, but in a poetic sense that touches upon the quality of myth. His place in the history of art has to do with the development of an 'abstract' expression; nevertheless, one can never deny his immediacy as an observer of nature. His way has implicated the natural and the metaphysical, without compromising the integrity of either. He has arrived at harmony by accepting ambiguity in its fullness—which is, perhaps, the secret of being modern.

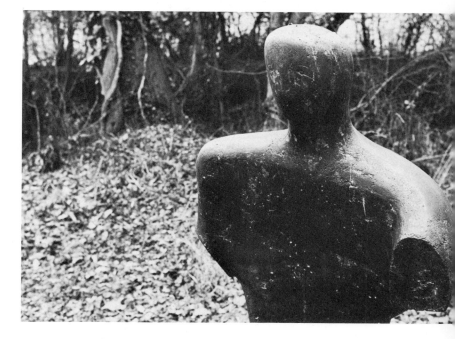

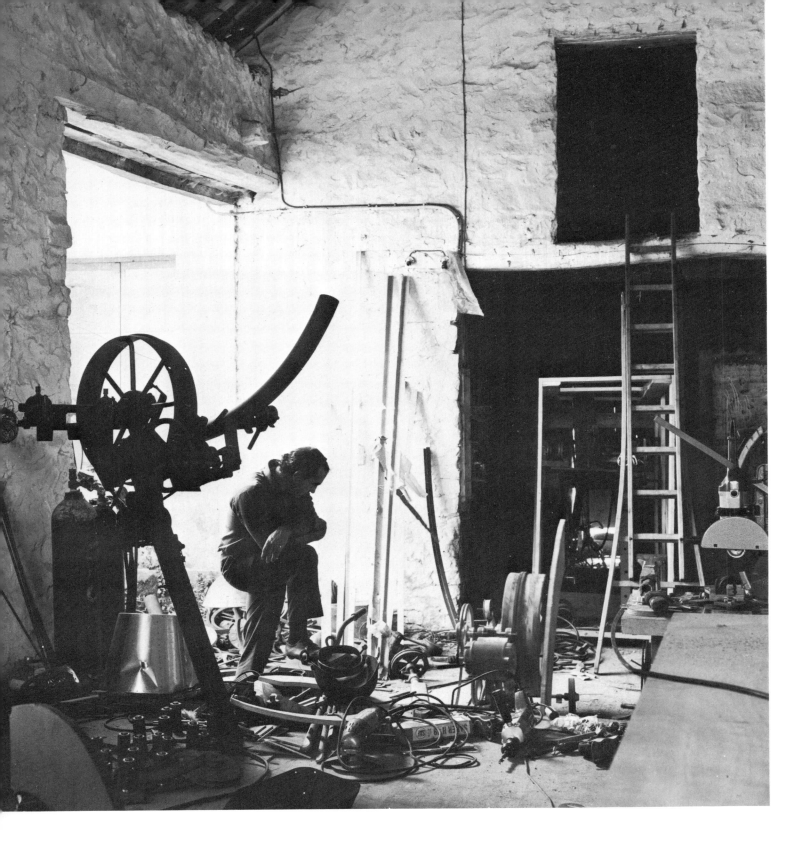

Jean Tinguely

THE ROAD THAT LINKS PARIS to Soisy-les-Ecoles is a relentless strip of steel and concrete, a faceless utility. At one end are the southern gates of the capital, at the other, green villages of wood and stone and silence. The highway belongs to neither world, neither to the Ile-de-France nor to any other place. The hiss of rubber on concrete; the cryptic complicity of telegraph wire strung between expressionless steel giants; the cynical facade of the inevitable gas station. Yet, once arrived at the Auberge au Cheval Blanc, none of that seems to exist. But Jean Tinguely, who now occupies the inn, keeps it all very much in mind. There is more than enough room there for Tinguely and for Niki de Saint-Phalle, the American sculptress, to work there together and separately at once. The signs that promise 'dancing' and 'wedding banquets' and pledge 'the suppression of public drunkedness' are still hanging. But the lawns are now overgrown with leaves, weeds, and flowers, since all order and organization at the Cheval Blanc are now directed toward sculpture.

Black and stark and dour in stillness, playful and puckish and febrile in motion, Tinguely's machines inhabit the house and the underbrush, a kind of occupation force in the heart of Nature. During lunch, a machine quakes spasmodically if rhythmically at the other end of the great hall. Outside, a great wheel mechanism glares into the sun-brilliant foliage. The huge barn structure, at right angles to the inn proper, serves as Tinguely's actual studio, and machines straddle its high stone walls like vines. Machines populate the great floor, Lilliputians and Brobdingnagians together. The wooden planks and parts of Tinguely's incipient project for Canada's Expo 67 flank one wall, a spinning, vibrating facade of kinetic construction.

In conversation, Tinguely almost never uses the word 'sculpture' in reference to his works—he almost always speaks of his 'machines.' In fact, are they sculpture? (The question is legitimate.) Perhaps they are, or perhaps they are rather the tangible delinea-

tion of an idea. Are they objects that exist primarily in the flesh, or everywhere but? Do these black superstructures exist in full sculptural face, or just in profile? I told Tinguely that there certainly seemed to be a plastic side, but that there also seemed to be an effort to escape the plastic side. Tinguely, who is adept at expressing his thoughts, expressed them.

"For me, it's— a long story. It's been a long road. I moved progressively from painting and from what's called conventional sculpture—abstract, that is—to a search for movement, to give it an added dimension, to take it out of a static state. Let's say that after a certain immobility I had experienced, I no longer wanted to be able to finish a painting, to be able to say, 'it's finished.' Well, I made it move, so that it might be *infinite*. And that was the primary step. But it still wasn't a true machine, even though there were motors inside and it moved. It was a thing characterized by a technical invention, going beyond the context of a canvas, of an easel painting.

"But that was the very beginning. There were perhaps fifteen or twenty years of that. Then, progressively, I came to discover the different and multiple possibilities—plastic, chromatic, kinetic—of the machine: the possibility of making sculpture-spectacles; the possibility of sculptures leading up to the

Homage to New York,[*] which is an auto-destructive machine, the sort of machine that has as much psychology as no psychology. That is, I simply discovered the chromatic beauty of movement. There were other machines which were simply 'mad'—that is to say, the movement was utilized as a sort of *provocateur* element, doing things, reanimating the cadavers of old machines, making them move in a useless madness yet utilizing the psychological reaction of spectators face-to-face with the multiplicity of objects. Like old ironware and half-motorcycles mixed together in an insane ballet. It was all based, during that period, on the idea of 'the New Realism.' But after that, there was the possibility of the pure mechanism, of the chromatics of movement. And that became a purely sculptural thing. Today I don't even make a distinction between the machine and sculpture."

—— . . . And a species of architecture?

"It's all those things. It's constructive, it's intuitive, it's architectural, it's— today, perhaps, it's very well done. I've finally learned a *métier,* on the side: knowing how to assemble ironwork, making it turn correctly."

——But isn't there also a social side, a comment about the machine today?

[*]This was a machine that did away with itself electronically in the garden of The Museum of Modern Art, New York.

"Yes, obviously. There is that. There is farce, too. It's simple enough, this idea of reviewing the inutility of all our efforts, the madness of all our mechanisms, the terrifying quantity of machines that begin by serving us. Obviously, there is that. One can say that the machine is mad.—It becomes a kind of god.—God makes what he wants. But in fact it's not true. My machine is much more human than the majority of machines, which are functional, which must incessantly produce the same object. I think that the useless machines, so to speak, which I make, are less *made* than has been said. Because I have a purely plastic, purely artistic point of view in making them work. While the point of view of the engineers, which is a matter of efficiency, of efficacy, is often a nuttier point of view, much crazier."

——But what about the machines, say, at IBM, in the Place Vendôme? Those also have a sense of plasticity, in another direction, and they also comment on themselves.

"Yes? I should say that the high romanticism of the machine perhaps still exists today in the great machines, in the great projects. The really efficacious machine of our time,

the most formidable—the electronic brain—is not, in my opinion, spectacular to see. Plastically speaking, it is even without interest. Machines today have a tendency to become discreet and anonymous. They were beautiful at the beginning of this century and at the end of the nineteenth. You can look at them; they are magnificent, gripping, beautiful—more interesting than today. Today the machine has a tendency to become so efficient—thirty, a hundred times more efficient than the machines of the beginning of the century. But, on the other hand, the spectacle side of the machine disappears."

Which points to a great ambiguity in this sculpture that is sawed, hammered, fitted, and wired into shape at the Auberge au Cheval Blanc in the peace of the Seine-et-Oise. If it has a dynamism, its dynamic comes out of a definite nostalgia. If it looks forward in concept and principle, it also looks back in taste. The turn-of-the-century machine was greeted with a hopeful innocence, as testament to the perfectability of man—the idea that had been current since Newton in a world that could never have anticipated Einstein. The absolute, viewed with qualita-

tive and quantitative confidence, was then thought of as entirely plausible and within human grasp. And here were machines extending the human reach. Of course, painters and sculptors tended to look elsewhere, into a non-quantitative realm that Einstein would one day confirm as a branch of 'science.'

——But, given the plastic side, why the auto-destructive machine?

"Logical consequence. It's at once the auto-destructive side that was in me and in my object, and at the same time a total working out of the joyous and free possibilities of construction, without caring about what it might yield. I constructed, and I occupied myself absolutely without knowing if this motor was going to work for one minute, or two days, or ten years. I made it and— it would explode or it would hold up. And in

making it I made the parts knock against each other. That is to say, there was a harmony, but a harmony of war. And it was an attack too. It was an attack on the cultural system, which is why I did it in a museum."

——A bit like a Surrealist act.

"No, an attack. I had had this idea of the ancient nihilists, anarchists. I felt very much at ease making a machine in a museum—a machine that was going to be very, very beautiful. I went to a lot of trouble. It was a good sculpture, a good spectacle—funny, dangerous, and it had qualities that were— bizarre. Making this machine, and doing it in a museum, was also escaping from the museum. It was a glorious passage under the nose of the assembled museum directors, symbolized for me by the New York Museum of Modern Art, which is an exponent of the

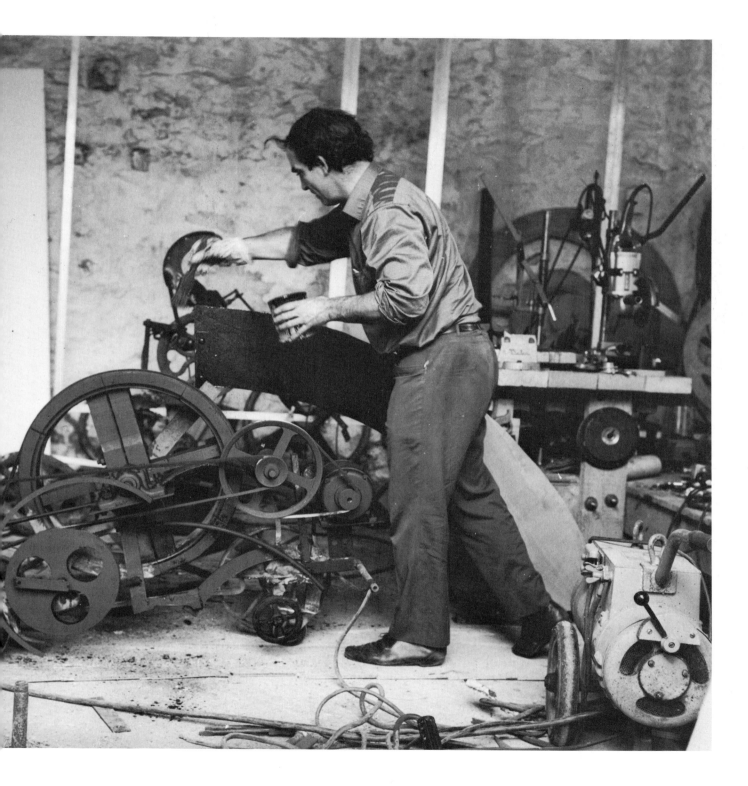

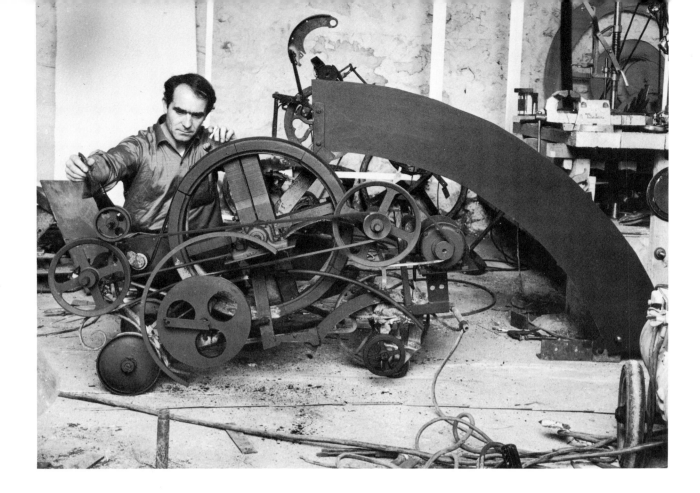

cultural exploitation of art.

". . . I am fond of dangerous art, art that moves on its own in society. And all these museums, all these cultural services, all these art historians, all these critics, all these collectors, all together— they diminish the general attention that art can provoke face-to-face with society. They 'pedestalify' it, or 'museumify' it. Don't you see, I would like to succeed in making a little art that is still art. Note, I don't give a damn if it's art or not. To do my work — which, as with many other things, they classify as art because they can't find any other possible classification—is a

manifestation of the free spirit. To do that work in such a way that I can't be absorbed easily. That's at bottom the reason I ought, and am obliged, to renew myself.

"So I renew myself. I don't, in fact, renew myself much in the final analysis, since I discover that I always do the same thing. But I arrive at— doing it differently. It's not like someone who knows how to play a violin the usual way, but tries playing it behind his back. That's not what I mean. It's really a question of renewing the plastic means. And if I say, 'It's always the same thing,' it's in the sense that it's always perhaps the same ab-

surdity, the same— the same wheel that always turns— the same basic idea is there."

——And do you find any connection with, say Kupka, who was fascinated by the machine?

"I don't see Kupka very much. I feel far more rapport with the attitude of Marinetti, for example—the Italian Futurists. Their connection with the machine would seem to me fairly close. But at the same time, I don't only glorify. I ironize, while the Futurists had a tendency to glorify. Marinetti, for example, wrote poems in which he cried, 'Vive la Locomotive!' But I know that the locomotive isn't everything, isn't the end of the world. Alas, it's something else. By the machine, I mean the ensemble of millions of little mechanisms which are our slaves but which, at the same time, imply a bizarre change in man's lot with respect to the object— I mean the mass production of no matter what object, which is done today by machines, and the automation of this mass production, which will modify us, without any doubt. Well, I continue, obviously, to keep that always in mind, but without— without making a philosophical thesis of it, without having that as a basic principle in my work. I let myself go, calmly, and I've also been able to ironize on top of it, as I did with the drawing machines, where each one came and did its little painting, all by itself. There one really had a direct rap-

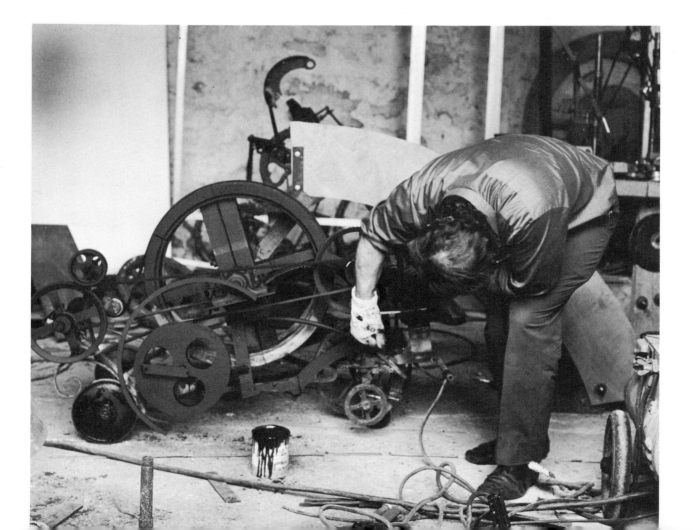

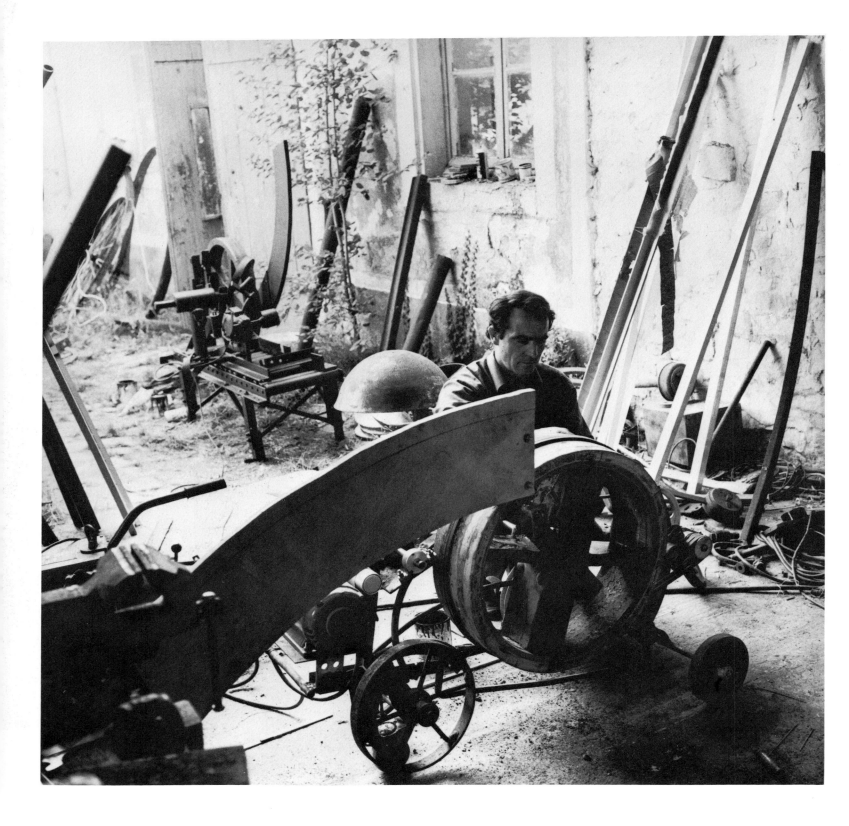

232 / JEAN TINGUELY

port. Not with the standardization of spirit—I don't mean that—but with material standardization."

——And all the machines are now kinetic, aren't they?

"They always have been. It's essential that they move. It's a dimension which is necessary to me in order to give the machine its true value. It seems to me that it's very difficult to do a sculpture otherwise. And I find that one must replace a certain attitude about classicism by introducing new dimensions, new actors; one must resist in some way the spectacle of our time. Enormous spectacle, isn't it? The engineers are doing tremendous things. Something is necessary. If a sculptor believes he can contribute something to the twentieth century by taking his little piece of granite and happily tapping away on it, fine. I myself doubt it. I believe it will give very little message. I don't really mean message. I mean, rather, that it won't give an expression of his age. It's difficult for me to conceive that someone today can make an image of his age using potter's clay."

Of course, there is also the point that great art is as exceptional as it is typical, that there are ages that kill just as there are ages that sustain. The Victorian age tended to be a great trap for artists, just as it was, in another way, a generator of art for those who opposed it. The false coin of the nineteenth-century Salon in some ways represented the epoch as much as did the revolutionaries who rebelled against it. Chardin represented his

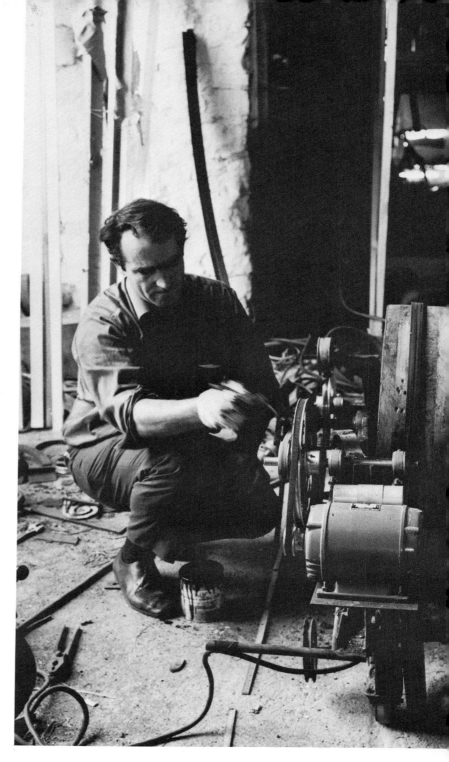

apple tree in your nook, of sleeping in it and looking at the sky. You can do that. It's magnificent, and I do it myself. But I don't think art can do it."

——But not necessarily with a view toward repose. Rather in opposition——

"One can— abstain."

——No, there is a movement that is created by opposing present activity — a contained movement——

"Yes . . . yes."

— . . . which holds its ground, which——

"Yes, yes. But it can also happen that you are very easily 'out,' that you set up this opposition, and you put yourself outside of present currents, and then you *are* outside. Then you risk not moving with your time. I think that many of our images have changed. Our images have been modified by the pace that accelerates us. We see many more things. We have a different way of seeing—

time in one way, Boucher in another. The visible currents of time hold dangerous shoals. Contemporary estimates are always risky.

——But perhaps, from another point of view, there is so much movement and action in modern life that one might say, to the contrary, that it's a certain stillness and lack of action that are likely to contain the most motion.

"Which would give us repose?"

——Which would give us repose, or——

"But we don't want repose. We want testimony. We want expression. Ultimately, we will search for expression, for the art that will have the greatest significance for our time. It's not a question of having a nice

from a car, from the *métro,* from an airplane, not to mention a train. And we begin to see images transmitted by thousands of possibilities in communications. I mean television, obviously, which invades us, which modifies our image. And the cinema, but also the imagery of others—the image that the cosmonaut has. We each have that image, don't we? And all these images concentrate, in fact, into a climate which makes our eye begin to see differently. Can we still confront a potato sculpted in stone? Do you think so?" Tinguely laughed out loud at what he considered the patent absurdity of the thought.

"Look here, the eventual contemplator or spectator is a man who is— hunted, visually hunted. Well, all the same, I'm not trying to catch him. True, I don't give a damn about him. Finally, at heart, I don't give a damn altogether, and I come back to the point of view that the less people see what I do, the better it is. But this is simply a form of— protection that I practice to be able to continue my work in peace. In fact, if my work functions well in rapport with the spectator, I am completely satisfied, and I should be. I am the first spectator, and I don't let a sculpture leave my field of action without impregnating it with a certain quality that permits it to be at the same time both a spectacle and a good sculpture."

——You paint all your sculpture black, which adds a certain formality.

"Yes, yes. I'm not embarrassed about trying to make good sculpture while I'm at it. No, I'm not against that. I can easily addict myself to endeavors that can qualify as being of an aesthetic order. And why not? ('En-

deavors' is a pretty big word!) I let myself go. I work a great deal, and since I work a great deal I know a great deal. I know how to do, I have ideas, and, in addition, I can work freely, which is marvellous in this age. It's fantastic. I am nourished by and for the pleasure I have, and also for the anguish that I end by getting rid of. But, at any rate, my person is now so freed from my self—I've done away with my 'me' to such a point— that I feel myself almost in a state 'beyond.' I have almost no more pride, no more vanity. In human terms, I am intensely purged. It's like giving a violent push to an engine to try to clean out the spark plugs; my 'me' is intensely purged. With time, nothing remains but an almost empty sack — just right, at heart, for lying under an apple tree and looking at the sky."

In which the issue of time, in time and out of time—and also of the self, in time and out of time—is paramount. The black paint serves as "a means of depsychologizing —not really of dematerializing, but of obliterating the first contact with the spectator." There is an appeal to something beyond the ego in shape, in symbol, in energy. And the appeal rests upon the conviction that the machine is the energy of our time—almost, perhaps, in the sense Henry Adams meant in 1900. Tinguely laughs at what he calls "a potato sculpted in stone." Implied is confidence in an idea—an idea that opposes technology and biology — and there a stone sculptor would disagree.

The old question presents itself, the old duality of the idea and the flesh, the old power principle. Where does the true, the most potent kinetic energy reside today? Is there perhaps too much kinetic impetus, kinetic confusion, for an artificially active totem to be of great force? Is silence in stone dated, as Tinguely suggests—or is it larger than the moment? Is a quivering, eerily autonomous, and purposely useless machine in the current of time—or is it in some narrow tributary?

Or, in another perspective, is Tinguely pursuing the iconography of a moment in time that offers action but not motion, ritual but not magic? I asked if the great wall at the Canadian exposition—then in formative stages at the inn—was also going to be entirely kinetic.

"Yes. There's no doubt that it has to move. Because if not, what would it be? Can you imagine a wheel that doesn't turn? That would be a catastrophe. It has to turn. Otherwise it would be logical, yet at the same time it would be mad. Which is to say that in some way the circle that does not turn represents madness. I want to escape that, and I will never make a wheel that won't turn."

——But is there such a thing as a circle that doesn't turn?

"I don't know. A circle can be thought of as an infinity, can't it? And yet I find it would be madness to imagine such a circle. I like the circle in its natural function. I find it, at heart, fuller in the possibilities of delight

when it is in its natural state—which is when it is turning—than when it is in eventual immobility. In a state of immobility, the wheel would seem to me to be interesting only as a function of the possibilities of speed that it contains."

——Yet the circle itself is a very ancient symbol.

"Yes, and in any case a symbol very necessary to our time. You know, perhaps, that in our technical civilization everything that moves is based upon the wheel. All energies, all— well, it's very banal, what I'm saying now."

——But it's very contemporary to conceive of the circle as a symbol of madness.

"I often think that it's one of the madnesses of our epoch—all our wheels, the thousands of machines, motors, wheels that turn, advancing, withdrawing— Everywhere there is a rotary movement, in everything——"

——But it depends in part upon whether or not it's directed toward something.

"It's always directed toward something, at bottom. There is always a dimension, the dimension of speed or the dimension of quantity. With the machine, with the wheel, that is almost inevitable."

One thinks of the Buddhist wheel, of the Chinese circle of yin and yang, of the absolute Euclidean ideal, of the Gothic rose window: all circles inscribed in stillness, indifferent or oblivious or opposed to action, yet alive and rich in motion.

We spoke about drawing, and there Tinguely's point of view seemed quite

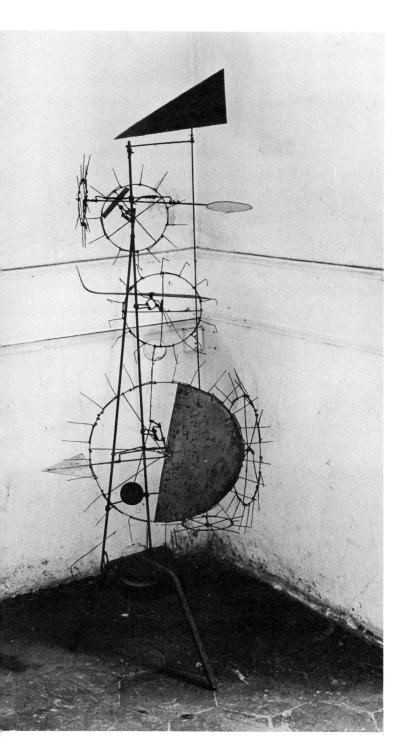

parallel to his attitude toward action.

"When I can't work, or when I have a problem, I immediately start to draw. In order to disengage myself, to try to find solutions. My drawings generally remain techniques. They are drawings that I do for myself; I don't do them for others."

——But you draw often, and you draw with sculptures specifically in mind, don't you?

"Always. My drawings are purely functional. They have no goal in themselves. I don't draw for the sake of the drawing. Which is why I can't make graphics, why I refuse to do etchings and things like that. For me, the drawing is only a possible approach toward my real work."

——And graphics don't interest you at all. Wouldn't it be possible to imagine some fine things in graphics?

"No, I don't see why. I make a drawing. It's immediate and direct. That's sufficient. I can't make— Well, they might be good, but that I couldn't tell you. I know that the Museum of Modern Art bought one and they like it down there, but I don't see them at all in that light."

——But wouldn't it be another dimension?

"No, it's secondary. It's a little whatnot that's nothing at all. Drawing, as a discipline, doesn't carry very far."

——But it exists on another plane entirely.

Tinguely laughed uproariously. "But that would seem to me such a minuscule plane for the twentieth century. I find that insufficient to fill galleries. Planes! No, I am for

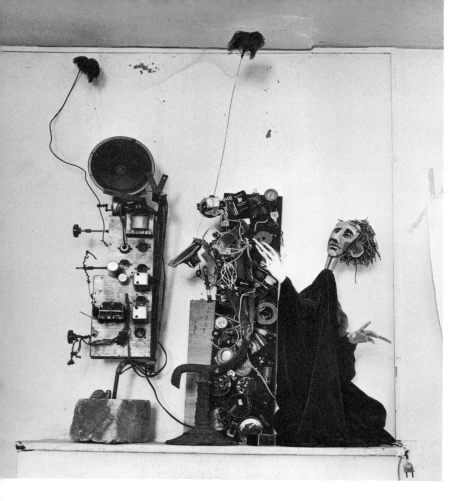

life. What do you want me to do with a drawing? A drawing is there in order to make life. It's an intermediary step, if absolutely necessary. Not more."

——Doesn't it have a place in life all the same?

"You think so? I don't. Obviously, if it's some fellow's principal means of expression, then drawing is great. But in my case, well, I don't really see——"

——And then, anything one does depends, to some extent, upon the receptivity of the spectator.

"Obviously."

——One can do no matter what, but if the spectator is dead, he sees nothing.

"Then it's fouled up. But it would be difficult to wake them up with a drawing. That I guarantee you. You don't touch the public anymore with drawings."

——That depends upon the public. There is always a minority, isn't there?

"Yes. Agreed. Yes, there are perhaps characters who like only drawings."

Tinguely, then, is greatly taken with a level of action in more ways than one. And it perhaps comes down to a question of focus. Is it implied that a Michelangelo drawing or a Cézanne drawing, in their kinetic power, have meaning only in relative, historical perspective? Or is it only contem-

porary drawing that is insufficient in dimension?

On the other hand, to what extent, do Tinguely's machines participate in the currents of modern times? Or do they, instead, parody those gigantic forces? Is it possible to conclude that the ultimate appeal made by Tinguely's work is quite apart from the rationale he applies to it? Or is there, in his love for those recent machines that seem so ancient, a tactile and imaginative impulse that has little to do with the dilemma of the contemporary machine? Is there less irony and more romanticism involved than he supposes?

Perhaps a schism between form and content is the ultimate problem of the contemporary artist, larger than any one poet but solvable only in the mind of a single poet. Which brings us back to the old challenge of poetry and power.

Tinguely said: "The only fellow who really impressed me, the only artist I really

242 / JEAN TINGUELY

liked, who really— gave me confidence in my work, is Alexander Calder. Because he has a world of his own—formidable, splendid, and airy—and in addition, he too made machines, very bizarre, very funny. I find that, in the last analysis, he's truly the only artist-sculptor who says something to me."

Why? Tinguely explains by referring to his boyhood in his native Switzerland.

"One has complexes. One has the art complex. One goes to the Schools of Fine Arts and catches the complexes. Of course, one doesn't have them to begin with. When I was about fourteen I didn't have complexes. I used to go joyously into the forest, where I made very beautiful concerts with little wheels on a small stream that crossed the forest. This pine forest was like a marvellous cathedral. I made my little wheels out of wood, and each turned at a different speed because each was a different size. And, with a reed, I made them lift up a little hammer that tapped on a little box of preserves or

sardines, or cardboard — whatever — which gave each a different tone. And I placed them every 3 or 4 or 5 meters, over a length of 150 meters: concerts in the forest.

"It was fabulous. It might not hold up for long—or it might go on the blink right away —but in any case the result was terrific. You see, I was very relaxed. Afterwards, I went to the Beaux-Arts, and I began to pick up a certain handicap—knowing how to draw,

knowing how to paint."

Like the echoes in a pine forest, the underlying rhythms of Tinguely's work may be hard to locate precisely. They may be up ahead, toward an art that stems from an act and ends in an act rather than in a presence. They may be essentially behind, in the world of the talisman and the object. They may be actual, they may be reverberations. They have a definite resonance.